To Professor Darsh Wasan; Many warm thanks for
the opportunity to v[...] of Technology
during our eMBA [...] Many thanks also
for your fine prese[...]
All success to you

17.7.2010

Tampere Technical University, Finland
University of Tampere, Finland

KARI NEILIMO
Director of MBA

D1480312

FINLAND

THE LAND OF LAKES

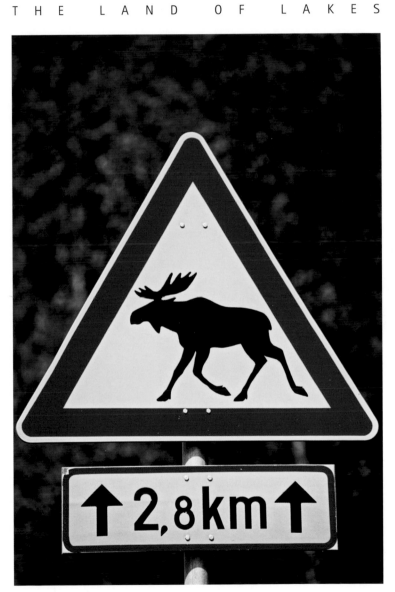

WHITE STAR PUBLISHERS

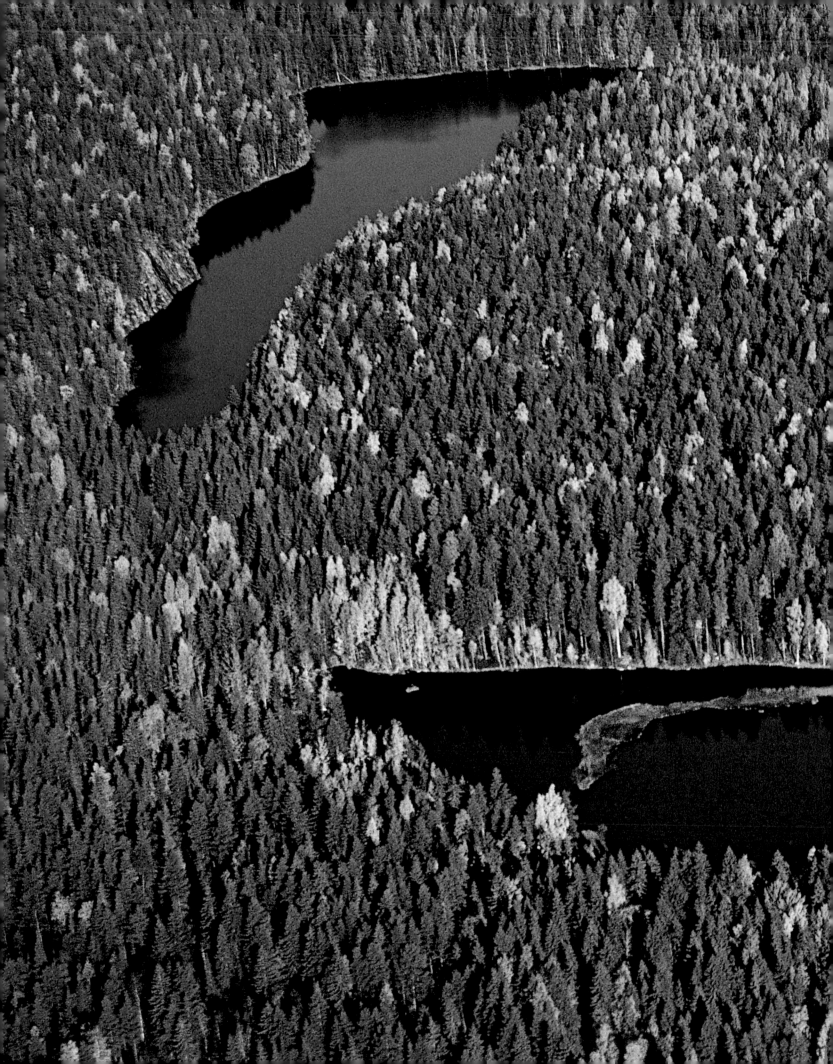

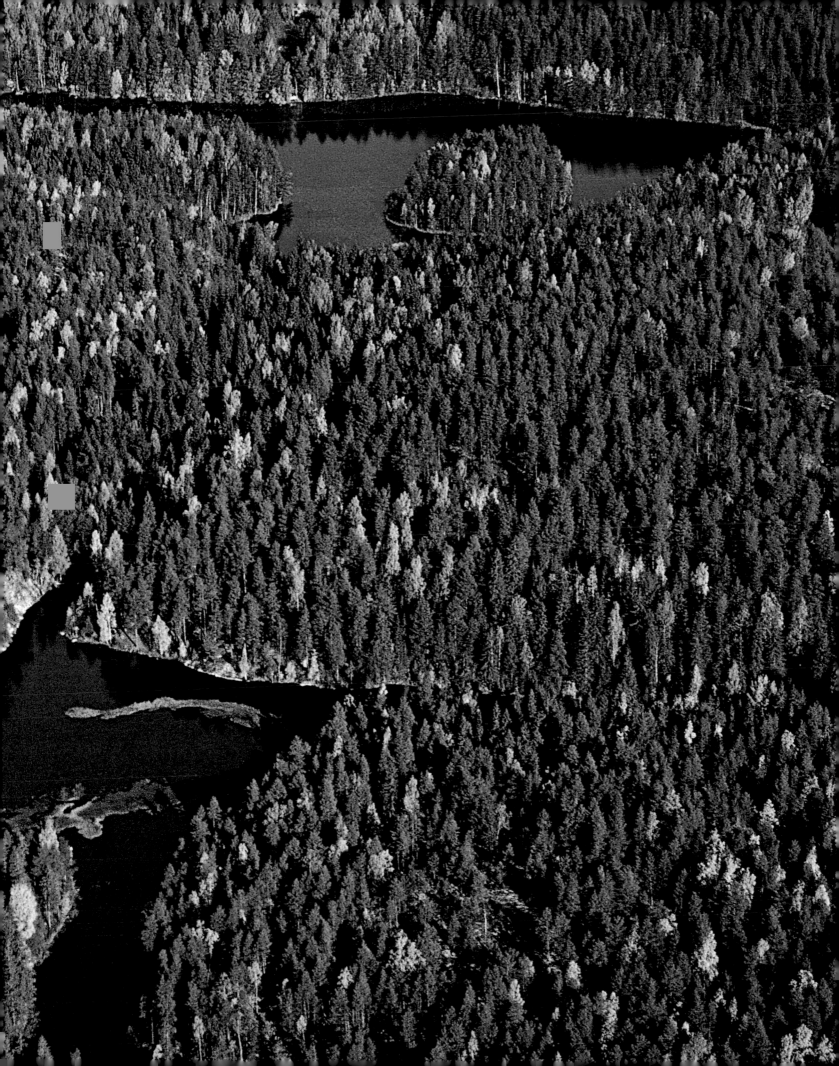

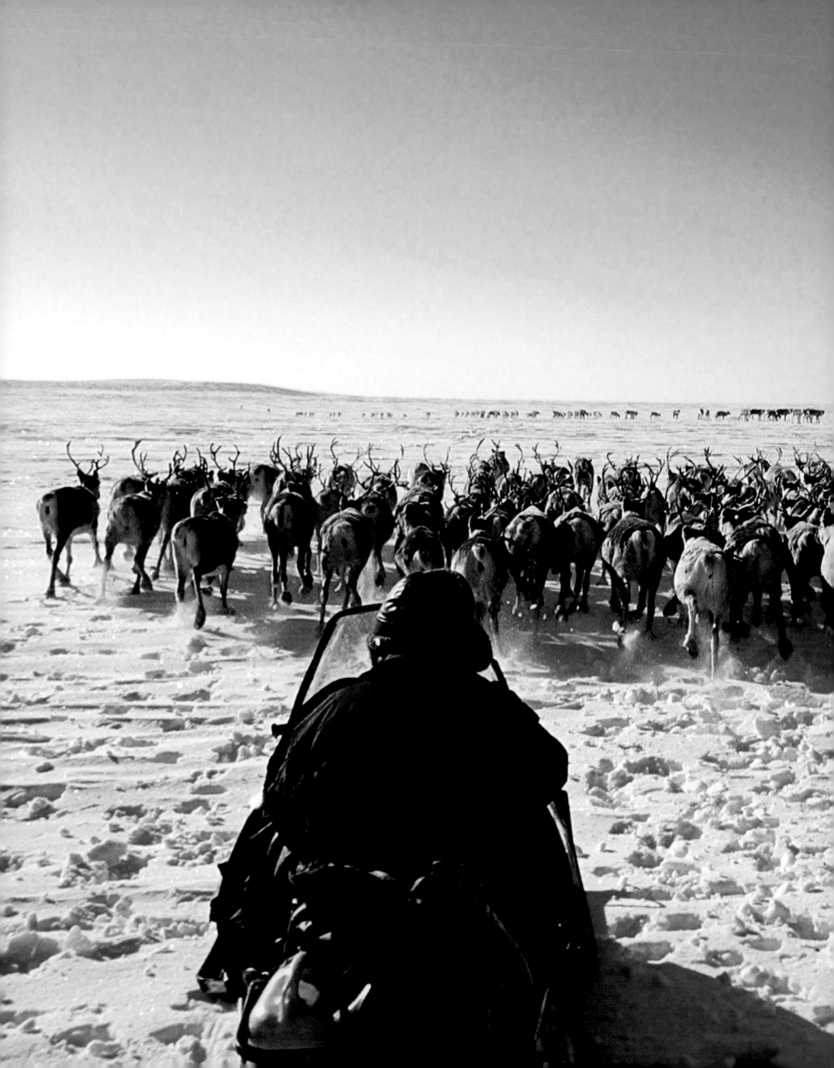

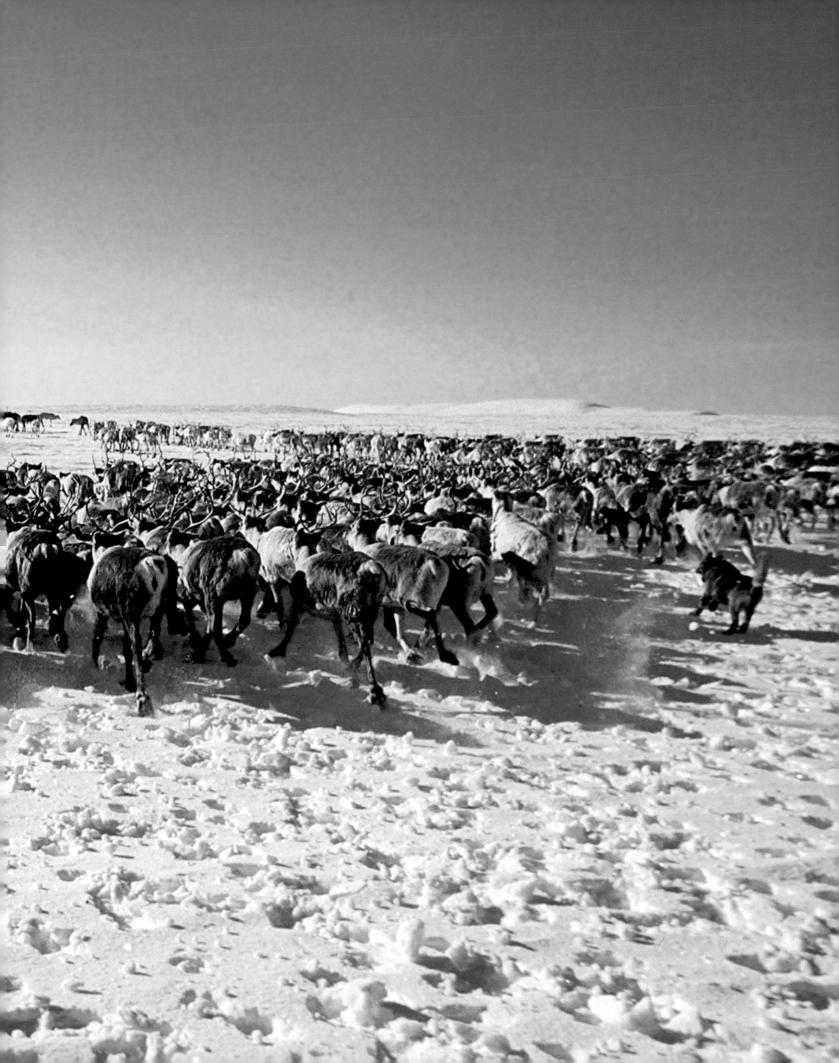

Text
Franco Figari

Contents

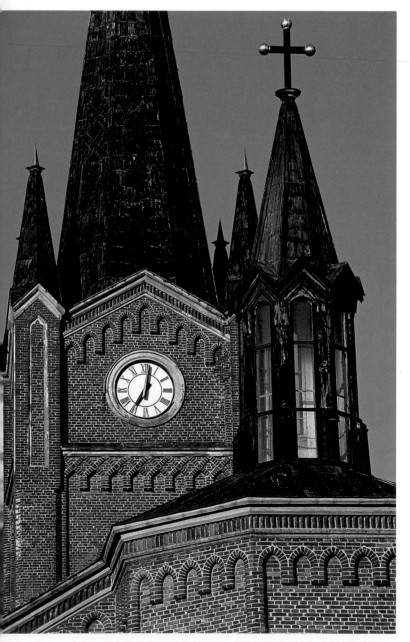

1 "Elk-crossing" street signs accompany drivers along the majority of roads above all in southern and central Finland. This mammal, whose bulk can even cause fatal accidents, prefers to come out of the woods during twilight hours or at the first light of day.

2-3 The Finnish landscape is characterized by a continuous alternation of mirror-like lakes, winding rivers, and the dense coniferous and birch forests that make up the immense woodlands of the taiga, which represent, in unprotected areas, the country's primary economic resource.

4-5 Once upon a time, the Lapp population was nomadic and followed the seasonal migrations of the reindeer. Today, the reindeer herds are rounded up twice a year, in summer to brand the newborns and in autumn/winter for the slaughter. By now, to facilitate working in the tundra, ultramodern means like powerful snowmobiles are used.

6 The church of Loviisa, today a small resort town on the eastern coast 56 miles from Helsinki but once a flourishing location for its hot springs and harbor in the 1800s, is an important neo-gothic building in red brick built in 1865 in the market square.

7 The surreal magic and mysterious charm of the winter fog partly envelops the winding path of the Kitkajoki River, a tributary of the Oulankajoki in the national park of the same name, a few miles from the Russian border in northern Finland.

8-9 At the beginning of summer, the yellow splotches of the colza farms characterize the typical landscape of the rolling plains between Helsinki and Turku in southern Finland.

10-11 The uniform lowlands of western Finland that from Vaasa follow the coastline of the Gulf of Bothnia to the north have favored the expansion of agriculture and to a lesser degree the raising of livestock. The partial deforestation and draining of swamps that took place over past centuries has made it possible to utilize the territory for intensive grain and cereal cultivation.

12-13 A single-file line of a group of elks crosses a frozen lake in the heart of the Lake District. Among all the animals living in the Finnish forest, the elk is undoubtedly a mammal that, in the wake of the slaughter of past centuries, is now in continuous expansion throughout the Scandinavian territory.

© 2005 White Star S.p.A.
Via Candido Sassone, 22/24
13100 Vercelli, Italy
www.whitestar.it

All rights reserved. This book, or any portion thereof, may not be reproduced in any form without written permission of the publisher. WS White Star Publishers® is a registered trademark property of White Star S.p.A.

TRANSLATION
Amy Christine Ezrin

ISBN: 978-88-544-0064-1

REPRINT:
 6 7 8 9 13 12 11 10 09

Printed in China
Color separation: Fotomec, Turin

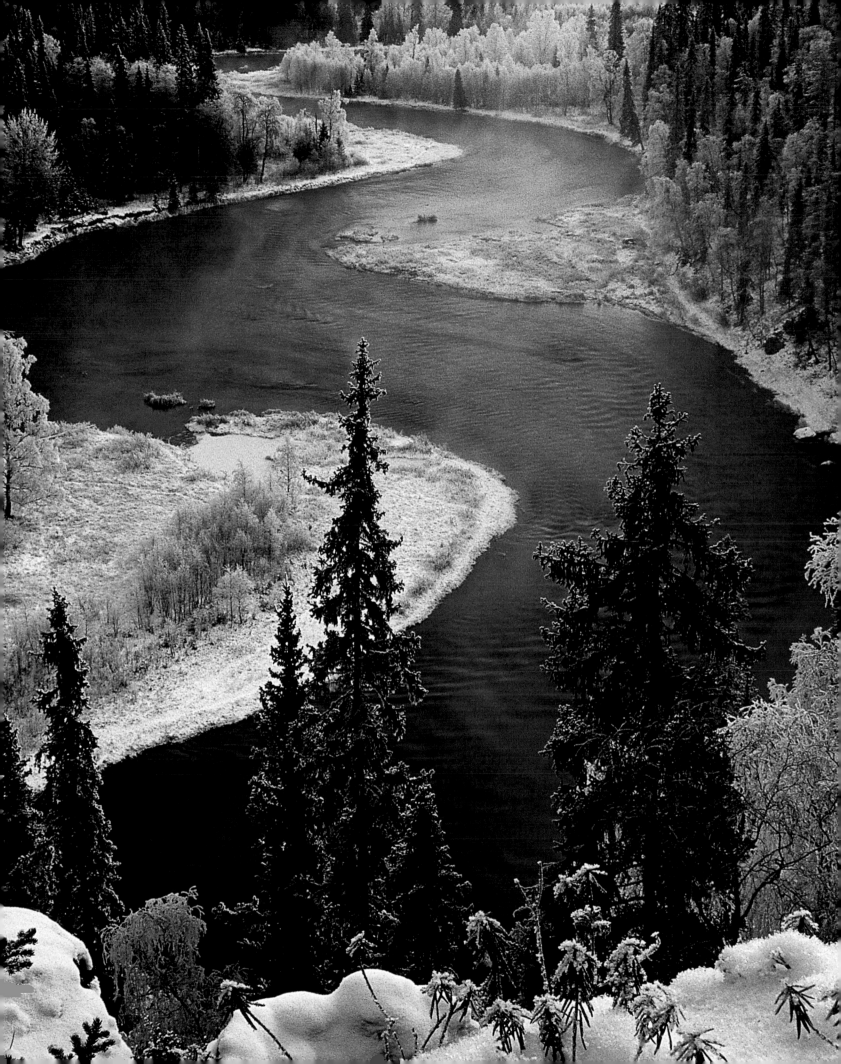

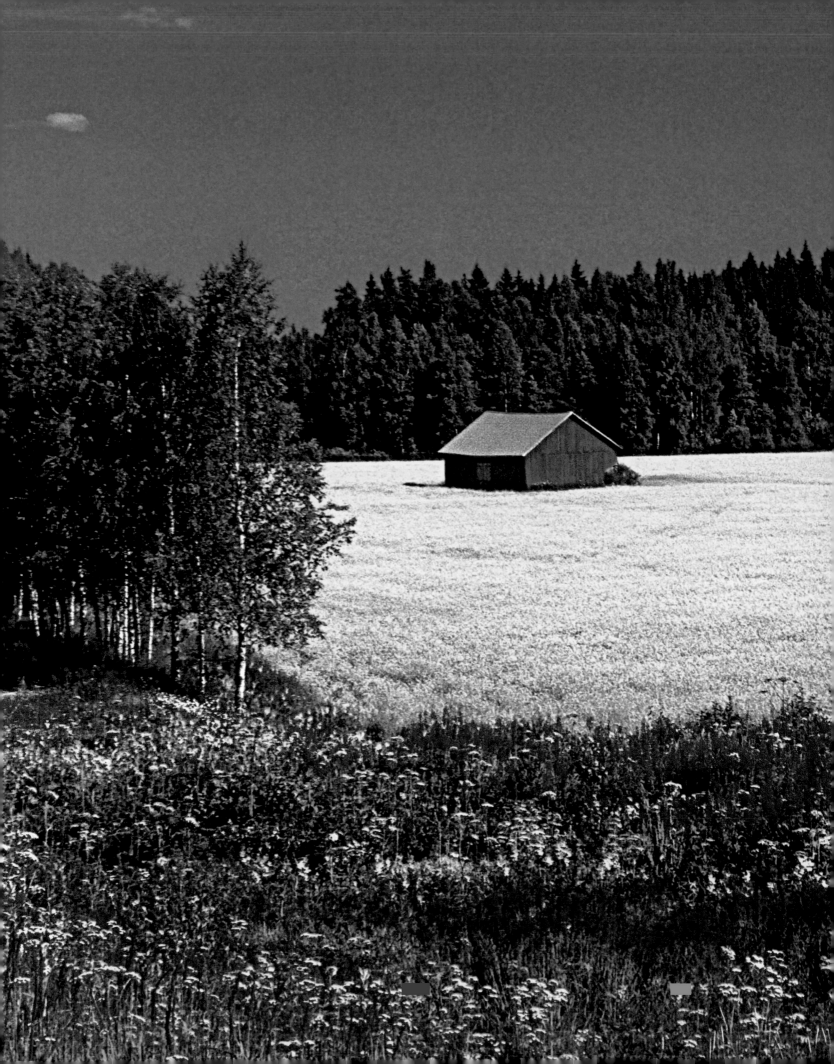

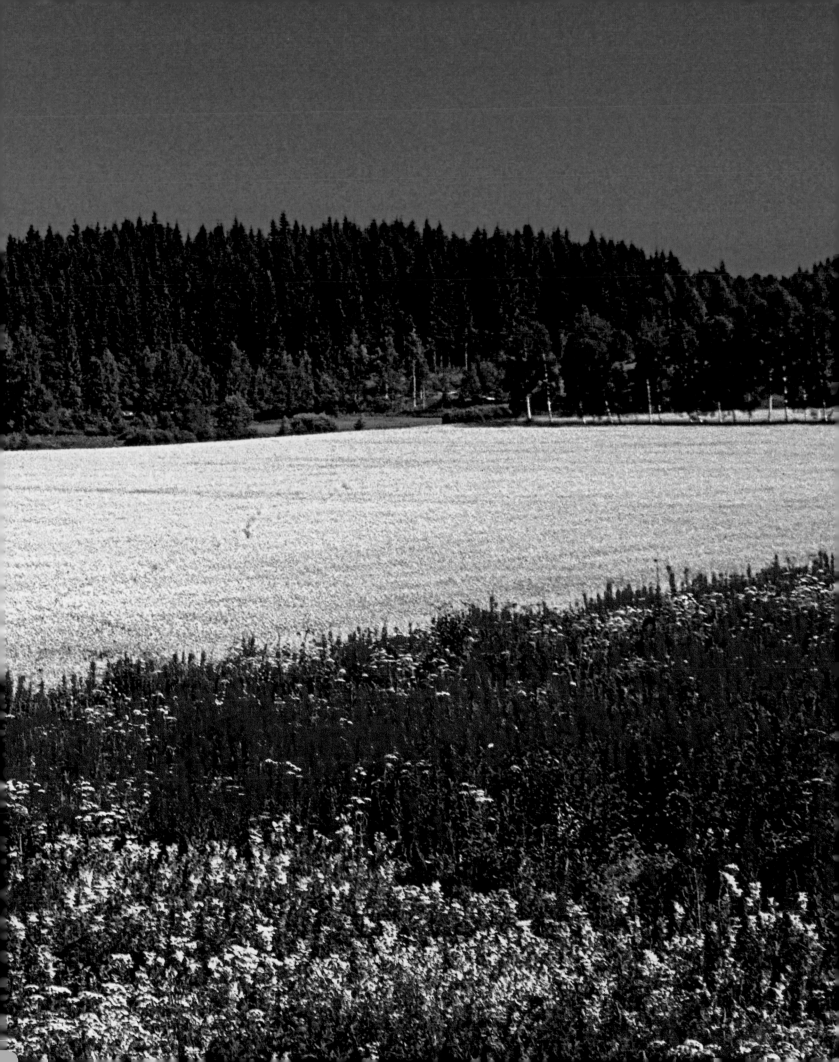

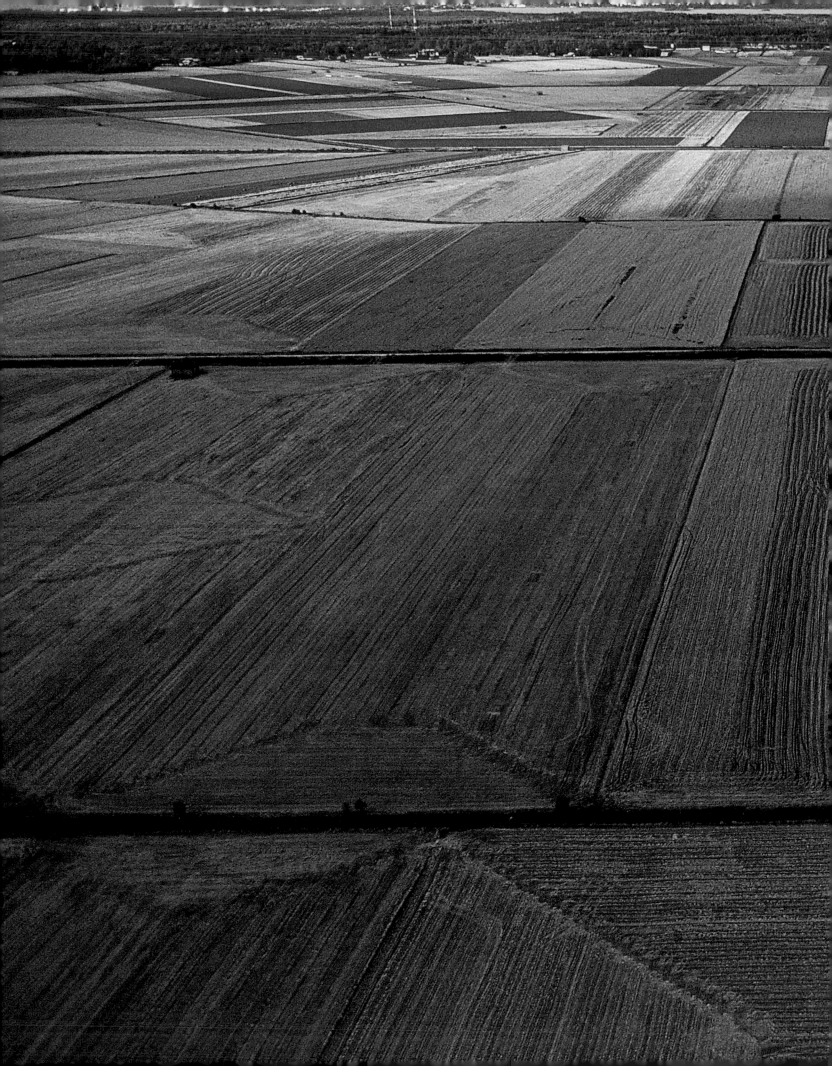

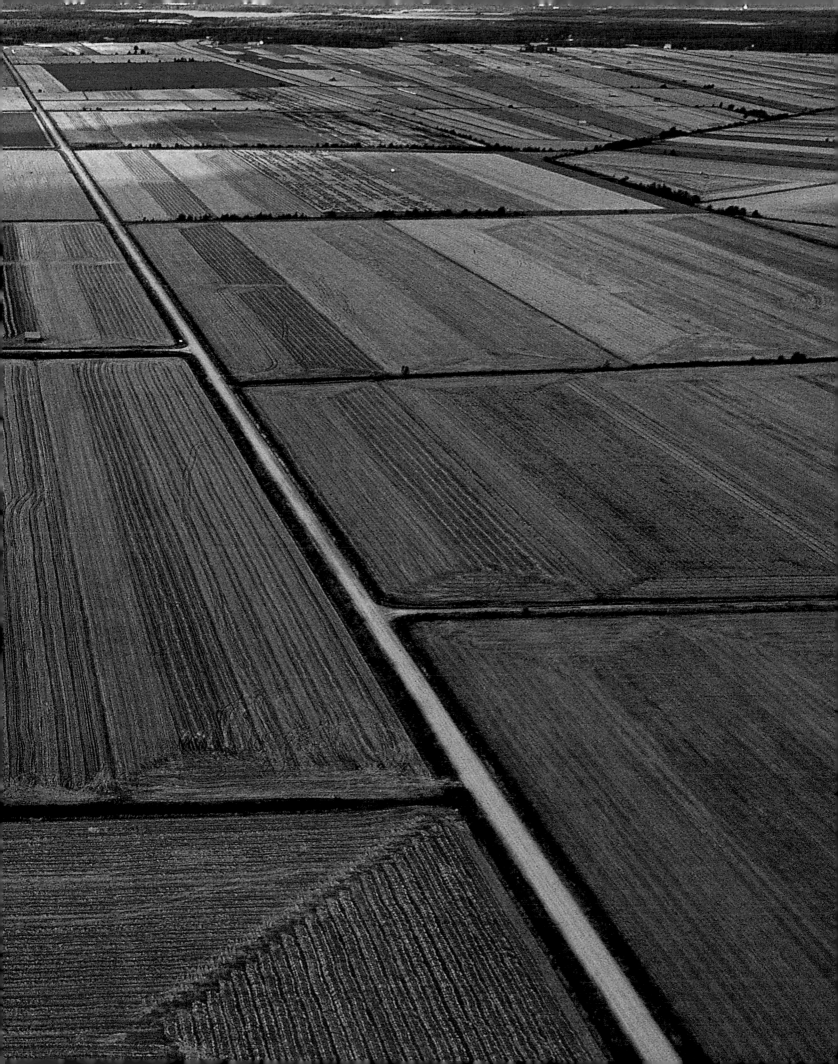

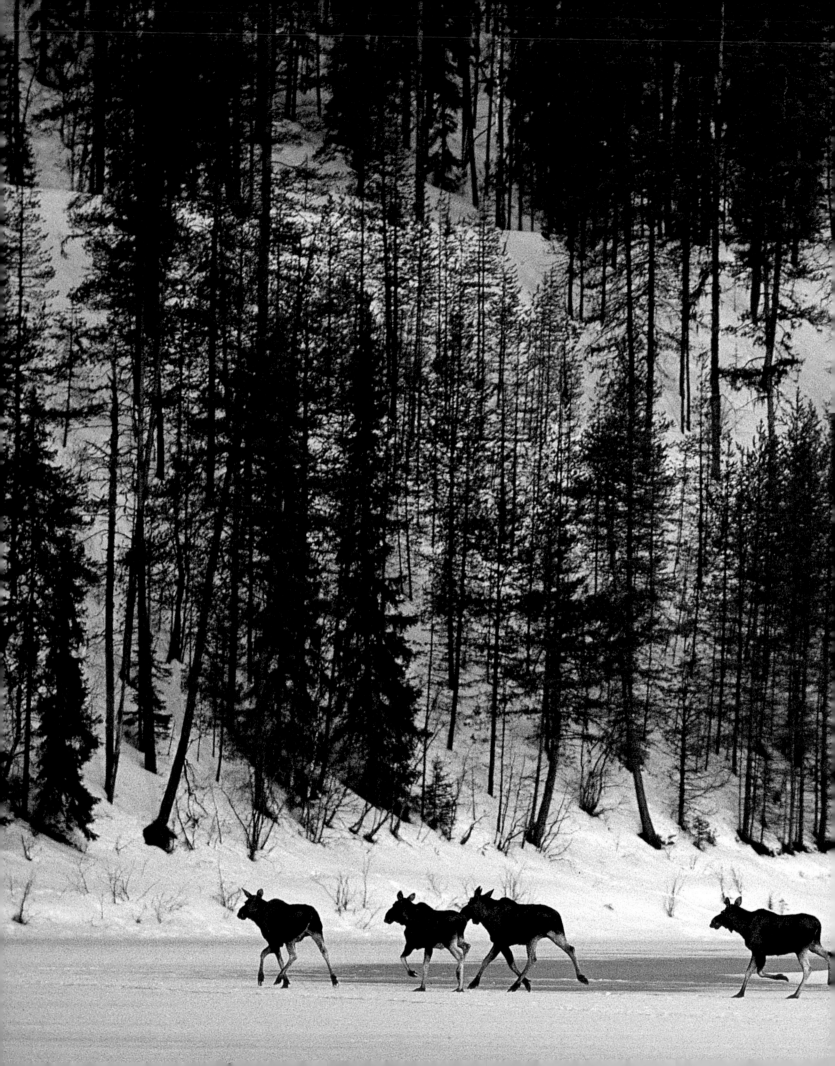

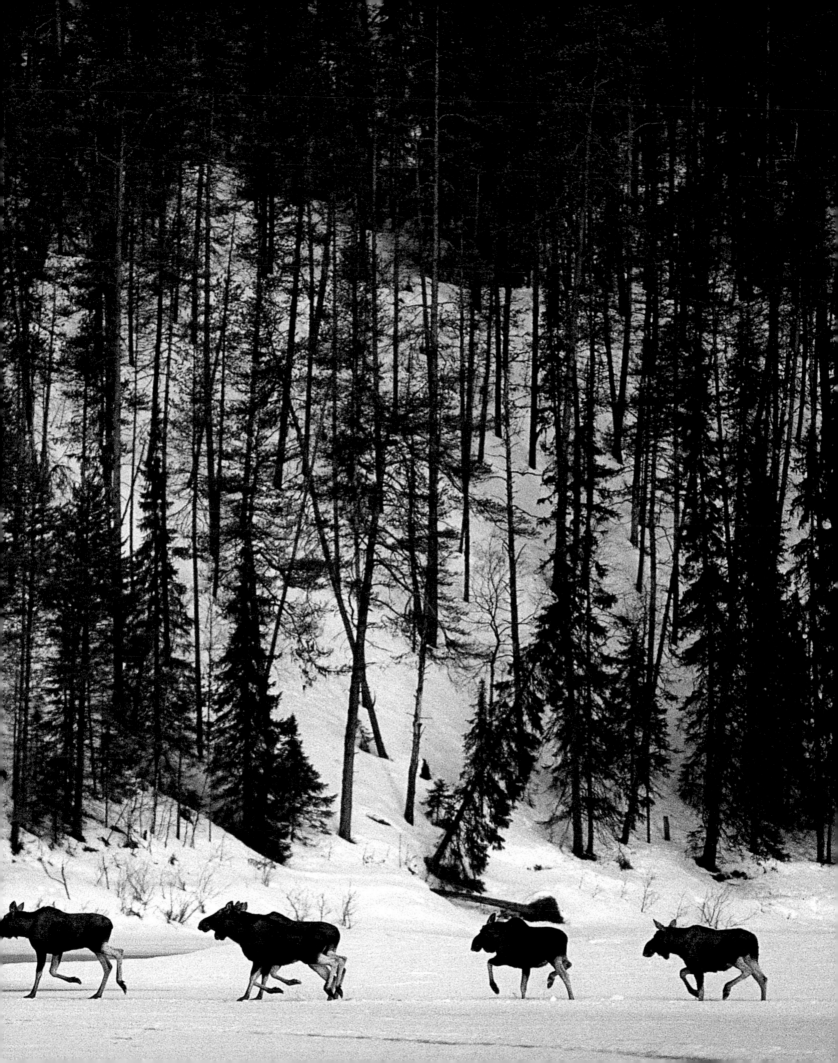

Introduction

Pressed against the rail of a ship slipping silently through the choppy waters of the Baltic Sea, visitors to Finland arrive at the port of Helsinki. Welcomed by flocks of playful seagulls, they are immediately gathered into the enveloping arms of a natural setting that seems to have the upper hand, even in the city. The whisper of Finland's sharp, steady summertime wind, the acrid smell of moss and timber wafting from the mainland, and the continuous shifting of the light in the clear-blue northern sky feed the sensations of freedom that repeat every time the visitor sets foot in this country of wide-open spaces. Likewise, arriving in Helsinki is an immediate immersion into nature: it can be seen and felt by visitors strolling around the colorful market stalls overflowing with wild berries and vegetables or walking along the tree-lined avenues and in the parks where squirrels often chase after them.

However, visitors to Finland won't always be able to appreciate its hidden treasures at first sight. Some countries have environmental and cultural features that can impress people right away; if so, even a passive attitude to fascinating wonders will not spoil a vacation's pleasures. But if a trip to Finland is not to disappoint, the visitor must participate actively both physically and mentally and display at least some initiative. Every summer, for example, hundreds of Italians retrace the steps of Giuseppe Acerbi, the explorer who in 1799, attracted by the adventurous appeal of a journey in Northern Europe, planned expeditions to reach North Cape, the Old Continent's northernmost point. Seldom leaving their cars, these 21st-century explorers shoot unknowingly and unwittingly across a seemingly monotonous setting, their trips completed in long-distance round-trip race with few stops and minimal excitement, lost in the seldom-changing environment of the taiga and Lapland. They miss the opportunity to discover the secrets of a natural world more varied and interesting than they anticipated, a magical world that for attentive and unhurried visitors has scarcely changed since in two centuries.

Visitors to Finland must learn to let themselves be enveloped by nature without fear and to accept its great silences and the seesaw of emotion that it brings. Traveling in Finland is also a journey into self. Not only do the vast panoramas of the taiga and the tundra, the cobalt-color mosaics of the lakes, and the breathtaking rivers and waterfalls enrich the experience, but smaller, simpler discoveries wait to be made in the unknown natural setting: the silence of the woods, a reflection in the water, an animal track, an owl's hoot across the motionless mirror-like surface of a lake in the middle of the night, the happy crackle of a fire in a cottage fireplace....

With only 5 million inhabitants, a surface area of just under 131,000 square miles, with about 25 percent of it

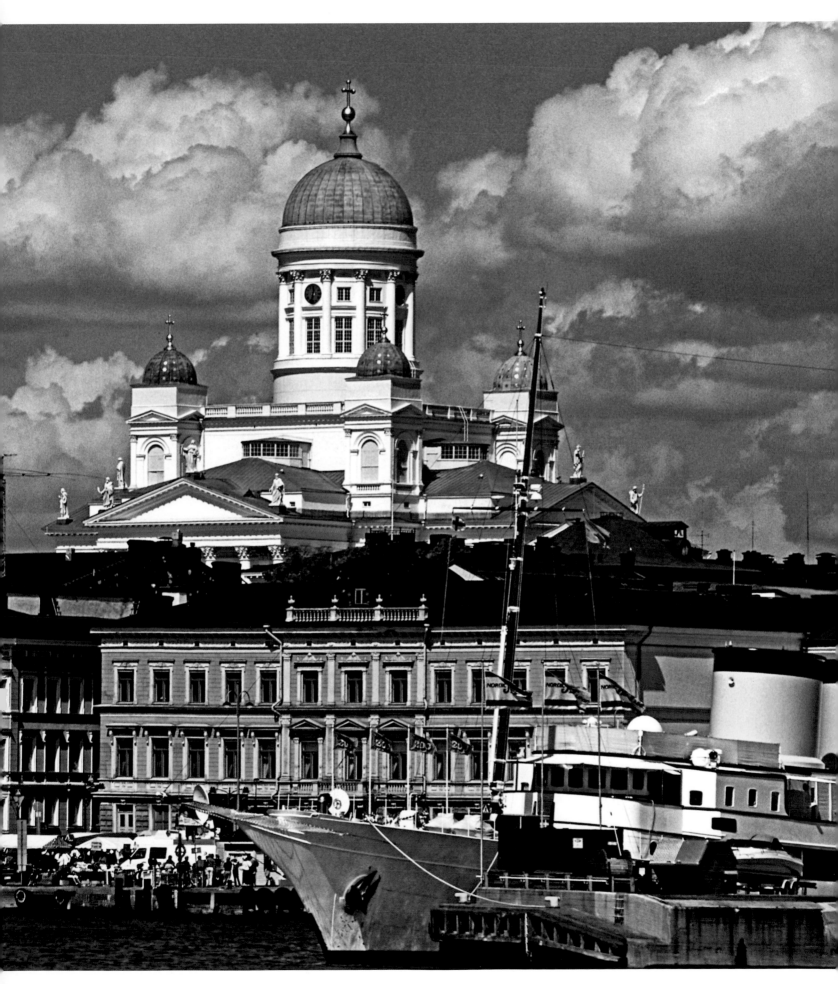

above the Arctic Circle and 70 percent of the rest covered by forest, Finland is above all about nature. Its landscapes recall, though on a smaller scale, the magnificent scenery of the Great North of America and Canada.

"Land of 1,000 Lakes": this is Finland's traditional nickname as featured in tourist brochures. In fact, if "lakes" that are little more than puddles are counted, the 60,000 triples to 180,000. A single glance at the map shows the stain of blue blotches indicating the complex system of waterways that constitute the great lake basin of Saimaa in east-central Finland. The waters of Saimaa form a tangled mosaic of internal islands and interconnected canals that have long favored the region's commercial and cultural development, besides contributing powerfully to the landscape's charm.

The Finnish landscape's contours were largely shaped about 10,000 years ago, at the end of the last Ice Age. As they shifted, the glaciers, which covered the entire Scandinavian territory with ice at times up to 10,000 feet thick, dug out the basins of the lakes in a northwesterly to southeasterly direction. When the cold front slowly began to recede and the ice melted, the entire region became completely submerged under water. The traces of that period are clearly visible today in the grooved and rounded rocks in the Saimaa Lake District and on the archipelago's coastline, and the thin banks that stretch between the mirror-like lakes are the borders of moraines deposited during the glaciers' retreat. The isthmuses of Punkaharju, near the town of Savonlinna, and those of Lietveden Tie, near the village of Puumala, form, from lake to lake, wooden arms of rare and unforgettable beauty, without doubt among the most spectacular panoramic roadways in Finland.

Over the course of the centuries, the lands that had been compacted began to rise, emerging from the sea that had formed, partly transforming it into a vast lake dotted with thousands of islands. Even today, the Finnish landscape is, geologically speaking, in continuous evolution: on the northwestern coast of the Gulf of Bothnia, the level of the land rises about three feet every 100 years, whereas in the Helsinki area, the growth is about eleven inches. Each year, the country's surface area increases, though at least a third of that total is composed of peat bogs and swamps that were once lakes whose cavities, produced by glaciers loaded with water and debris, were transformed into vast marsh zones, largely inaccessible to man but not to the abundant bird life that has made them its natural refuge. Actually, in no other part of the world do swamps cover such a high percentage of a nation's territory, even though the drainage projects underway in Finland to create new farming and forest lands is diminishing the swamps' extent bit by bit.

People sailing from Stockholm to Helsinki on the big ferryboats linking Sweden and Finland see another side of the Nordic landscape that was clearly formed at the end of the last Ice Age. In the heart of the Gulf of Bothnia extends the complex mosaic of the Åland Islands, to which can be added those of the Saaristomeren Archipelago, located along the indented coast of southwestern Finland. Because the land is rising above sea level, new reefs are coming to the surface that will eventually take the form of still-growing islands. A quick glance at old maps will prove how the coast's configuration has changed in just a few decades and how the underwater world of back then is now dry land.

Farther north, the landscape exhibits gradual changes in a continuous interweaving of different ecosystems. Along the coastal regions of the Gulf of Bothnia and in the bucolic countryside of the south, the country takes on the appearance of vast, rolling plains favoring the scattered settlement of farms as part of the agricultural and livestock development program. Proceeding inland and north along the eastern border with Russia, the terrain rises and the contours of the landscape become increasingly varied, with a chain of rises and hilltops covered by forests and interspersed with an amazing labyrinth of mirror-like lakes. This is the Lake District, one of the main tourist attractions in Finland, the habitat of the renowned Saimaa fresh-water seal (*Phoca hispida saimensis*), the symbol of the Finnish World Wildlife Fund and a true relic of the Ice Age. It is also called the marble seal because of the characteristic pattern on its fur. This mammal, one of the world's rarest species, remained trapped among the lakes when the glaciers receded and to survive has had to adapt to an environment very different from its original marine habitat. Now protected, a few hundred marble seals still exist; in summer they bask in the sun on the grooved rocks emerging from the water, the color of the rock providing a natural camouflage.

Nonetheless, for the traveler on the largely deserted roads of the southern and central Finnish countryside, the human presence remains noticeable. Some 75 percent of the population lives the south, with a population density of about 300 inhabitants per square mile in a territory that has sustained massive deforestation over the past centuries.

In the north, however, once away from the main tourist-frequented routes that lead toward Lapland and North Cape, it is much harder to run into people. Nearing the Arctic Circle, the visitor enters the enchanted realm of the great forests of the northern taiga. The dense, endless woodlands covering two-thirds of the country's total surface area cross into the boreal zone of the conifer-filled taiga and continue to the east, disappearing into the vast solitude of Russia. This ecosystem is made up of an essentially continuous ring that from Northern Europe passes through desolate northern Siberia to the Pacific Ocean and then carries over into the North American continent. Many species, both animal and vegetable, are present in the European as well as in the American and Canadian regions. In the Scandinavian territory, the Scotch pine and the spruce tree are predominant, and the wood of both is widely used by the paper industry. However, the most typical Finnish tree is undoubtedly the birch, praised in numerous popular songs. Their trunks, white and slender like candles, look like supporting columns in an immense natural cathedral. The quivering of their windblown leaves reflected in the rippled surface of the lakes offers a delicate contrast to the somber fir-tree woods, softening the Nordic landscape.

The Finnish forest is the national paper industry's most important economic resource and is still the source of the primary materials used to build houses and for the manufacture of craft and art items. Finland's prosperity has always depended on its woodland assets, and forest conservation represents a vital interest for the entire country. Precisely for this reason, the exploitation of timber, "the green gold" of the national economy, is carefully controlled. Since large parts of the forest areas are privately held, the State and the Federation of Forest Industries cooperate to promote a widespread information campaign in an attempt to establish a balance between economic exploitation and the maintenance of good environmental and ecological standards. The two parties agree on cutting and forest-renewal criteria;

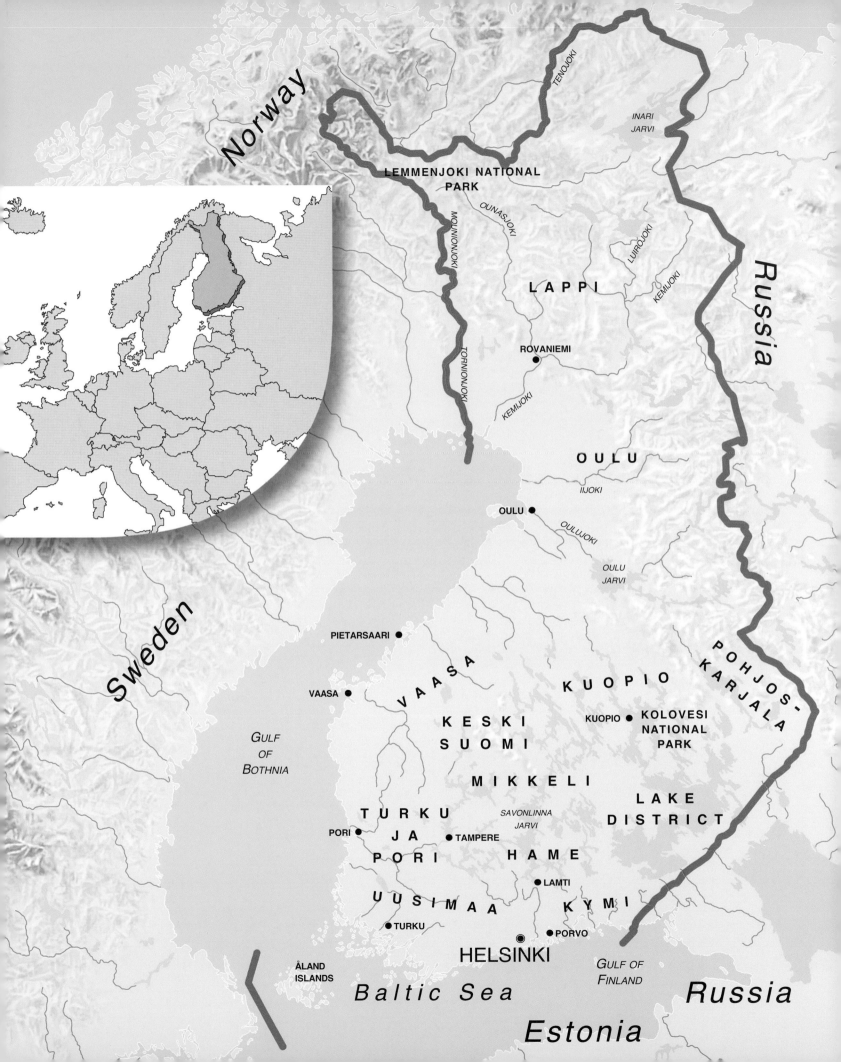

Norway

Russia

LEMMENJOKI NATIONAL PARK

MOUNIONJOKI

OUNASJOKI

TENOJOKI

INARI JARVI

LUIROJOKI

KEMIJOKI

L A P P I

● ROVANIEMI

TORNIONJOKI

KEMIJOKI

O U L U

IIJOKI

OULU ●

OULUJOKI

OULU JARVI

Sweden

GULF OF BOTHNIA

PIETARSAARI ●

V A A S A

VAASA ●

K U O P I O

KESKI SUOMI

KUOPIO ● KOLOVESI NATIONAL PARK

POHJOS- KARJALA

M I K K E L I

LAKE DISTRICT

TURKU JA PORI

PORI ●

SAVONLINNA JARVI

● TAMPERE

HAME

U U S I M A A

● LAMTI

K Y M I

● TURKU

◉ PORVO

HELSINKI

GULF OF FINLAND

Russia

ÅLAND ISLANDS

Baltic Sea

Estonia

deforestation is regulated by strict laws based on an evenhanded political policy regarding reforestation. Today, natural reforestation methods are favored. These avoid the felling of all the trees in any one area and leave belts of vegetation that ensure that lakes and ponds are protected and that the lifecycles dependent on them can continue uninterrupted until decomposition.

Even though deforestation has caused the drastic reduction of still-intact forests, and new "commercial" forests do not offer the same guarantee of survival rates, all elements of the animal population of the taiga are still well represented in the Finnish territory, an ideal habitat for reproduction, and perhaps the last region of Europe where nature still has the upper hand.

Furthermore, efficient protective measures have brought about a fresh increase in the number of large predators from the Siberian forests that have migrated across the border, venturing as far as the southern and western regions. The brown bear population is growing along Finland's eastern border with Russia, and brown bears are still found in the national parks of Patvinsuo, Urho Kekkonen, and Oulanka. In fact, their expansion of their territory has been so remarkable that they are being found even at the margins of the cultivated countryside in southern Finland, bordering on the forest. As in oldwives' tales but also in contemporary accounts, wolves, emboldened by hunger in winter, have been reported venturing into residential areas in search of food. However, among the mammals of the Finnish forest, the unchallenged king is undoubtedly the elk. These formidable animals live mainly in the woods of south-central Finland and prefers the humid zones, home to the birch and willow trees on whose leaves and branches they feed.

In this territory characterized by an intricate labyrinth of waterways, the otter, an able swimmer ever in search of fish, and the beaver, the engineer of sophisticated natural constructions, both prosper. The amazing concentration of birds either populating Finland or migrating there each year justifies the local passion for bird watching. At the beginning of spring, ducks and geese and wading birds and passerines return, along with the thousands of people who dedicate themselves to recognizing lesser-known species and taking nest censuses. Finland's national bird is the wild swan, most likely a sacred bird since ancient times considering the similarity it bears to sun symbols present in the rock drawings found in Karelia.

In the remote darkness of the old forests, abundant bird species live in the safe refuges offered by cavities in decaying tree trunks, feeding on insects and larvae in the grooves of the bark. The endless conifer forests are the last refuge for birds of prey: peregrine falcons, buzzards, golden eagles, sparrow hawks, great gray owls, and eagle owls.

The journey north continues beyond the Arctic Circle. The effect of the Gulf Stream along the Norwegian coast makes the climate particularly mild, and the conifer forest still thrives, a peculiarity not found at the same latitude in other parts of the world. Bit by bit, however, the landscape changes and the vegetation, which begins to appear in distorted and stubby shapes better suited to the rigors of winter and Arctic storms, grows sparser until it completely disappears, giving way to the desolate and endless Lapp tundra. Against the force of the whipping winds and cold, only mosses, lichens, and brushy dwarf

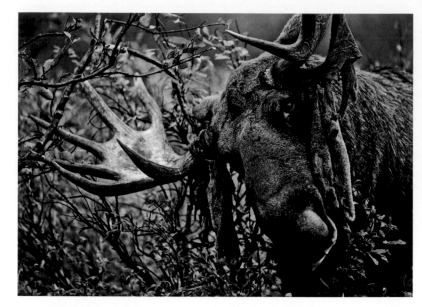

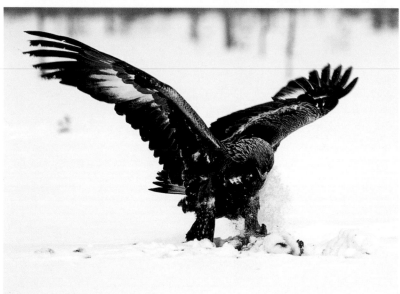

14-15 The Lutheran cathedral in Helsinki rises upon Senate Square and dominates the harbor where ships from Sweden and the European Continent dock. Originally built in honor of Czar Nicholas I, it was begun in 1827 by the architect Engel but only completed in 1852.

18 top The elk is lives prevalently in the forests of central-southern Finland and prefers humid areas where the birch trees, willows, and trembling poplars grow on whose leaves and branches it feeds. In summer during the hot hours of the day, it is unlikely to see one because they prefer to take shelter in the woods.

18 bottom The golden eagle lives in the great, pristine forests of the northern taiga along the Russian border and is a frequent visitor to the national park of Oulanka, at the beginning of the Arctic Circle. It feeds on rodents, hares, and rabbits, but it is also known to attack reindeer calfs.

19 top During the Arctic winter, snowmobiles have by now become an indispensable tool for the local Lapp population. Able to provide rapid transportation across any snowbound terrain, this useful means of transport makes it easier and reduces time needed to reach the reindeer herds.

19 bottom A Lapp breeder grapples with a reindeer calf born recently during the annual migration that follows the border between Finland and northern Norway.

21 The open-air museum of Luostarinmäki in Turku contains the old workshops and shops of the wooden-structure neighborhood that survived the fire of 1827, which almost completely destroyed the city. The small streets of the museum recreate the atmosphere of the past, and the tradesmen wear traditional clothing for the benefit of visitors.

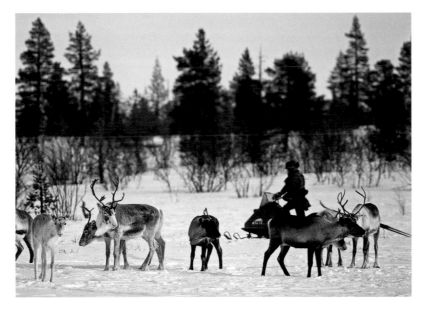

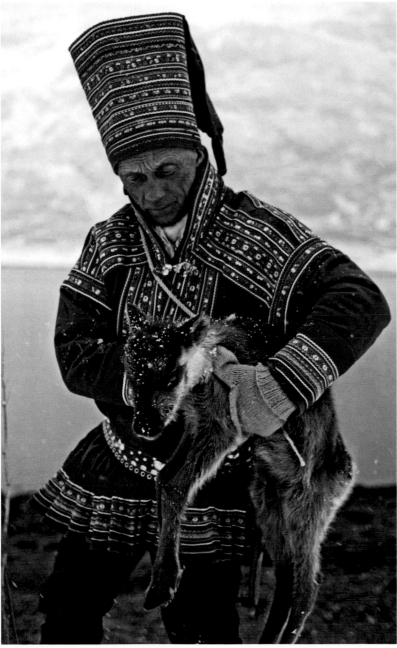

bilberry bushes survive, the latter being twisted tangle of branches squashed against the ground, with roots that manage to grow only horizontally, just under the surface; deeper down the permafrost would keep them frozen throughout the year.

The taiga's northern fringe and tundra are home to reindeer, with their tender gaze and slightly clumsy gait. They recall their forebears, the origin of the legend of Santa Claus, who drives his sleigh across the slopes of Mount Korvatunturi where he dwells. Reindeer are still an important economic resource for the Lapps, as well as being representative of their culture. As in the past, Lapp herdsmen round up the reindeer that wander the pasture lands of the tundra to brand them or mark them for slaughter, a ritual that has gone on for centuries and which is repeated every year. After butchering, every single part of the animal is used: the horns are carved as decorative objects, the skins are used for clothing, and the meat for food. Once upon a time, because of its mild disposition and strength, the reindeer was a play companion for the village children as well as a draft animal (today there are snowmobiles). Unlike other Arctic peoples, the Lapps actually used to use reindeers and not dogs to pull their sleds, called *pulka*.

According to the most recent estimates, the Sami population (the term by which the Lapps are called today) numbers over 60,000 individuals spread across Sweden, Finland, Norway, and the Kola Peninsula in Russia, of which 5,000 to 6,000 are based in Finland. Considered the "Indians of Europe," the Lapps have lived in the northern regions of the Scandinavian Peninsula for at least 5,000 years; they were the true and only inhabitants of the Finnish wilderness before being driven north by the various Finnish tribes. Along the edge of the roads that cut like blades across the tundra, they can be found displaying their handcrafted products, once objects of daily use but today an expression of a folklore created to satisfy the expectations of tourists passing through.

Since they abandoned their nomadic existence, the Lapps only occasionally use the *kohta*, the traditional tent and by now wear their national costume only on important occasions. Like all ethnic minorities, the Sami people experience difficulty with the contrast between their culture and ever-expanding modern technology. For generations, the Sami people had managed to create living conditions in a hostile environment, without imposing their dominion, but the speed of the transformations caused by the industrial era changed the habits of a large slice of the local population, which has sought systematic integration into the cities with all the accompanying social problems, bringing about the gradual loss of their cultural identity. Furthermore, because the reindeer's natural habitat has grown ever more restricted, the Lapps once dependent on them have now been forced, in order to survive, to work in power plants or in the tourist industry, thus finding themselves isolated and uprooted from their original environment. Many hope that growing international interest in ethnic minorities, new environmental protection laws, and the renewed interest of young people in their own cultural heritage might safeguard their identity – that of a people whose integration into Western culture risks driving them to extinction.

19

If the Sami can be considered the first indigenous inhabitants to tread Finnish ground, when and from where did the ancestors of modern-day Finns arrive? In the early centuries of the Christian Era, ethnic groups inhabiting the western spurs of the Ural Mountains migrated toward Finland and, coming up out of Estonia, populated the country along the main rivers, lake shores, and in the drier parts of the peat bogs. In his *Germania*, Tacitus described the Fenni as a people in annual cycle of movement, still very primitive and poor. It is believed that the inhabitants of this vast territory belonged, in terms of racial and linguistic origin, to the Ugro-Finnic branch, even though this included numerous tribes speaking different dialects that were often hostile to one another.

In the centuries to come, it was the fate of the Finnish territory, gripped in the vice of Sweden and Russia, to fall under the expansionist aims of both these bordering superpowers. Thus, the importance of its function as a buffer state between east and west was determined, demonstrated by the fact that the Roman Catholic Church put down roots in the southwest whereas the Greek Orthodox faith expanded along the shores of Lake Ladoga and the Gulf of Finland. Between 1200 and 1809, Finland remained under the control of the kingdom of Sweden, and its southern and western territories came under the cultural and religious sphere of Western Europe. Russian interest in an outlet on the Baltic Sea brought about the annexation of Finland by the empire of the Czar, but after the Russian Revolution of 1917, the Finns declared their independence. In 1919, they approved a new constitution that determined Finland was to be a parliamentary republic led by a president endowed with wide-ranging powers.

The young Finnish state's spirit of freedom and independence had long lain hidden. It began to blossom in the mid-1800s, along with other persons who became key personalities in Finnish history. Elias Lönnrot (1802-1884), father of his country's literature, collected popular traditions passed down orally and published the *Kalevala*, the epic poem that gave the Finns a national identity founded on the language and oral tradition of the common people. As the century ended, the *Kalevala* became a source of inspiration for a slew of artists in the fields of music, painting, literature, design, and architecture. The heroes of the *Kalevala* became the manifestation of the nation's patriotic and social ideals; there are no Finns who do not recognize their roots in this literary masterpiece. The *Kalevala* influenced the musical sensitivity and artistic personality of even Jean Sibelius (1865-1957), the greatest composer in Finnish history. His most important work, "Finland," became the symbol of national unity against the Russian oppression. During the same period, the poet Johan Ludvig Runeberg (1804–77), composed the patriotic verses that would later be used in the national anthem, and, in a country where only about 14 percent of the entire population spoke Swedish as their mother-tongue, the renowned statesman and politician Johan Vilhelm Snellman (1806-1881) called for its acceptance in schools and universities, together with Finnish, the official language. Today, despite the fact that Finland is officially a bilingual country, only 6 percent of its inhabitants, along the southwestern coast and in the Åland Archipelago, speak Swedish.

Having achieved independence, the young Finnish state had to defend itself strenuously during World War II against the Soviet army's invasion. The Finns adopted the strategy of a war of attrition to take advantage of their territory's highly inaccessible wilderness and the harshness of the winter weather, and succeeded in containing the Soviet attack. The Finnish soldiers used skis to move freely through the forests while the Soviet army needed roads. Their tenacious defense of their territory moved the world, inspiring much admiration. In the end, however, small Finland was forced to surrender, but not before inflicting heavy losses on the Red Army, thus managing to limit the destruction caused by a final, inevitable defeat. Territory was handed over, and the newly drawn borders brought about the great exodus of refugees from Karelia, people who preferred to abandon their birthplace and all their possessions rather than remain under Soviet rule. The experience of having fought for their sovereignty and independence helped unite the Finns even more strongly during this dramatic moment in their history.

The post-war years served to rebuild the country: Finland gave great importance to strengthening good-neighbor relations with the Soviet Union, which became its main trading partner. The policy of compromise and bilateral relations in commerce was often interpreted as an act of submission, but this moderation actually made it possible for Finland to maintain its independence.

Uncertain predictions regarding the political stability of the Soviet colossus pushed the Finnish people to vote to enter the European Community (since January 1, 1995), clearly demonstrating that Finland did not want to remain excluded from the Western world. Once again, Finland's strategic position significantly affected the choice its citizens made, with the arrival of the new millennium, to join "Euroland."

Finland produces 25 percent of world paper exports. Also, at the dawn of the new millennium, this small nation is a leader in several sectors, from communication technology to design, from the new economy to sports: modernity blends with nature. Without doubt Nokia, a giant in the telecommunications sector, is among Finland's best-known corporations. A cutting-edge company in the manufacture of mobile phones, it also produces data-communication networks; its diversified products include computer monitors and digital decoders for pay-TV. Facilitated by the country's great distances and its low population density, the Finns are among the world's most intensive Internet users, even more so than Americans and Canadians. In the marine sector, Finnish shipbuilders are specialists in the construction of ice-breakers, which enable the country keep its main ports open even during the winter.

Despite the nation's notable achievements in technology, in the mind and daily life of every Finn the role of nature has remained fundamental, and it is nature itself that unmistakably determines the Finnish personality. Even the harshness of the climate has unmistakably helped shape the Finns' disposition, pace, and feelings. Shy and introverted, they have had to develop strong and tenacious characters to face the rigors of winter and isolation.

Sibelius' symphonies and the architectural forms of Alvar Aalto (1898-1976) – one of the 20th century's greatest architects, known for combining different materials such as wood, reinforced cement, and glass in innovative ways – are among Finnish artistic expression inspired by and reflecting nature. Likewise, nature has been an important inspiration for artists and designers like Sarpaneva and Wirkala. In addition, many fables for children are set in the magic world of the forest, where gnomes and elves carve their dwellings out of

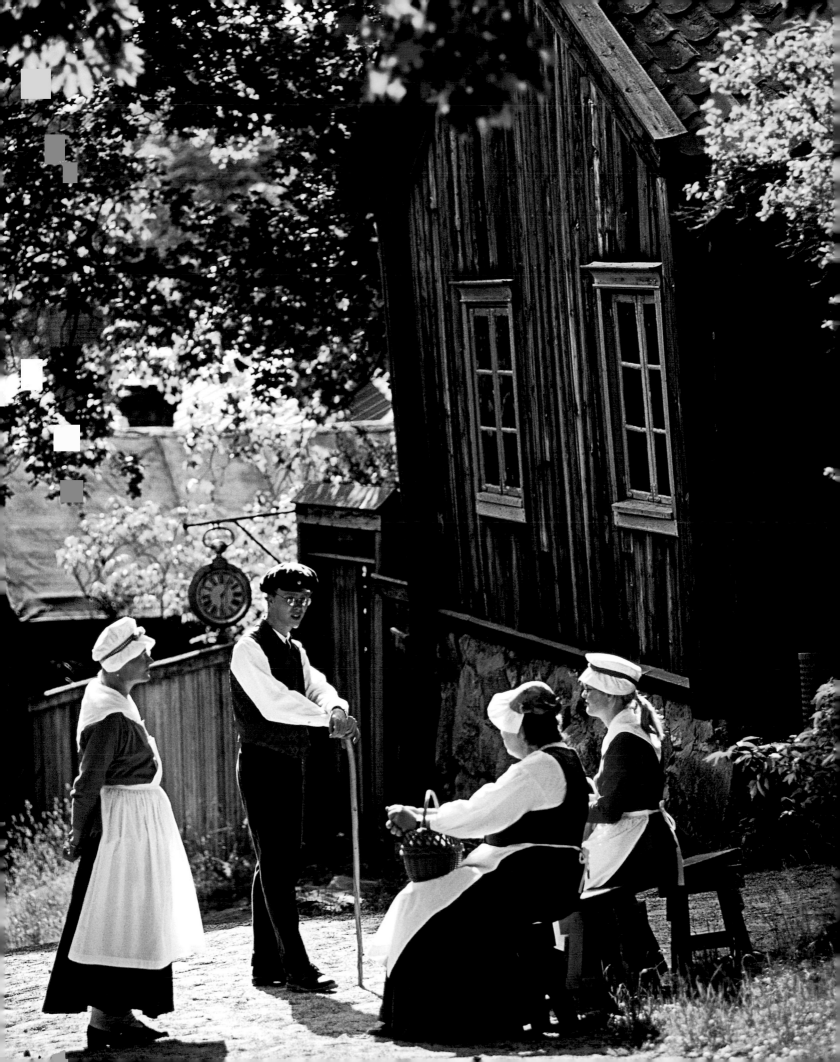

lingonberry bushes and mushrooms, and the mosses and lichens of the forest floor make a soft carpet to walk on.

From a very young age, Finns learn to know, respect, and to never underestimate nature; it is considered an integral part of everybody's life, even those who live in the cities. At school, children assimilate the basic rules of orientation and, with their family, establish the premises for a progressive type of environmental education still largely ignored by people in other countries. Open-air sports are promoted: in winter, fishermen break the ice with special hand-operated drills and fish sitting on the sea or on the frozen surfaces of the lakes; young people play hockey in freezing temperatures (even in city parks) and cross-country skiers slice along the snowbound paths of the parks. In summer Finns transform themselves into hikers, bike-riding enthusiasts, sailors, and canoeists.

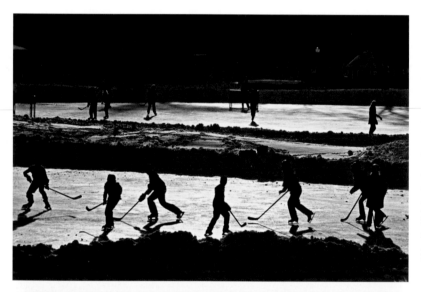

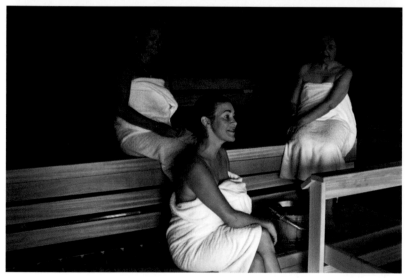

After the long, dark Arctic night and winter's freezing temperatures, nature's reawakening and the slow coming of summer see the flourishing of a veritable "cult of the country house." The house may not be big or luxurious; sometimes it may even lack electricity and water may have to be drawn directly from the lake. But for city-dwellers, the summer vacation represents an opportunity to reclaim their ties to the wilderness of their heritage, to the time when Finns were farmers, elk hunters, fishermen, and reindeer herders. Not surprisingly, at times even the more well-off are prepared to give up the most basic amenities and idle rest, preferring to spend their vacation impersonating the frenetic pace of the ant, getting up at dawn to place nets in the lake, fixing the roof, cutting wood, and repainting the sauna. As in the animal and plant world, rates of reproduction accelerate in the brief arc of the summer months. Likewise, Finns experience their days in the outdoors intensely, almost as if they wanted to take advantage of even the last flicker of the gift of the light that illuminates the nights of June and July.

The extent to which the concept of nature is rooted in the culture of the Finns can also be noted by observing their ecological conscientiousness. This is not necessarily based on external restrictions but on reciprocal respect. In Finland, "the right of all" to be able to enjoy the natural environment freely is an automatic principle according to the standards of the local tradition and customs, but the same right is forfeit if it impairs the equally paramount and earnest one of the individual. Programs of environmental protection are constantly being developed and are strengthened by the continual creation of new reserved areas and well-designed national parks with paths and facilities for visitors, while hunting and fishing are regulated by a policy of treating the environment properly.

After a day of outdoor activities, for Finns the sauna represents a place of purification: it is the source of physical and spiritual strength; as weariness and stress are dissolved in its hot vapor, the muscles relax. Even though it is not a Finnish invention, the sauna has been a deeply rooted and widespread tradition among the population for over 2,000 years, and it still maintains almost ancestral ties to those natural and opposed elements that characterize it: water and fire, hot and cold. In the summer, Finns dive into the freezing waters of the lake; in winter, they roll around in the powdery snow or cut a hole into the layers of ice. Preparing the *vasta* (leafy birch-tree branches with which the body is struck to stimulate the circulation); the hygienic, relaxing practice of alternating periods of sweating with rapid temperature changes; and the after-sauna dedicated to the contemplation of the peace and quiet of the evening with a glass of good beer – all are inseparable parts of a ritual that takes place in the great outdoors, which no Finn could ever forsake.

22 top Even during the frigid winter, it is likely to encounter kids involved in frenetic hockey games played on little ice patches in the streets of Helsinki.

22 bottom For all Finns, the sauna does not fulfill a solely hygienic function but is also a place to relax and meet people.

23 The Museum of Contemporary Art (Kiasma) of Helsinki was designed by the American architect Steven Holl. It opened its doors in 1998.

24-25 During the long months of the Arctic winter, nature comes alive in the magical colors of sunrise and sunset.

26-27 The aurora borealis is a magical event. Corpuscular rays emitted by the sunspots in contact with the upper atmosphere cause whirling and twisting light effects that can be spotted above all in the heart of winter on clear, moonless nights.

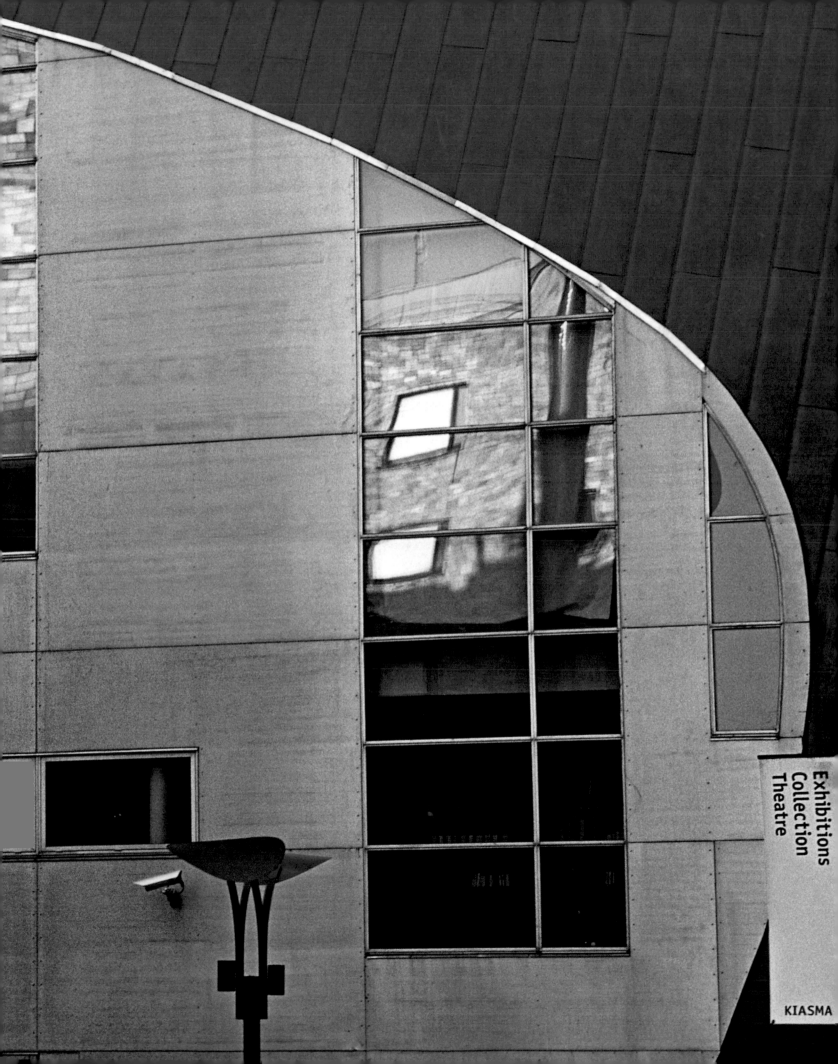

Exhibitions
Collection
Theatre

KIASMA

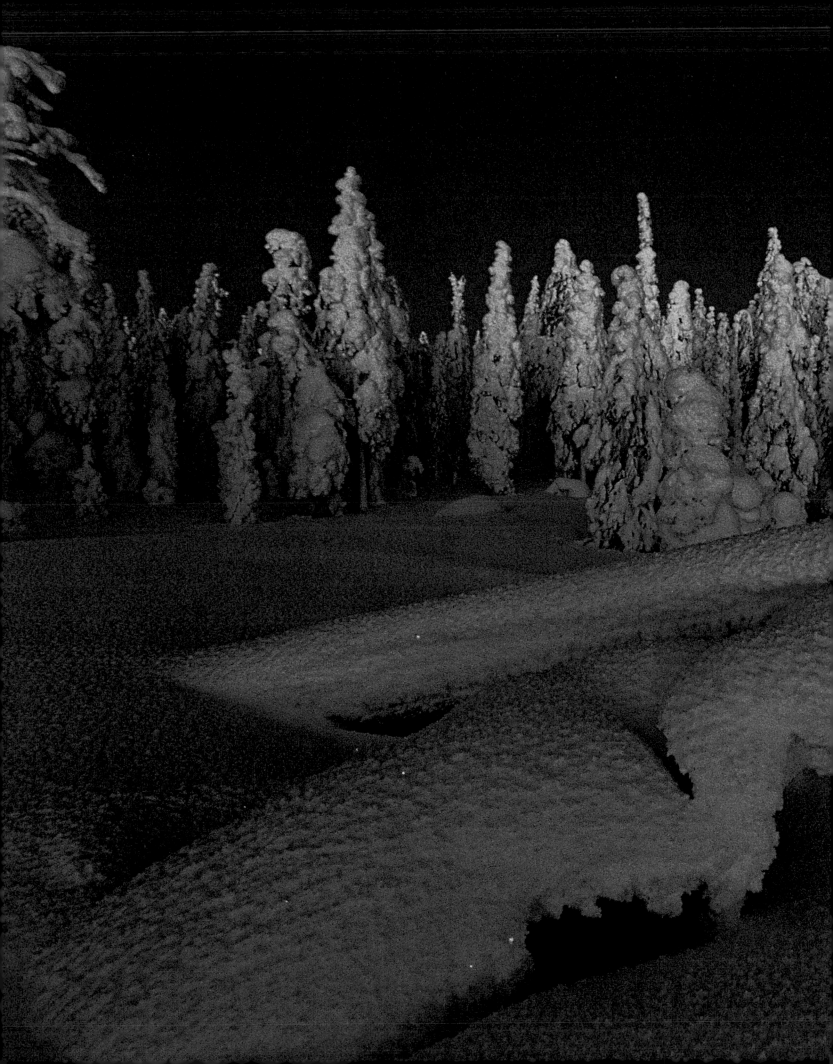

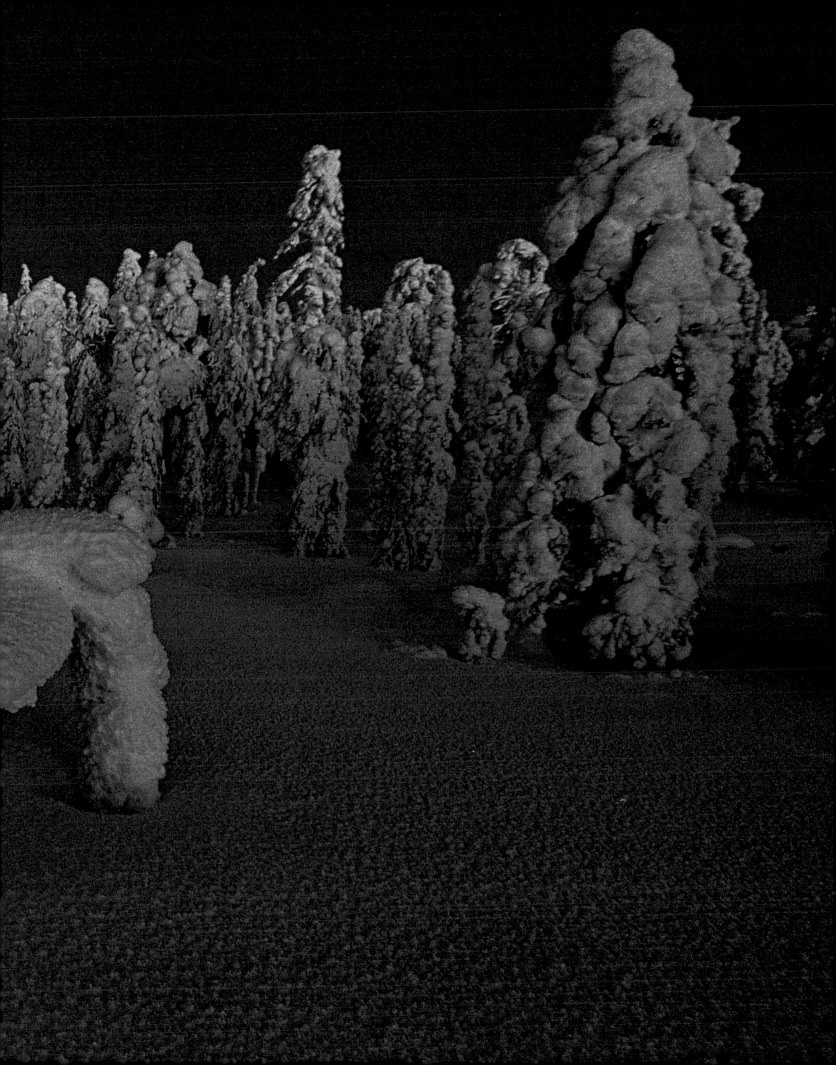

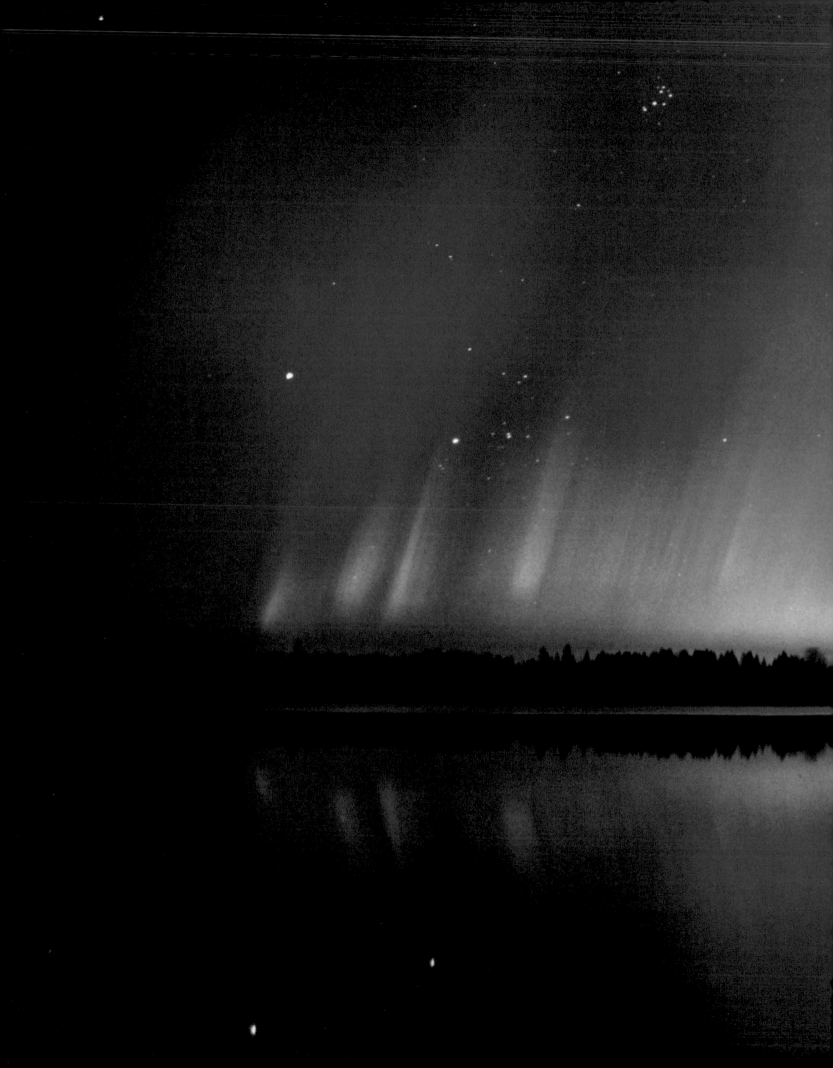

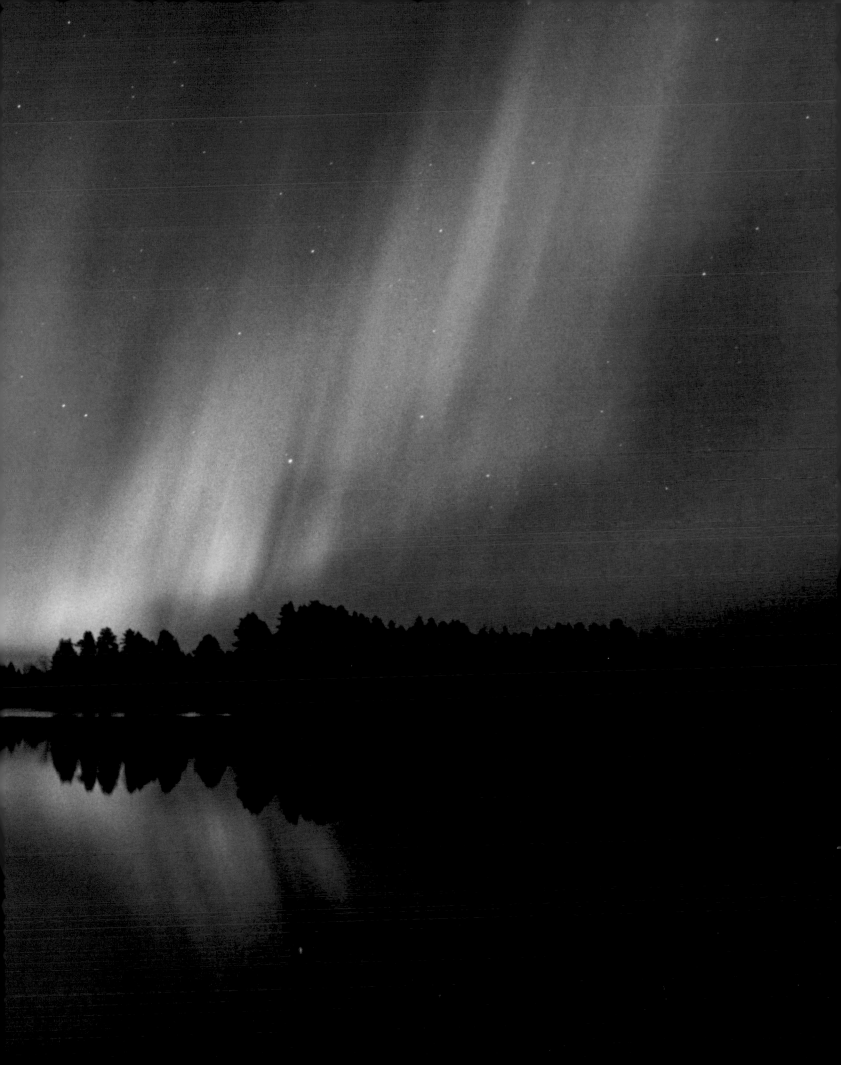

Sweet and Savage Finland

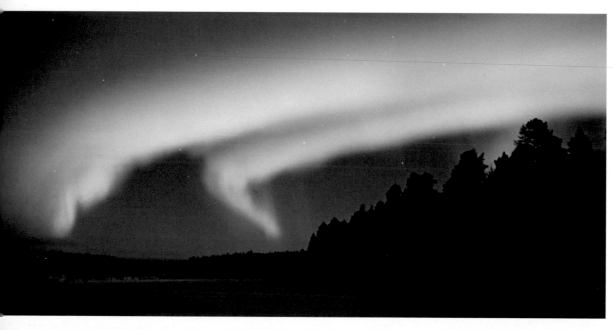

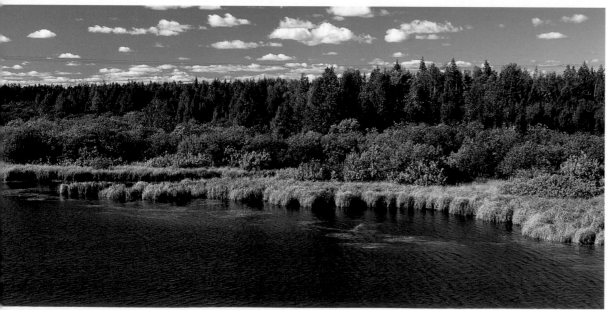

28 top It may seem a paradox, but during the long winter nights (the kaamos), darkness does not actually exist: the reflection of the snow, the light effects of the aurora borealis, the rays of the moon causing shadows to stretch across the terrain, and the rays of the sun reaching their final destination just below the horizon light up the landscape of the Finnish taiga.

28 bottom Uninhabited forests and lakes are still an integral part of the Finnish landscape even in unprotected areas: 75 percent of Finns live in the city and about half live in the south, and the population density gradually decreases as one travels north until it touches the lowest levels in Europe.

29 In the national park of Riisitunturi just below the Arctic Circle, the fir trees covering the rolling hills of the territory are laden with snow frozen by the icy Arctic wind, creating a fascinating world of fairy-tale creatures and imaginary monsters wrapped in a white cloak.

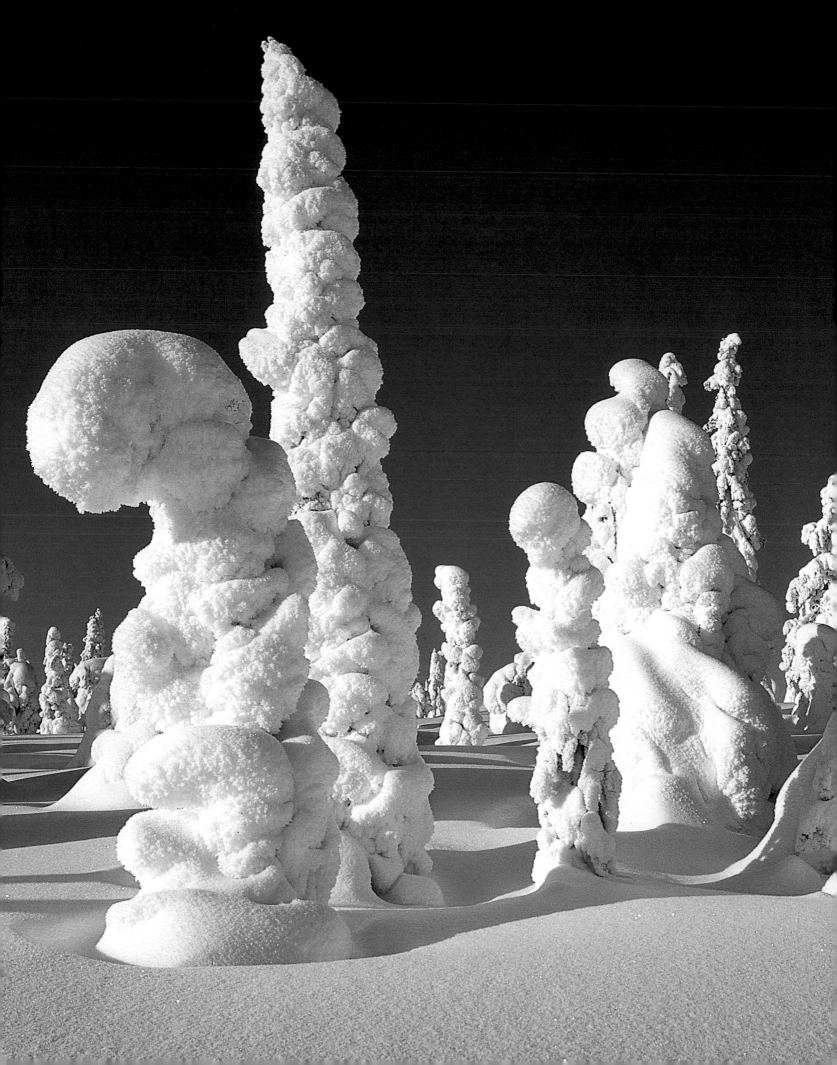

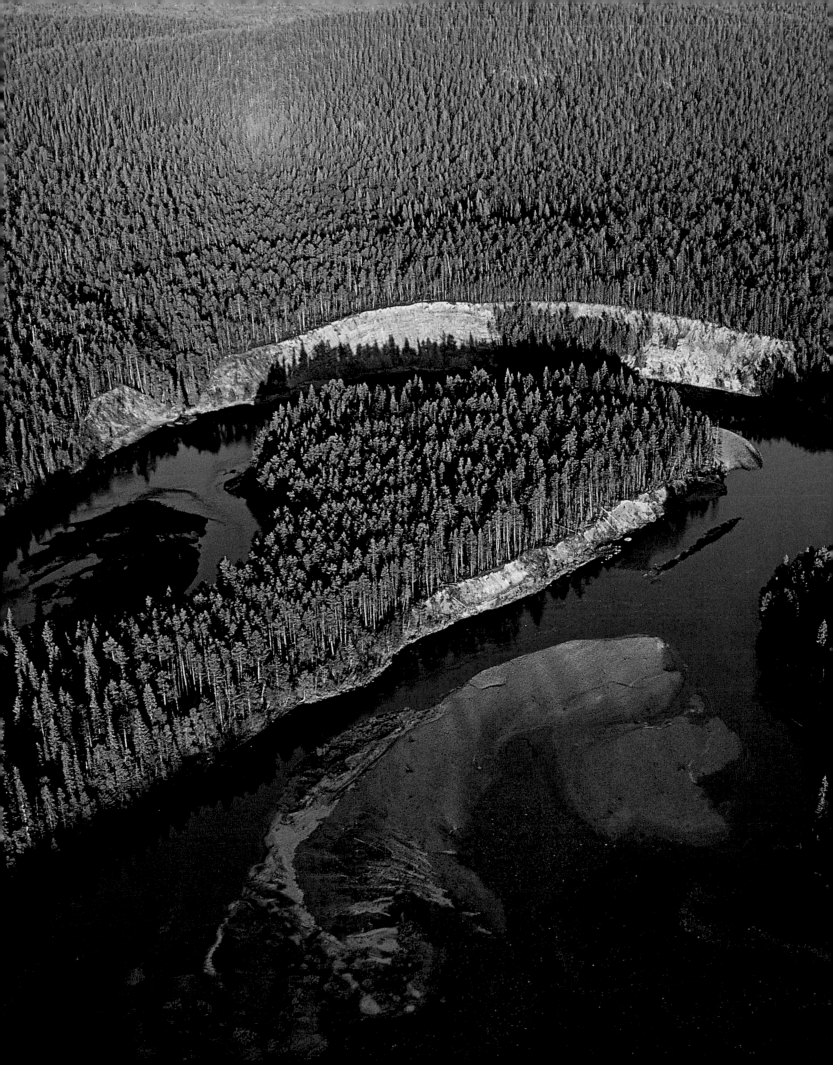

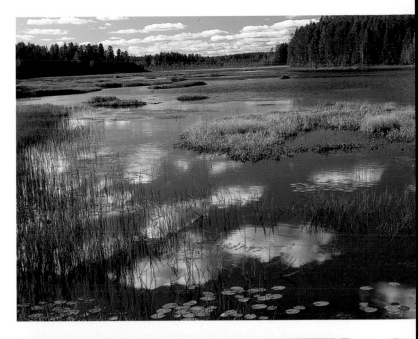

30-31 *The great rivers of the taiga and northern Lapland have been able to carve their path out of a generally sandy terrain that favors coniferous forests. On the sandy shores at times forming delicate inlets and idyllic little beaches, a solitary reindeer looking out from the edge of the woods can often be seen to idle about.*

31 top *Finland's lakes are generally not very deep and at times transform into swampy expanses of water difficult to access.*

31 center *The complex lake system of central-eastern Finland with its mosaic of islands and interconnected waterways is the geological result of the last ice age, which, with the melting of the glaciers about 10,000 years ago, molded the Finnish landscape.*

31 bottom *The lake system and the peat bogs originating in the ice age that cover vast swampy zones in the country are ecological niches essential to the conservation of the habitats of an extraordinary and abundant sedentary and migratory bird life.*

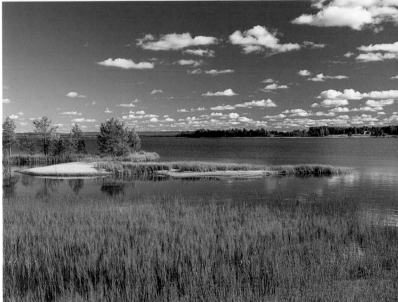

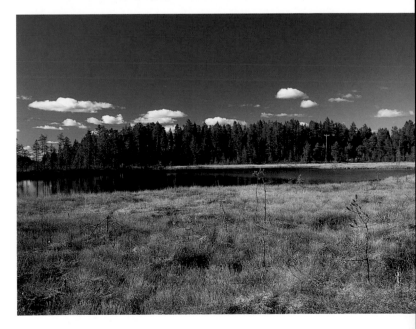

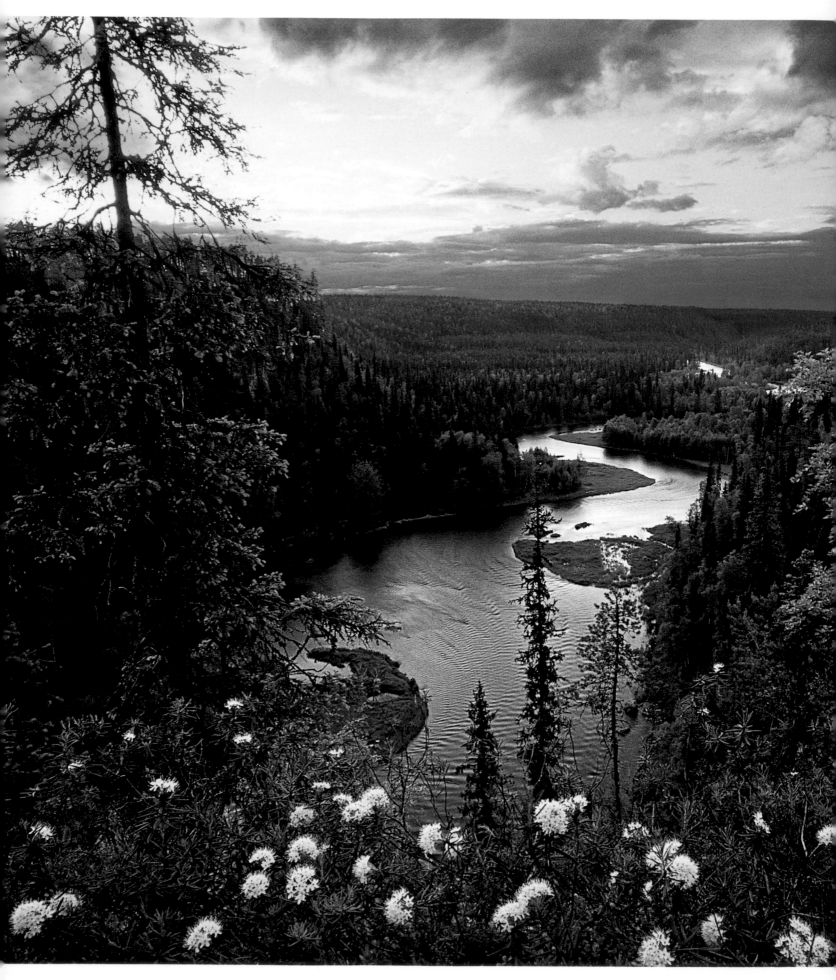

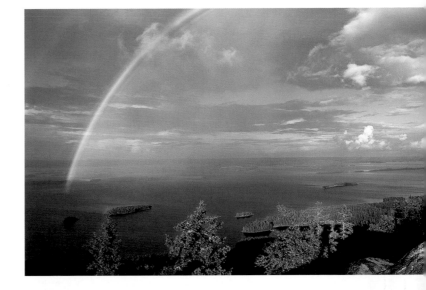

32-33 Finland is not only a land of lakes but also of large rivers whose meanderings, at times peaceful and silent, at times impetuous and foaming, score the vast expanses of the Great North.

33 top A magical moment for the photographer: the panorama from the hills of Koli on Lake Pielinen is in itself gorgeous, but it becomes extraordinary from the highest point at sunset and after a storm. The glaciers of the last ice age shaped the rocks and formed the line of islands in the lake.

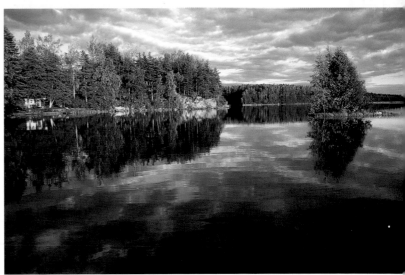

33 center The majority of Finns owns a house at one of the lakes – generally well hidden in the woods – where they spend their summer vacation. Joined to the house, on the shore, there is the traditional sauna where the family gathers every evening at dusk.

33 bottom On many Finnish lakes, a tacit agreement exists between the local inhabitants for which reason they have quit using motor boats. In southern Finland, the silent shores of Lake Valkjärvi are home to the black-throated diver and the location of the house in which, Elias Lönrot, the famous writer considered the Finnish Homer, was born.

34-35 The early morning light on a summer's day stretches the shadows of the pines and birch trees across the still and silent waters of a river that, carving its path through the taiga, has widened enough to form a vast lake basin.

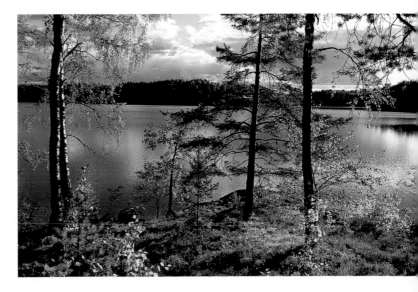

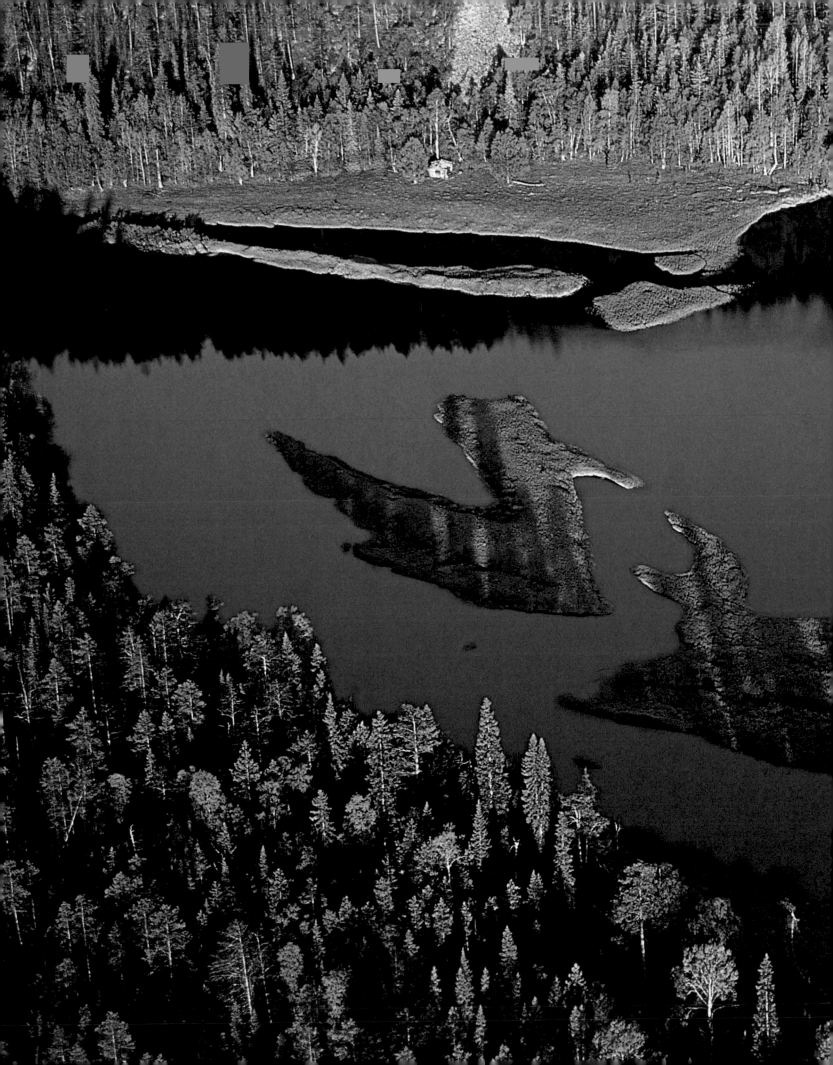

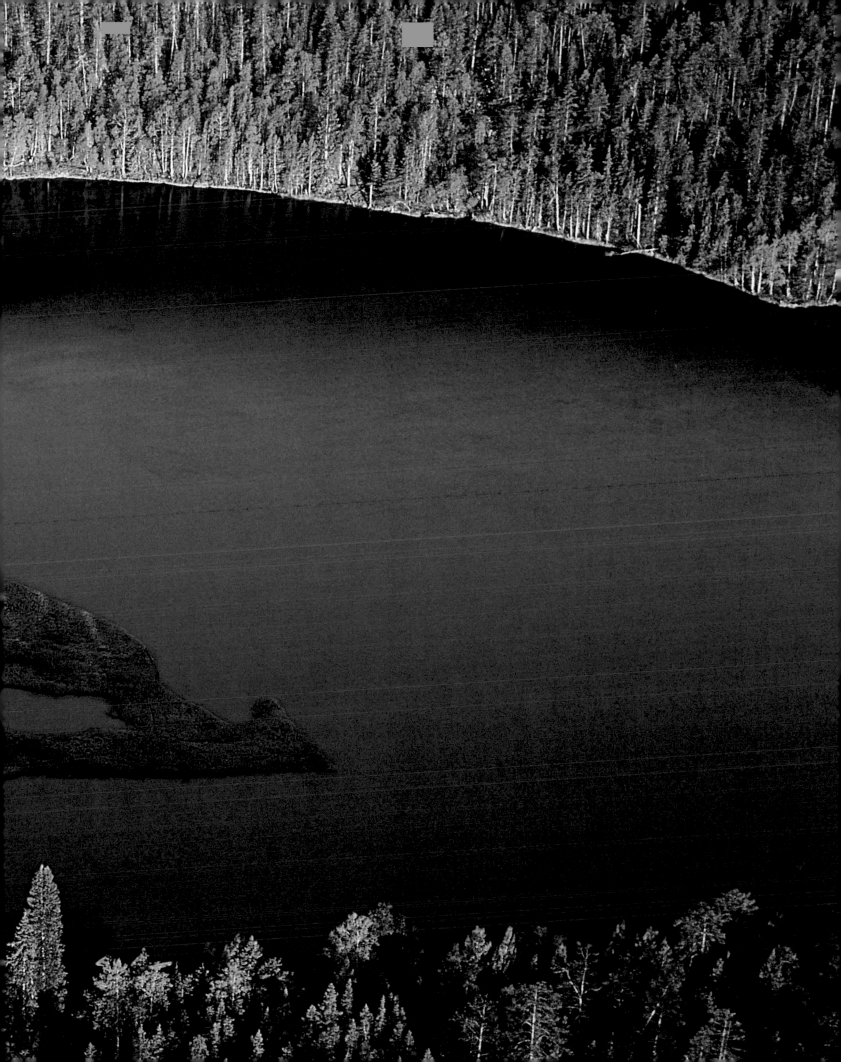

36 The lake basin of Saimaa, the fourth largest European river at 1,700 square miles big, is an intricate mosaic of islands and ponds that intersect to form the Lake District, of which the full effect of its landscape is best admired from an airplane window.

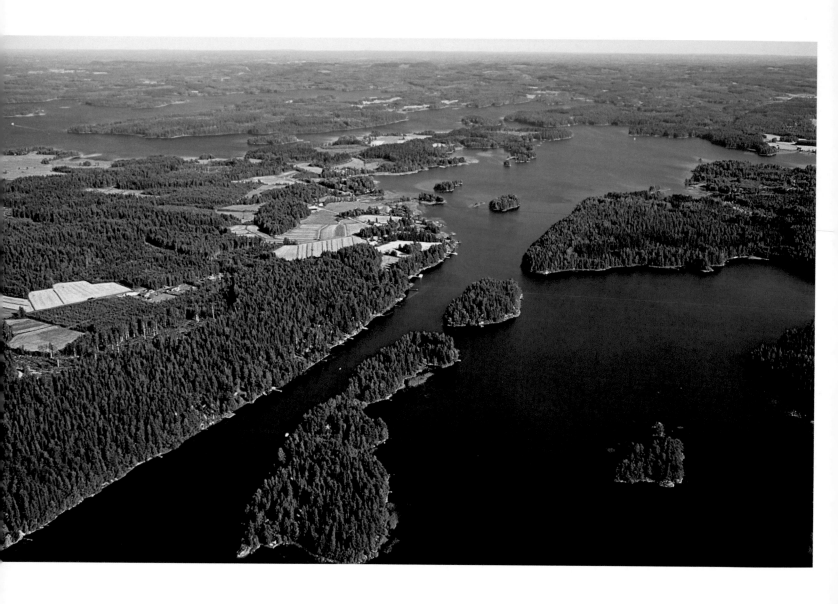

37 In the heart of the Lake District, the bucolic countryside around the village of Savonlinna is characterized by the continuous alternation of forests, farms scattered among grain fields or pasture lands, and limpid, crystal-blue lakes.

38-39 Not long ago, when the ice on the lakes only melted well into spring, transporting logs by water was facilitated by the complex labyrinth of interconnected waterways. Since 1950, with the improved efficiency of ground transport, the shipping of timber by water has been in great decline.

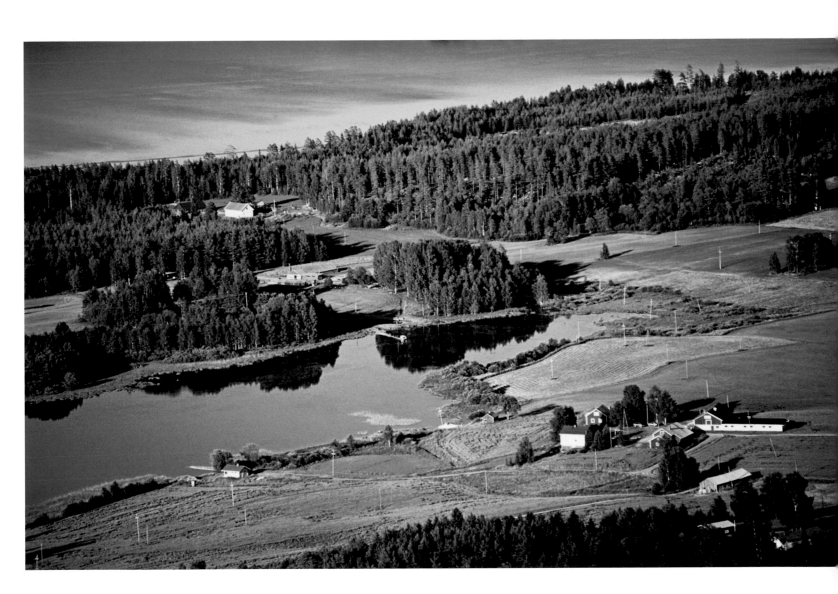

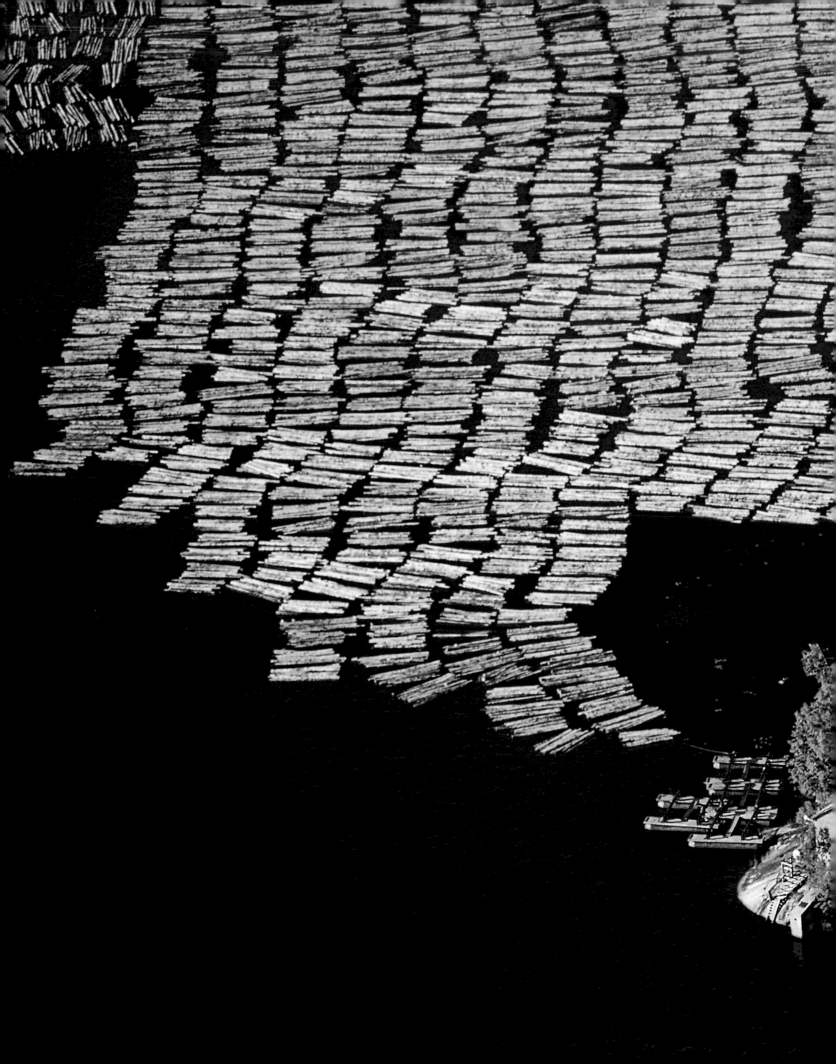

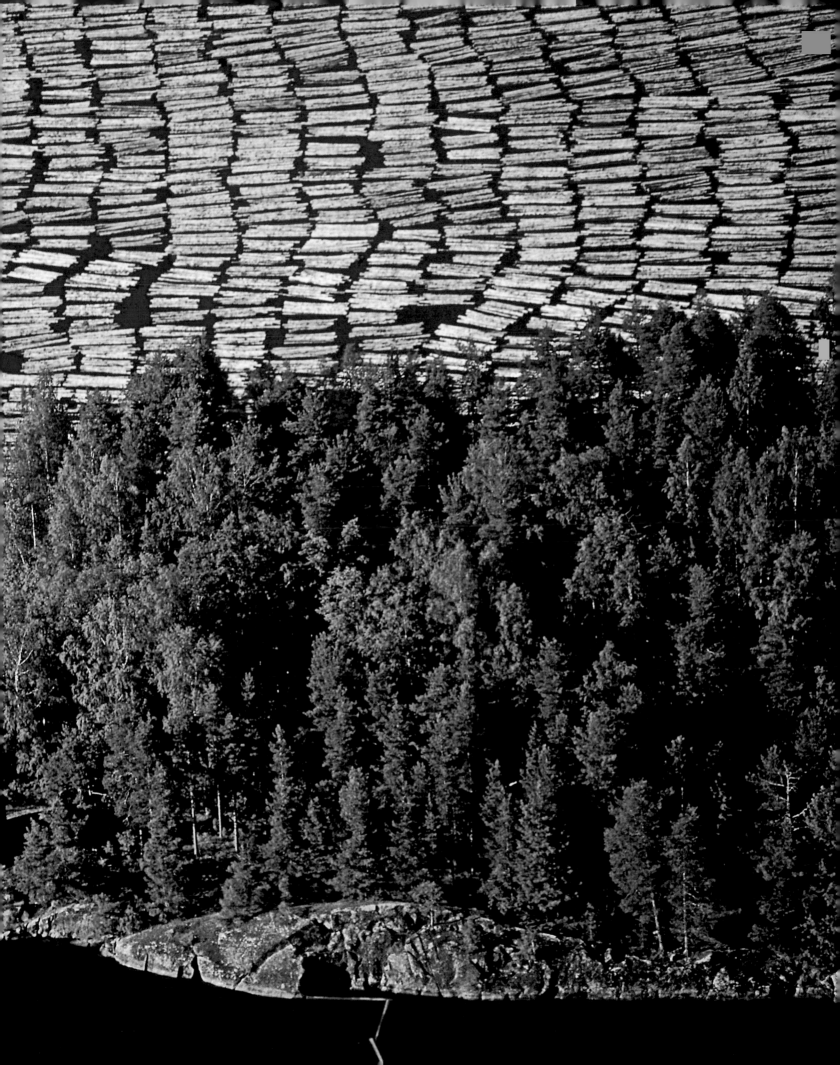

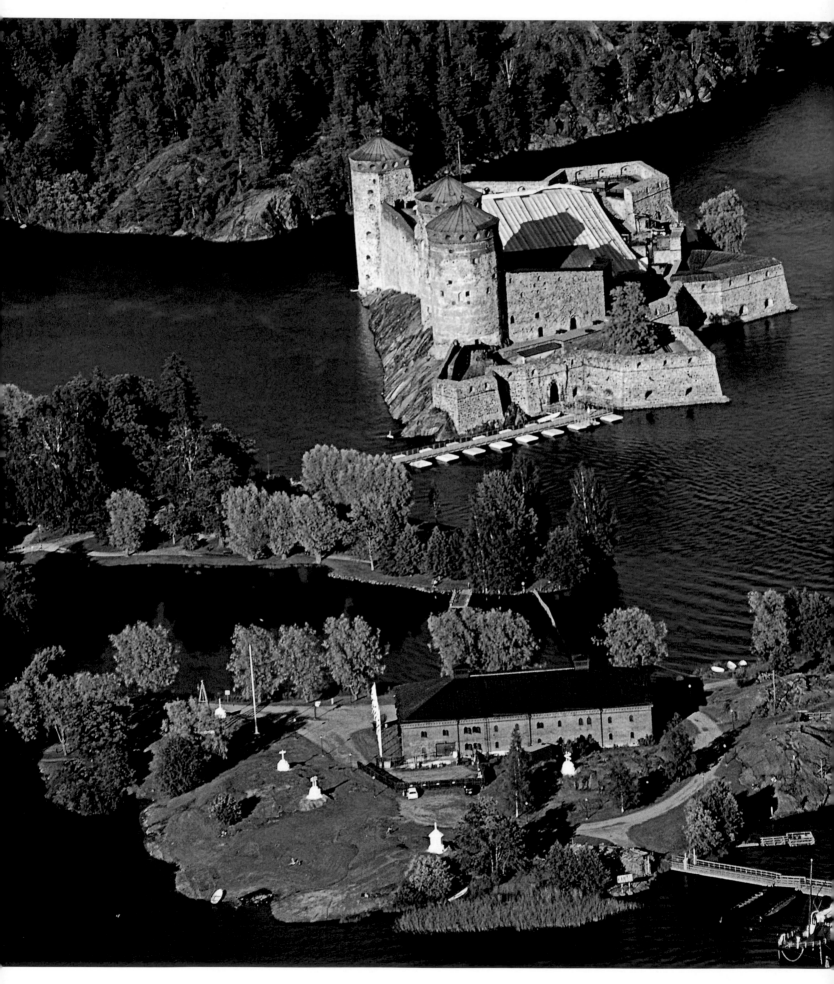

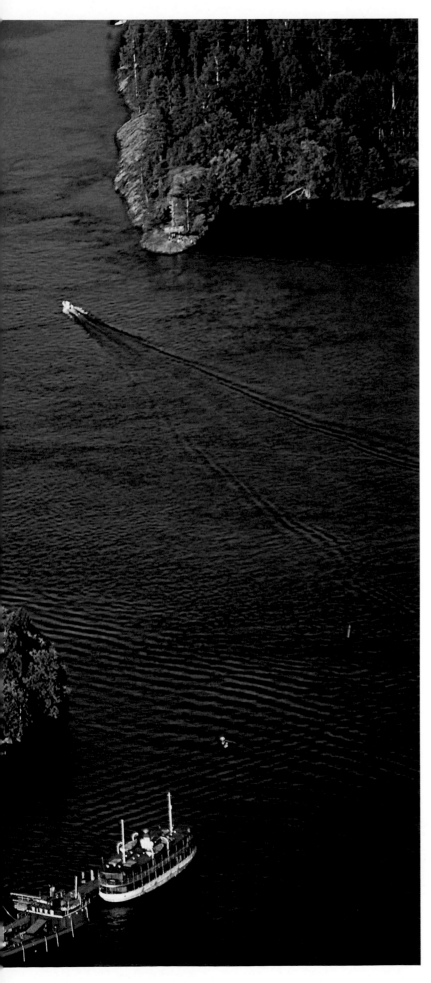

40-41 The village of Savonlinna, a cheerful resort town on the shores of the Saimaa Lake, is renowned for its medieval castle (Olavinlinna) founded in 1475 and dedicated to Olof, a tenth-century Catholic Norwegian saint. The structure was built to protect the eastern border of the Swedish Empire.

41 top The castle of Olavinlinna is today famous because every year in summer it holds an opera festival within its charming walls. The museums contained inside illustrate the castle's history and display a few treasures of the Orthodox Church.

41 bottom The castle of Häme is the most important sight in the city of the same name. The Swedes began its construction in red brick around 1260 in order to establish a military base in the Häme region. Today, its interior has been restored and contains a museum in which it is possible to see period furnishings and clothing.

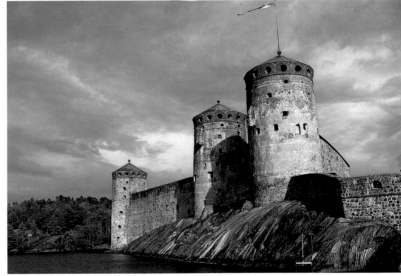

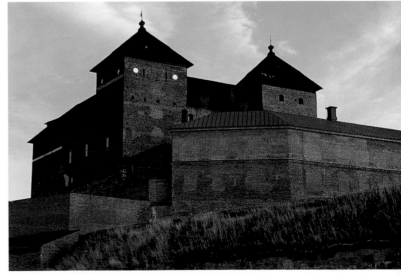

41

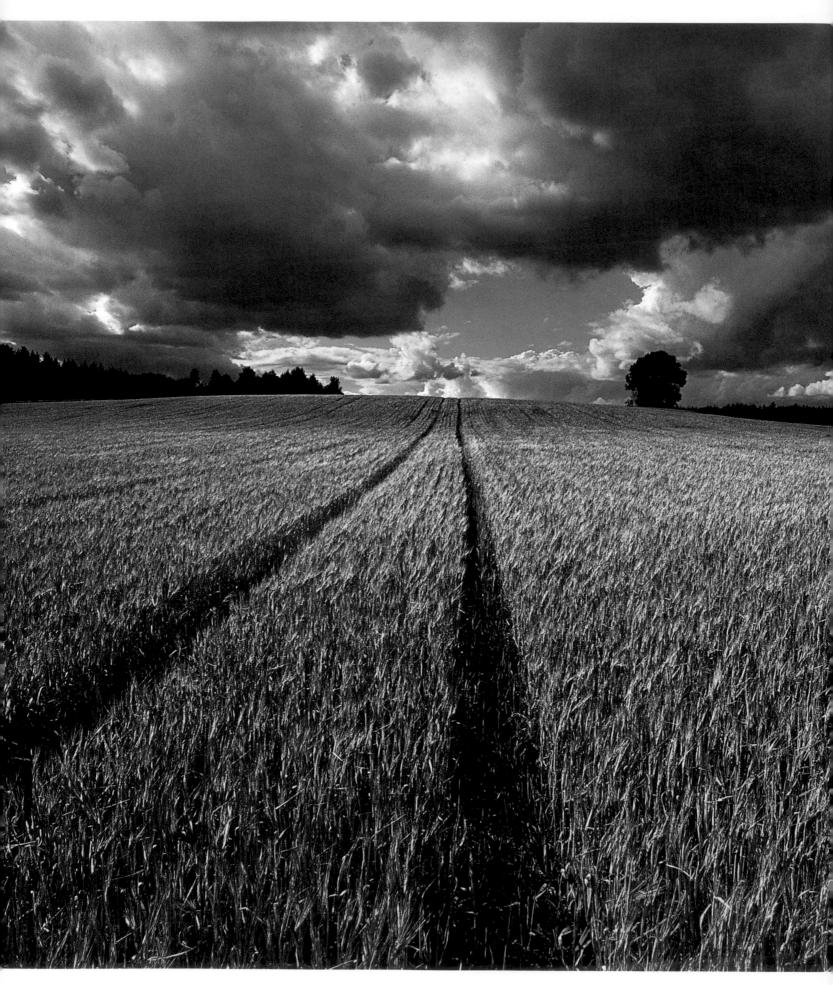

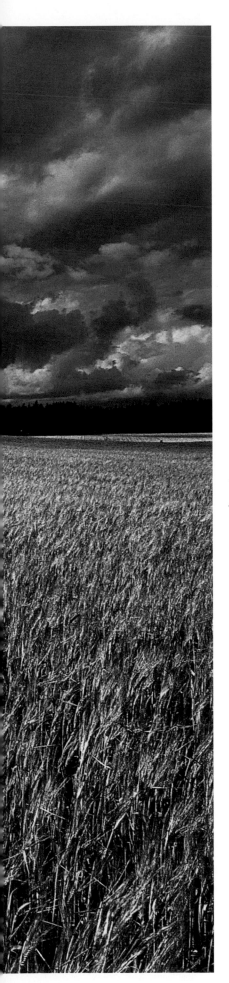

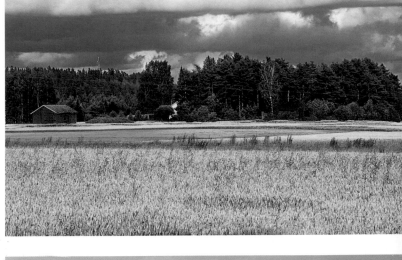

42-43 Once even all of southern Finland was covered by conifer forest: little by little, a portion of the territory was cleared and burned to create space for agriculture and pasture land. Today, the Finnish countryside is above all planted with grains: wheat, barley, rye, oats, and colza.

43 top and center In Finland, agricultural production has dropped over the last few decades. Although livestock breeding has been replaced by cultivated fields, the number of farms has decreased, and many young people have left the countryside for the southern cities.

43 bottom An ever rarer sight: hay stacks in the traditional conical shape are disappearing, and in Finland by now the harvest is almost never done manually but only with modern mechanical means.

44-45 The Finnish countryside is still dotted by old barns once used for the harvest and storing hay as fodder for animals when not only farming but also livestock breeding were the primary occupations. Nowadays, many of these barns are ruined and abandoned or are sometimes used as sheds for farming equipment.

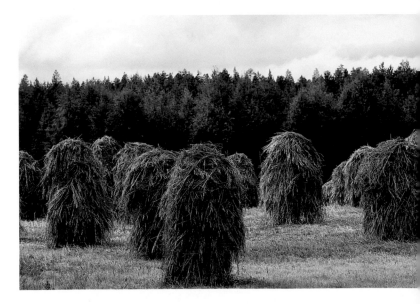

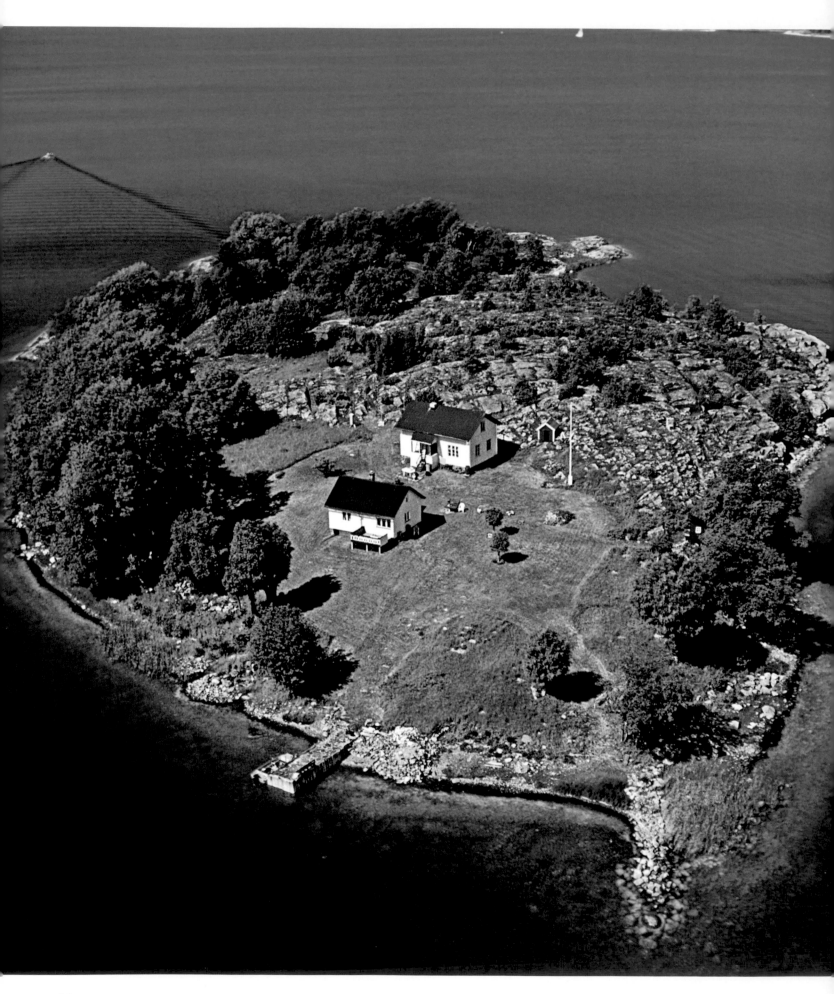

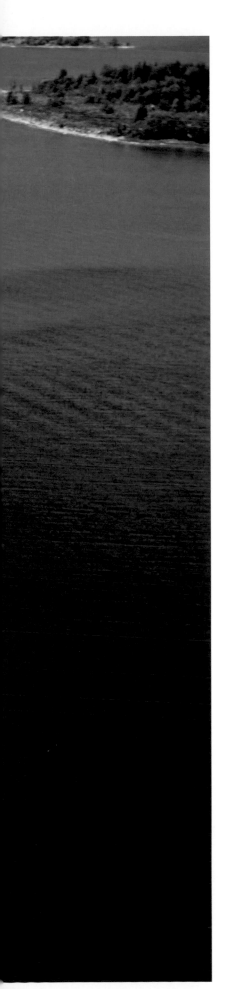

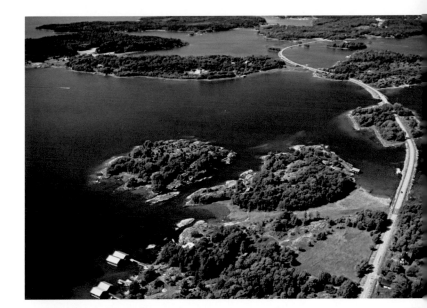

46-47 A tiny piece of Sweden in Finland, the archipelago of the Åland Islands contains more than 6,400 autonomous islands. Little islets either uninhabited or occupied by a few scant dwellings, like in this case, are common.

47 top A road crosses – where possible – the archipelago, connecting some of the little islands. Ferries guarantee links with continental Finland and Sweden. Only Sund can be reached by bus or bicycle.

47 center A close relationship with the sea characterizes the daily life of the inhabitants of the archipelago. For sailing or boating lovers, the archipelago offers several interesting ports to visit in addition to a large number of natural harbors.

47 bottom The Ålands, confident in their remarkable historical and environmental heritage and their advantageous geographical location, which allows the archipelago to be easily reached from Sweden as well, offers the ideal setting for a vacation.

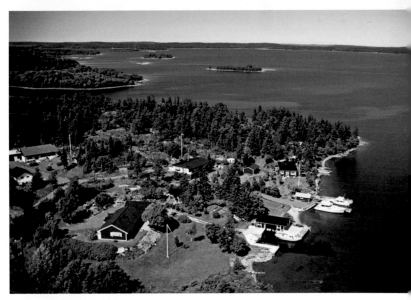

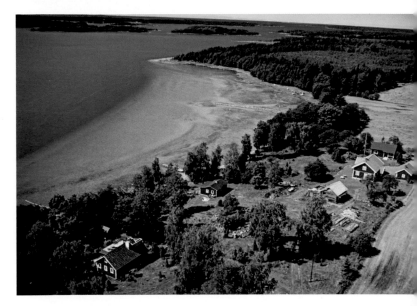

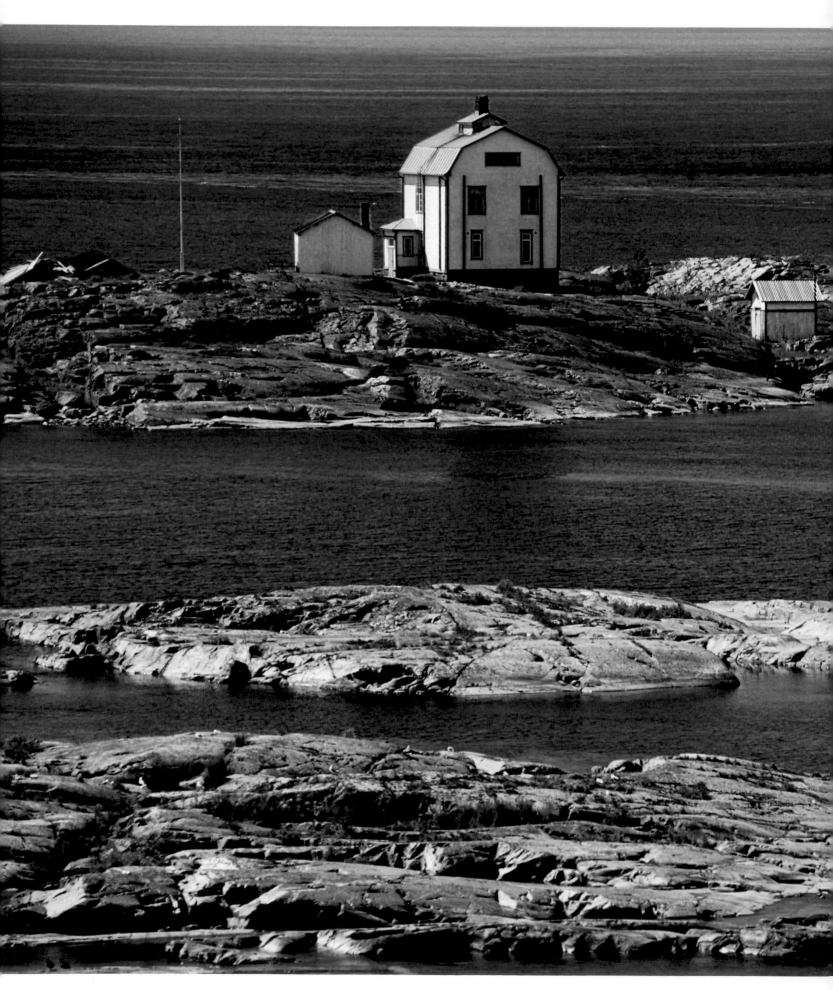

48

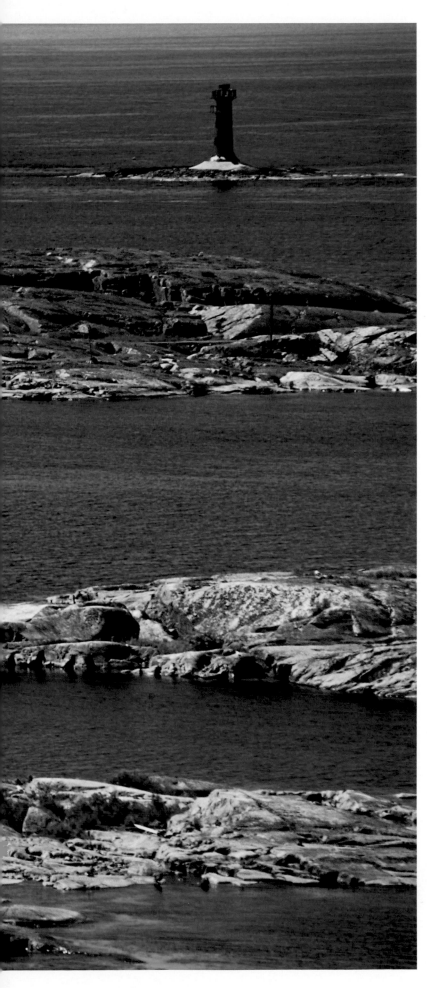

48-49 *The archipelagos of Saaristomeri and Ahvenanmaa (Åland) form a natural barrier at the southernmost point of the Gulf of Bothnia. An infinite number of reefs and strips of land that surface just barely above the water make navigation difficult and dangerous.*

49 top *An old fishing boat tied up at the dock of the island of Vänö in the archipelago of Saaristomeri: once fishing was an important resource for the inhabitants of the islands. Today, barely a dozen or so people live on Vänö, surviving on summer tourism.*

49 bottom *On the islands of the archipelago where the wind blows constant and strong, numerous windmills can still be found, many of which are still in an excellent state of preservation.*

50-51 *The cliffs along the southwest coast near the tourist resort of Hanko were formed by glaciers of the last ice age during their retreat about 10,000 years ago.*

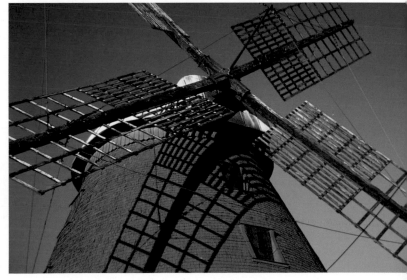

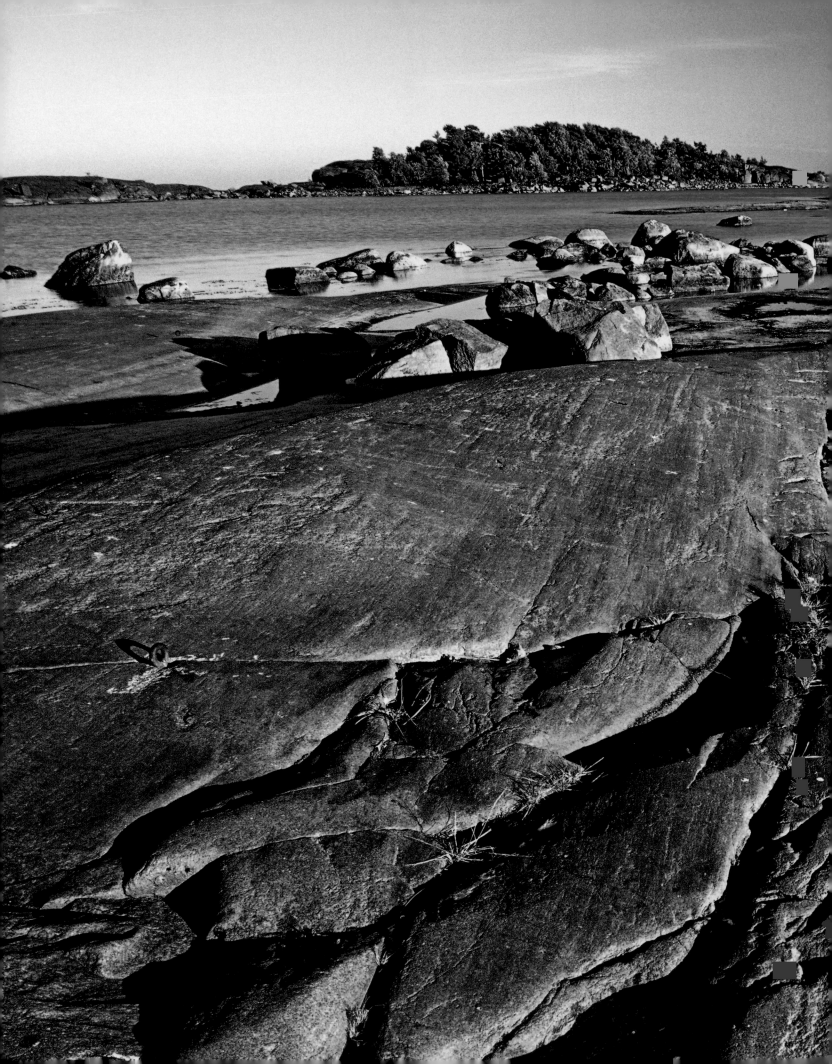

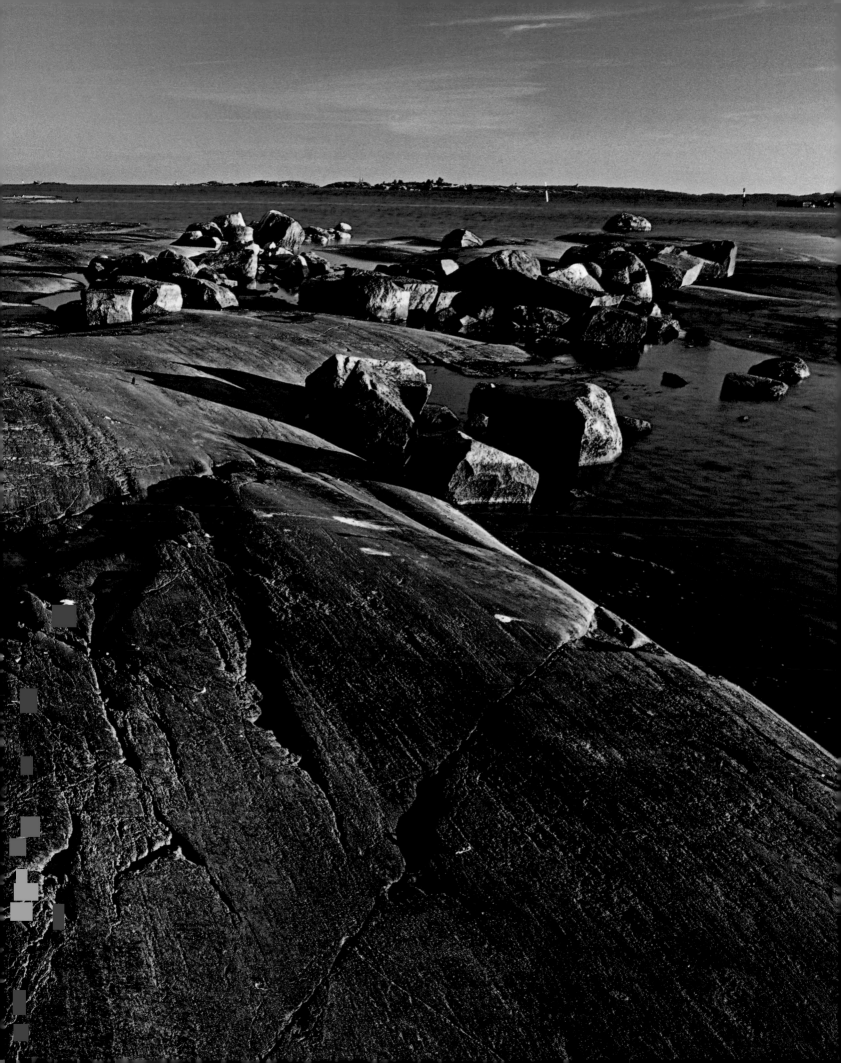

52 top left and right Wandering in the Finnish woods is a unique experience, particularly for photographers seeking details. It is like exploring a magical, fairy-tale world of gnomes and elves where the forest floor is full of mushrooms, mosses, lichens, and berries of every kind often creating a soft carpet on which to walk.

52 center left and right Uprooted by storms and the Arctic wind, old decomposing trees rot away, thus nourishing the forest floor for the growth of new forests. On the right, in the Finnish forests, in August and when autumn begins, there are thousands of tons of mushrooms rotting on the humid forest floor, left behind because of the low density of people around able to even partially gather them.

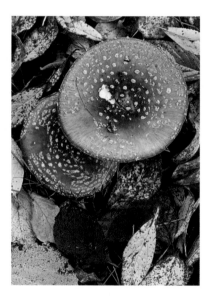

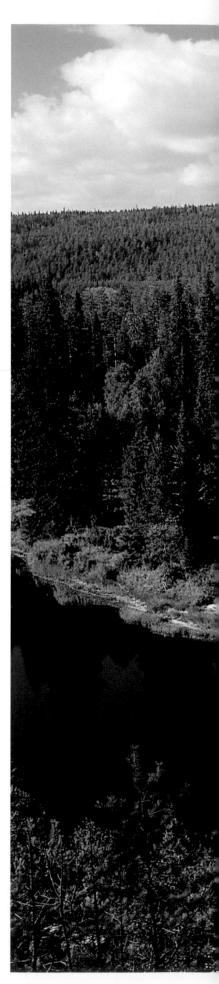

52 bottom Though the Scotch pine prefers a dry environment, the forest of fir and birch trees, being especially humid, nourish a richer and abounding undergrowth where a tangle of ferns prevails.

52-53 Along the twisting bends carved out of the sand of the Oulankajoki River, a short distance from the eastern border with Russia, in the national park of the same name, winds the path of the famous hike of the Karhunkierros (Path of the Bear), one of the most renowned and spectacular outdoor walks in northern Finland.

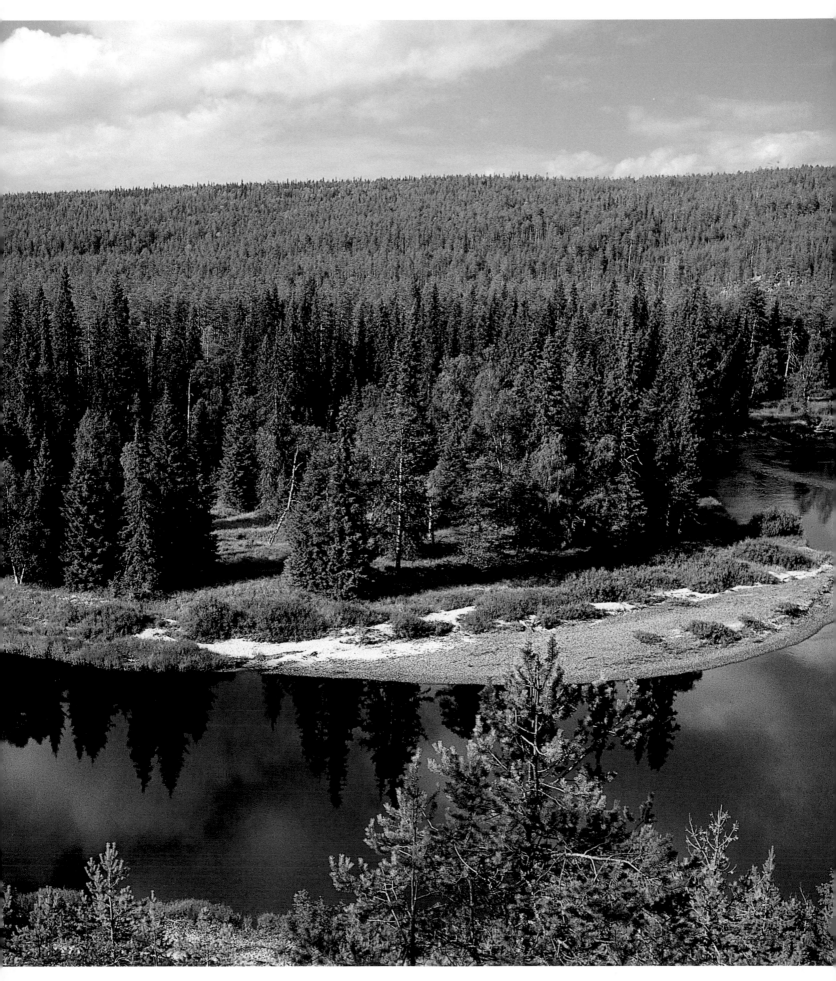

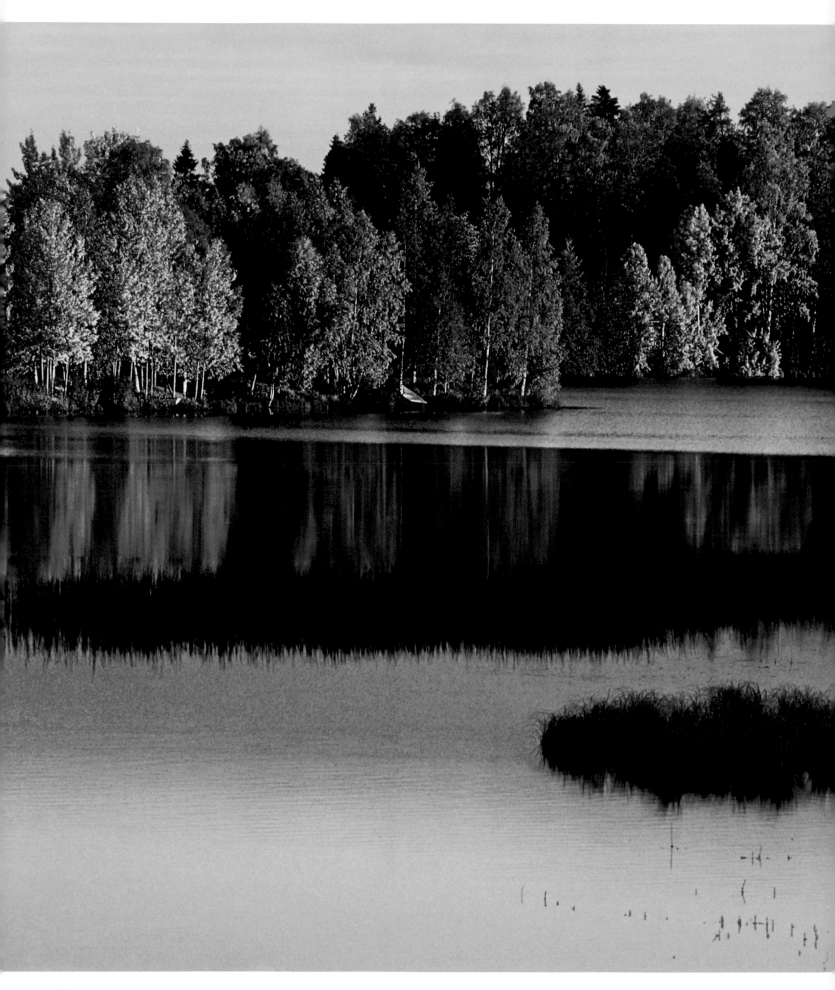

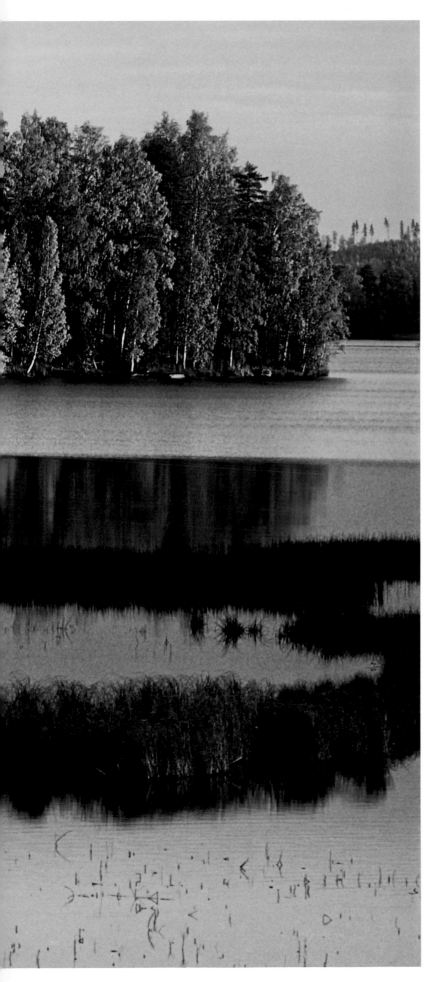

54-55 *The ruska is a brief but wonderful period in which the leaves of the willow and birch trees turn the classic colors and hues of yellow and red.*

55 top *The experience of an autumn hike in the national park of Urho Kekkonen is fascinating, despite frequent changes in the weather and the quick fade of light during the day.*

55 bottom *The undergrowth of ferns is the first to turn the characteristic autumn hues of the* ruska.

56-57 *As one gradually travels north beyond the Arctic Circle, the coniferous forest thins out more and more, leaving space only to birches and willows, trees that emphasize and render the phenomenon of the ruska particularly charming.*

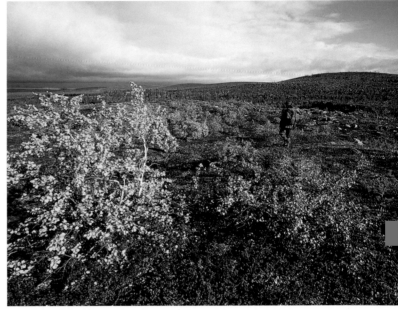

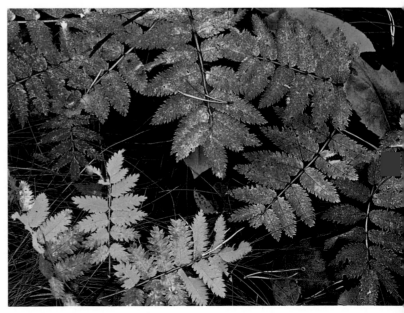

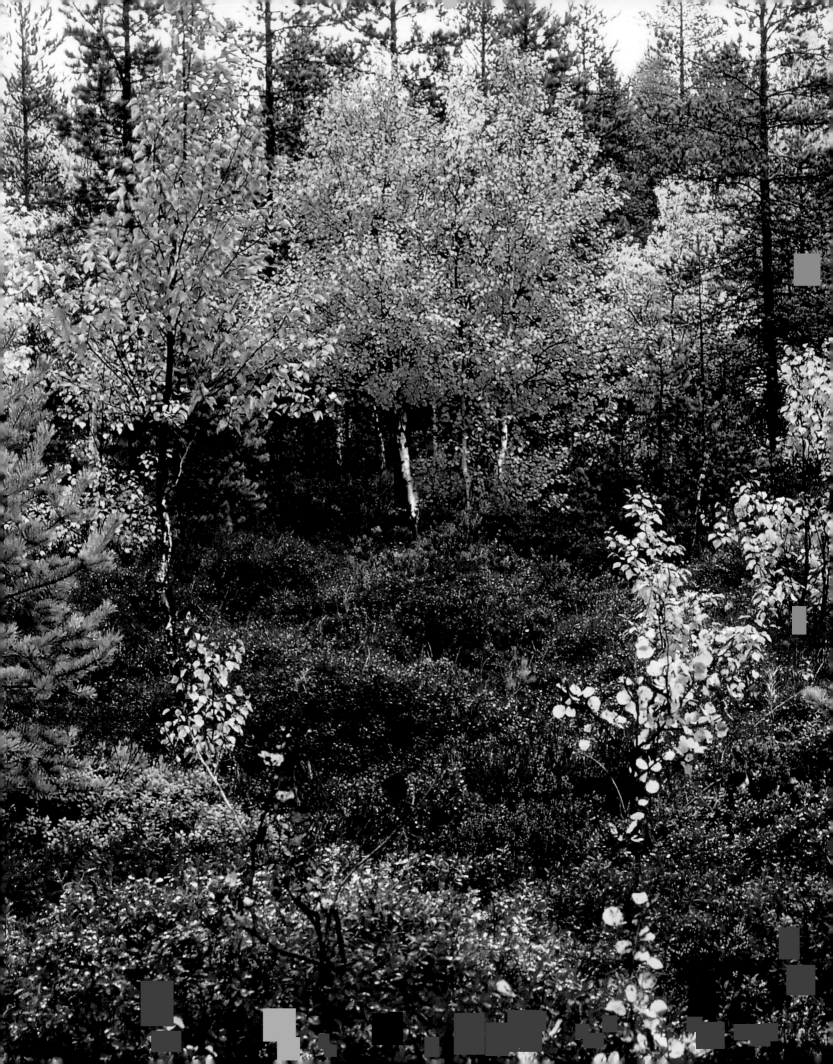

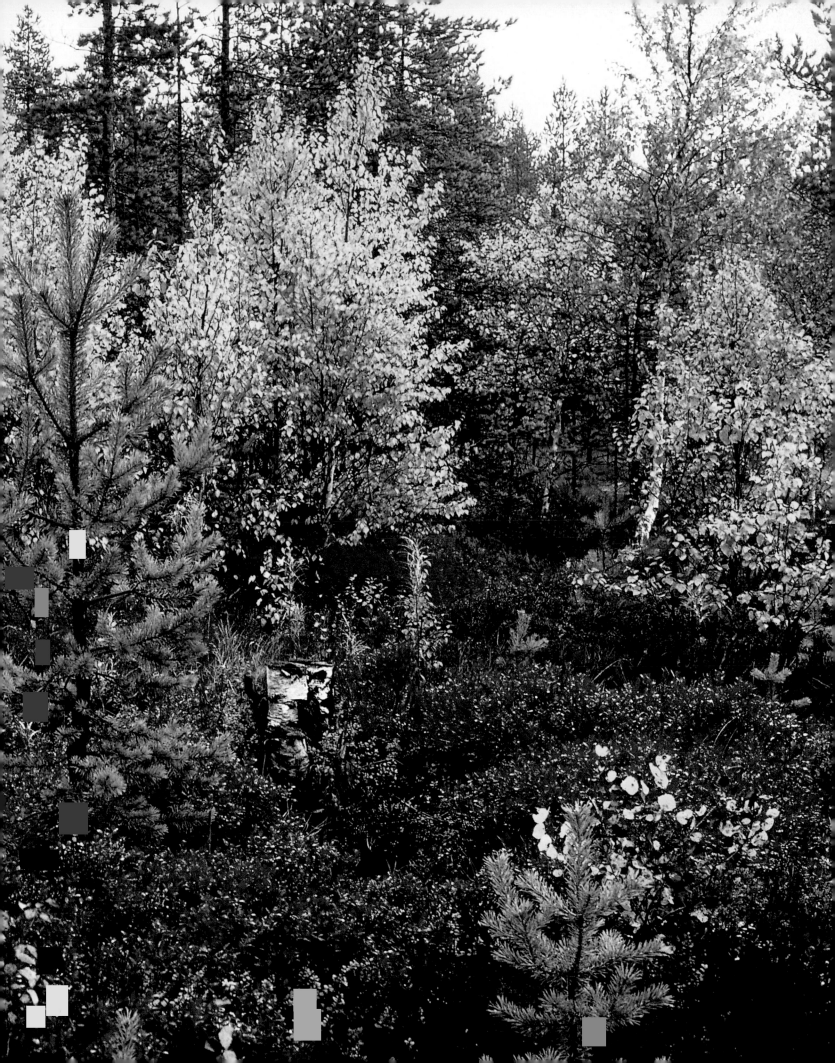

58 left The path of Karhunkierros (Path of the Bear) goes up and down the taiga, following the Kitkajoki River, a tributary of the Oulankajoki in the national park of Oulanka. Trekkers consider this trail one of the most spectacular in Finland for the variety along its route.

58 right The old watermill of Myllykoski, located on the frothing banks of the Kitkajoki River, once used as a shelter by fishermen and hunters, is today a Spartan bivouac for hikers along the famous Path of the Bear (Karhunkierros).

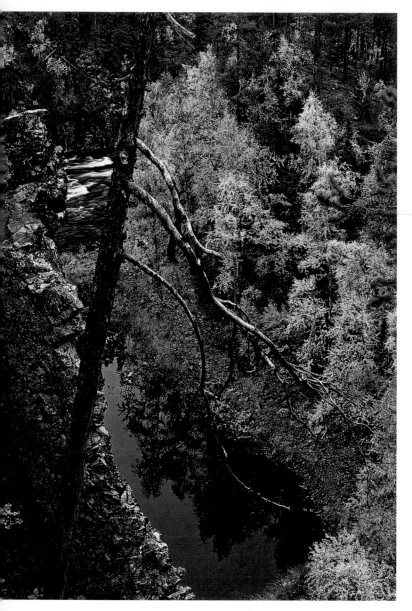

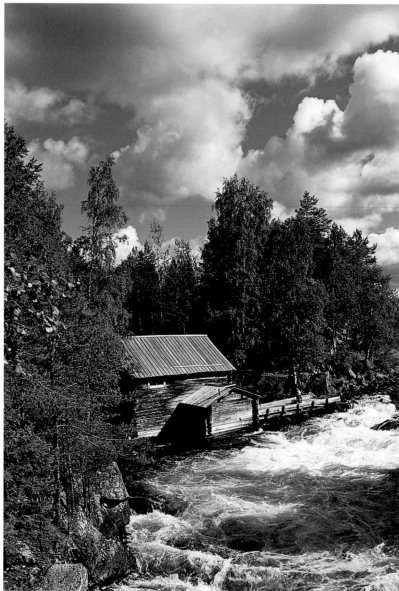

59 The Finnish landscape can still trace its geological origins back to the last ice age. Though the glaciers have retreated, the Finnish territory is still evolving today, and the level of the land continues to rise. Little by little, the hollows of the lakes produced by the glaciers and overflowing with water have filled with debris over time, transforming into vast swamp areas mostly inaccessible.

60-61 Not far from the rapids of Kiutaköngäs, two canoeists follow the soft bends of the Oulankajoki in northern Finland. Some tracts of the river can be traveled for several days without encountering any significant technical difficulty, and it is possible to camp in tents on the sandy banks of its shores or stay in refuges used by hikers and fishermen along the Path of the Bear.

62-63 The Oulankajoki River, with its tributary the Kitkajoki, marks the southern border of the national park of Oulanka and forms a river system that empties into the waters of the White Sea. Along its banks, the morphology of the landscape offers excursionists an amazing variety: canyons, sheer cliffs, rapids alternating with meandering tracts, and peaceful, sandy shores.

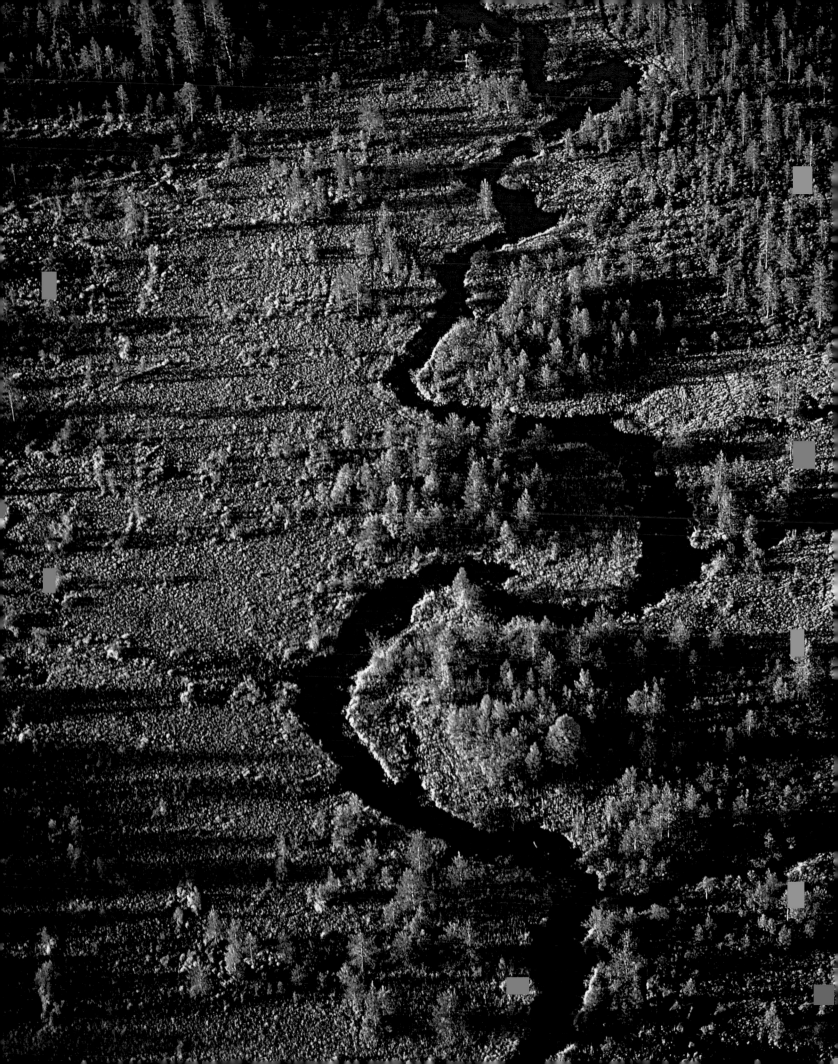

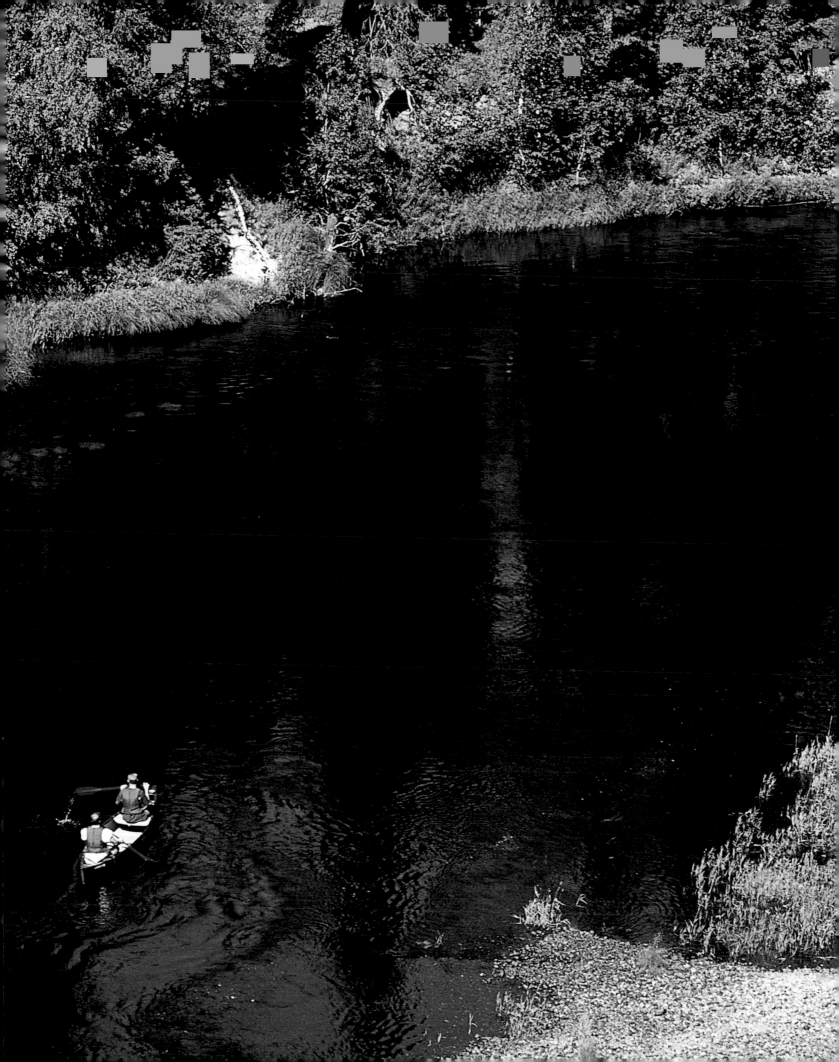

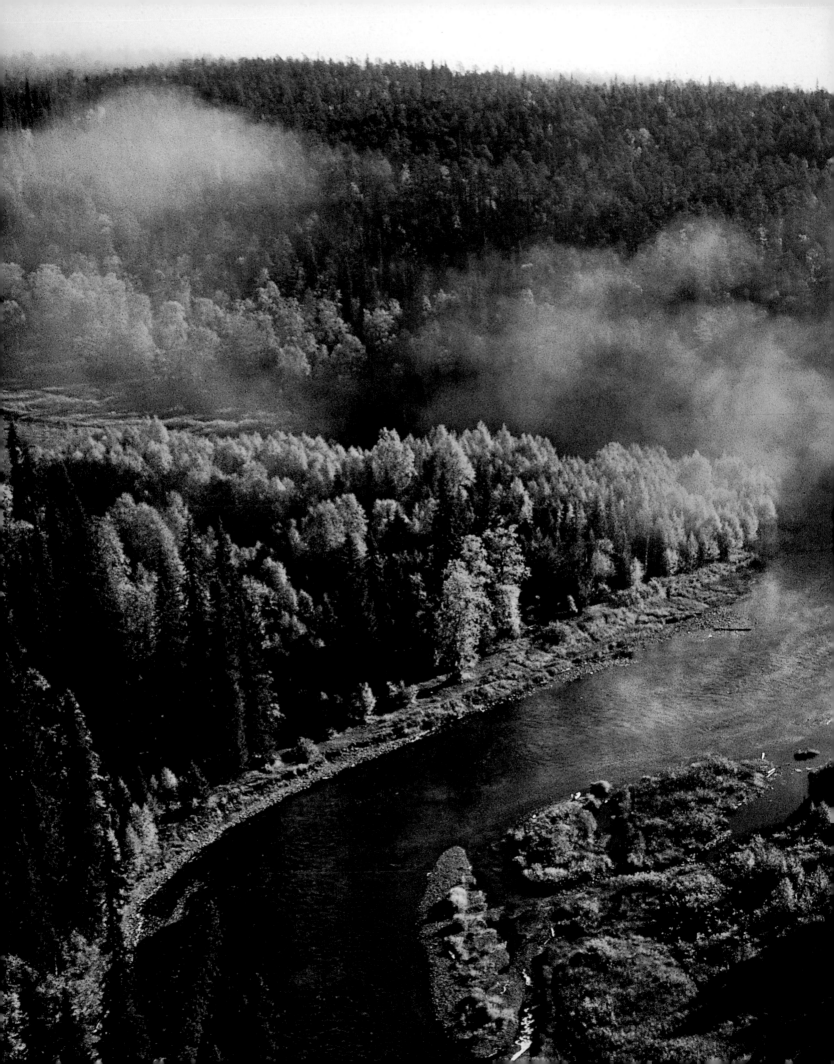

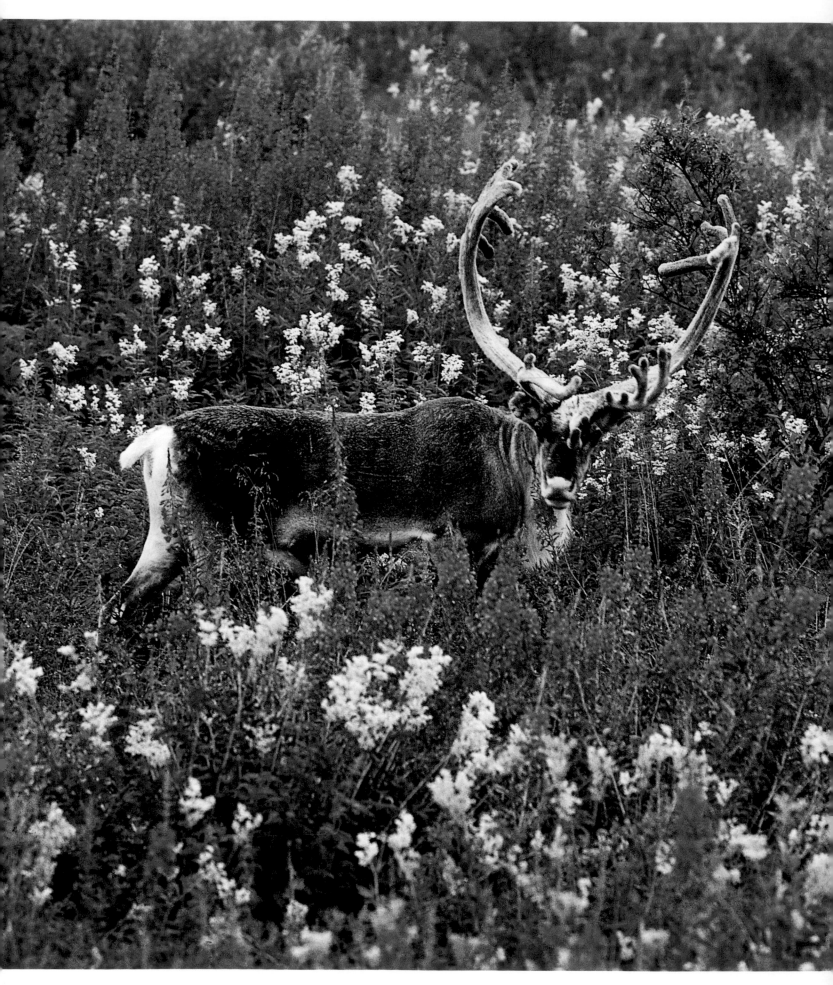

64-65 Well before reaching the Arctic Circle, it is likely to encounter reindeer grazing at the edge of the forest along the roads crossing Lapland. Generally, although they live in the wild, this mammal is the property of the Lapps and the local inhabitants. The reindeer are rounded up twice a year for branding and butchering.

65 top Unlike its American cousin who travels in packs, the wolf of the Finnish taiga is a solitary hunter that ranges along the eastern border with Russia. Even though it is today partially protected, this predator is one of the most highly hunted by reindeer breeders, who have contributed to its almost total disappearance from Finnish territory.

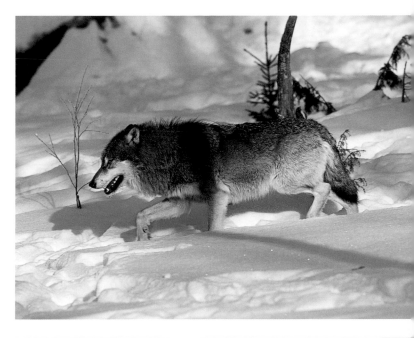

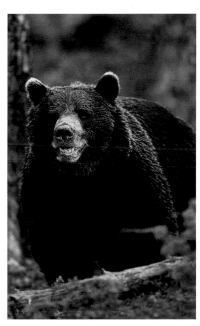

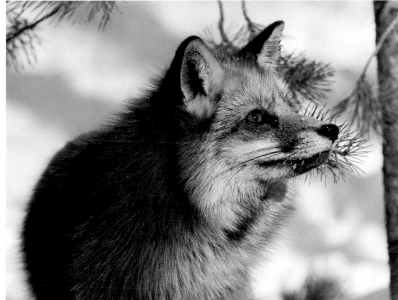

65 center left The brown bear populates the great expanses of the taiga and is a habitual visitor to the national parks of Patvinsuo, Oulanka, and Urho Kekkonen. Its traditional habitat lies along the eastern border with Russia, from the southern countryside as far as the northern forest and the edges of the tundra.

65 center right The red fox is common on all of the Finnish territory.

65 bottom The lynx has established its permanent residence above all along the southeastern border of the country and in Karelia. The capacity of this predator to catch his preferred prey is due not as much to speed as it is to spring: during particularly snowy winters, the hare becomes uncatchable and the cat encounters serious survival difficulties.

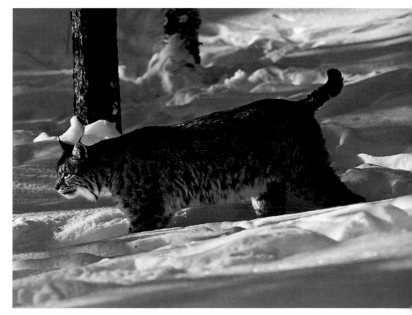

66 top The great gray owl of Lapland survives in the Finnish taiga thanks to the availability of small mammals and the cyclical abundance of field mice and rodents on which to feed.

66 bottom At the beginning of summer, in the Kuusamo region, a peregrine falcon observes its hunting territory from the privileged position of its high, tailor-made nest built on the twisted top of a Scotch pine, almost as if it were a castle with a panoramic view over the taiga.

66-67 In April, when the lakes are still frozen but the first signs have already begun to appear of spring and the reawakening of nature from its winter hibernation, the migratory flocks of wild swans and European cranes arrive: it is time to build a nest.

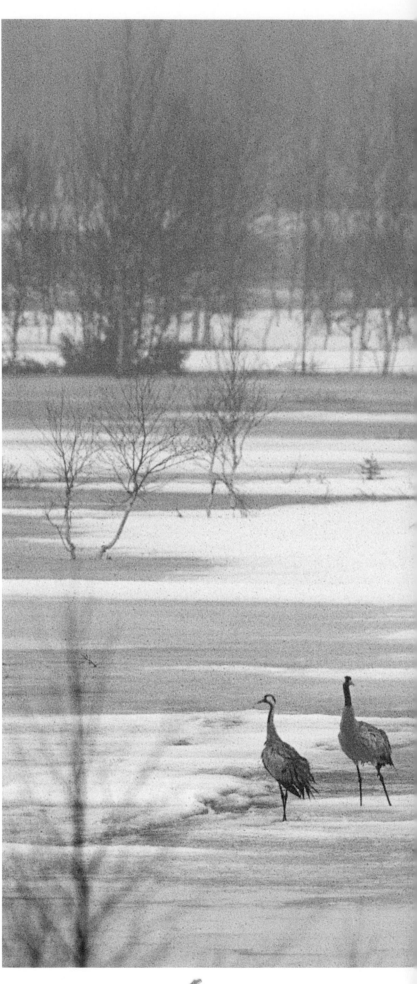

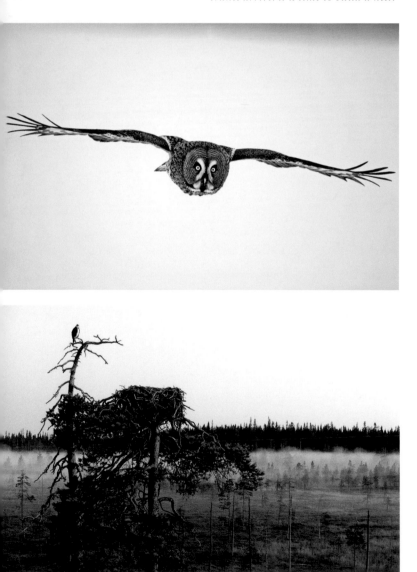

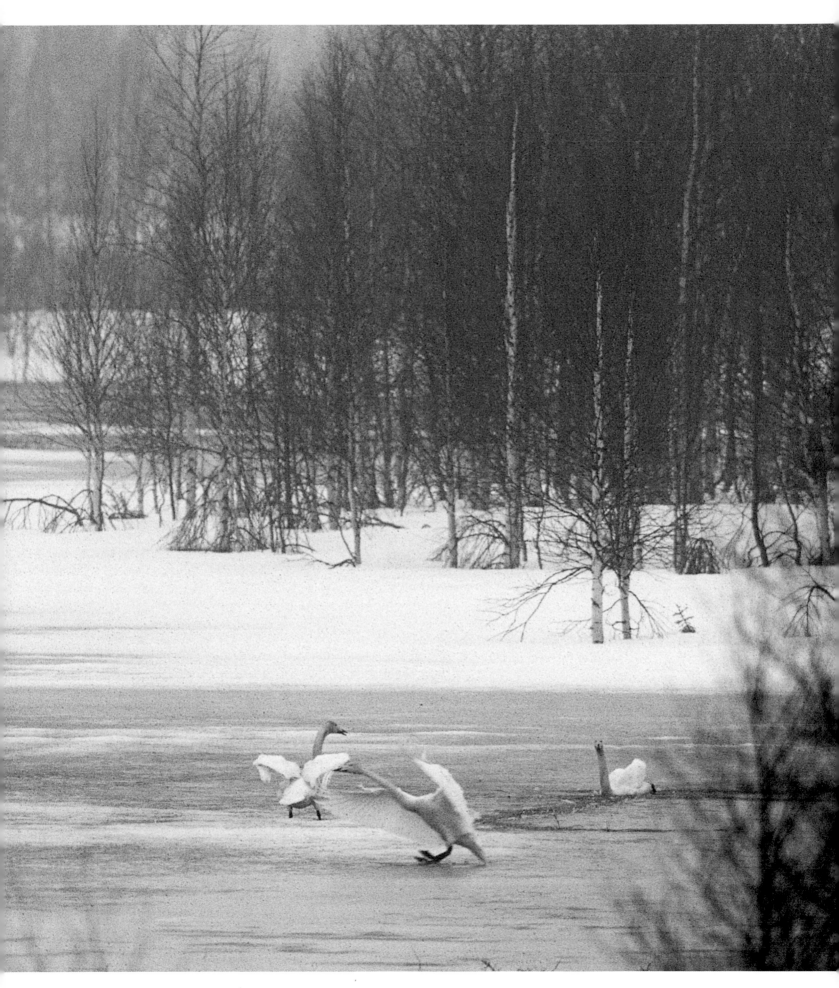

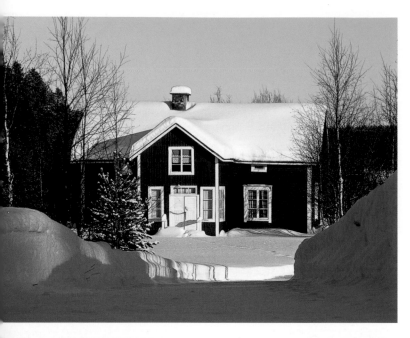

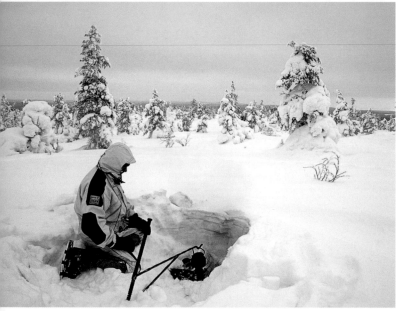

68 top At the edges of the forest, in the area of the village of Posio just below the Arctic Circle, a pretty wooden house remains isolated during the long Finnish winter.

68 center An outdoor campsite in the wilderness along a snowshoe hike in the national park of Riisitunturi: it is not unlikely for the temperature in January and February to drop to near 22°F below zero.

68 bottom Waking up in the morning among the mountains of the Kilpisjärvi region in western Lapland: ice crystals create a whimsical design on the window of a bivouac.

68-69 Even during the winter, the Finns do not give up their daily sauna: it is no longer possible to dive into the lake, but there are two options available after enjoying the warm temperatures of the sauna: rolling around in the refreshing snow or cutting a hole in the ice and courageously dipping into the freezing waters of the lake!

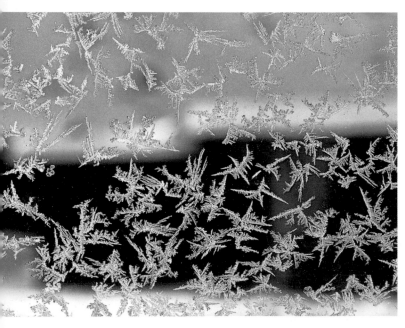

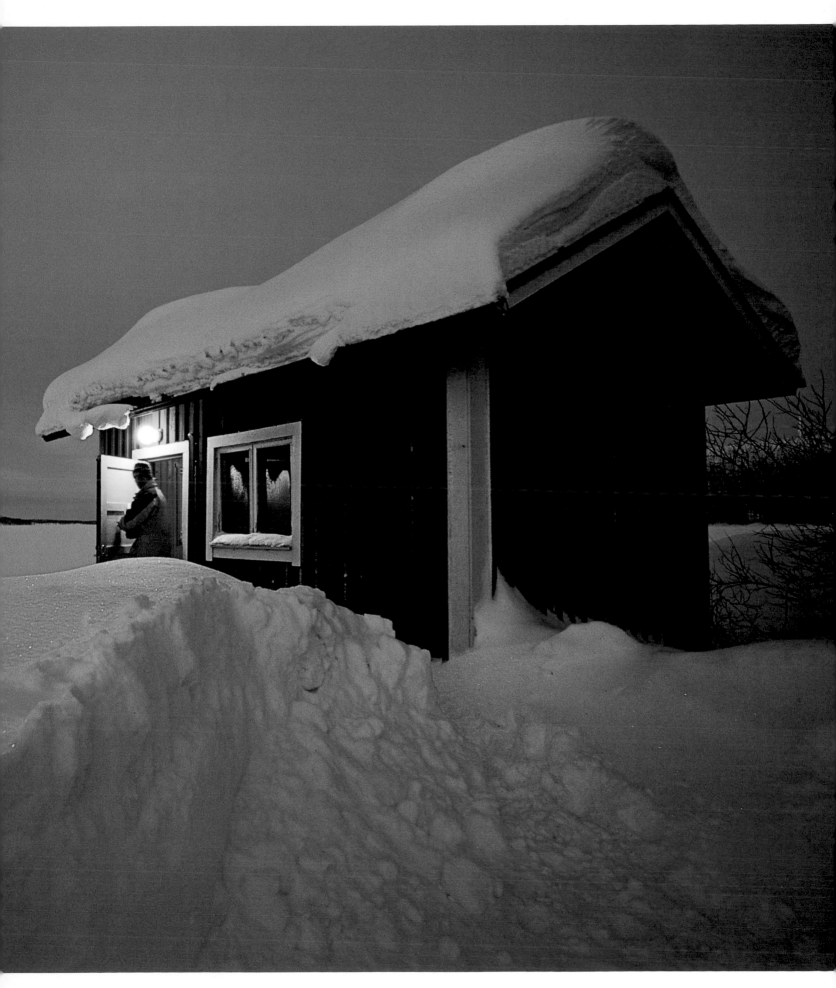

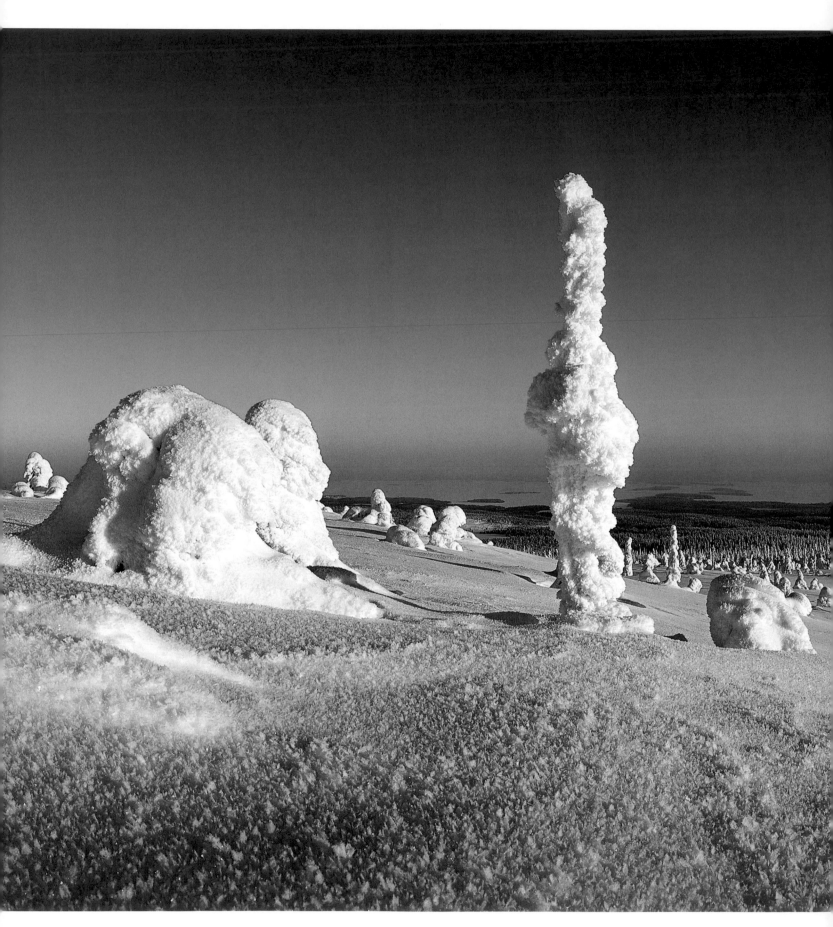

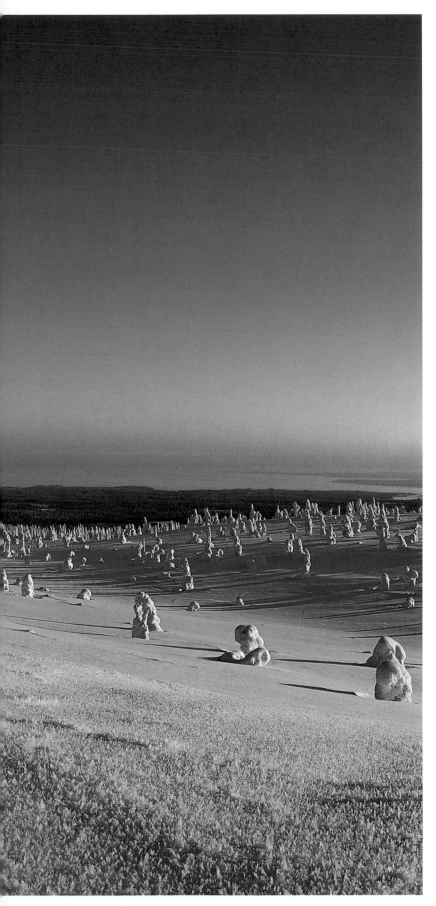

70-71 *From the hills of the national park of Riisitunturi in northern Finland, the view ranges as far as the big lake of Kitkajärvi. In the heart of the Lappish winter, the fir-tree forests covering the slopes of the rises are buried by the freezing snow blown by the Arctic wind: this is the phenomenon of the* tykky, *the magic of white.*

71 top and bottom *On every tree, the snow clings in a different way, creating sculptures that only nature could invent. The* tykky *is the highest expression of imagination that the Arctic winter is able to achieve: gnomes, monstrous animals, castles, giants, nineteenth-century ladies, and medieval soldiers; the fir-tree woods transform into an extraordinary parade of breathtakingly strange characters.*

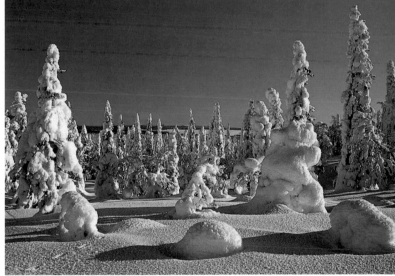

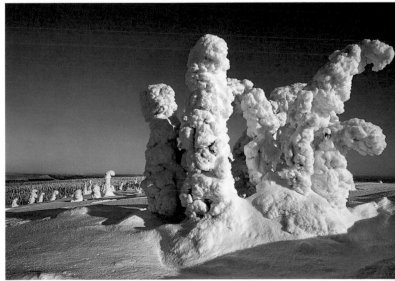

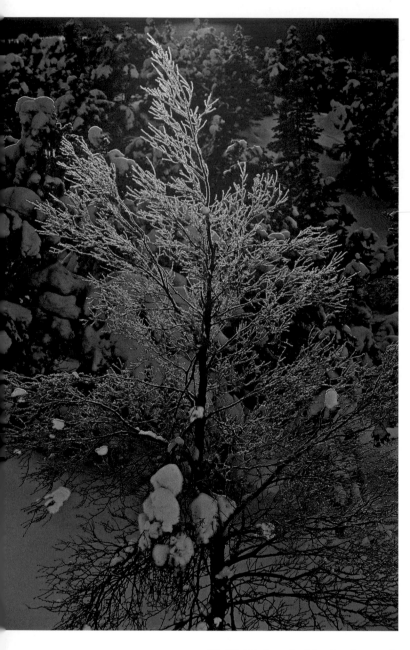

72 *Whereas the phenomenon locally called the* tykky *is best expressed on the trees, the* galaverna, *the frost that crystallizes to form thin needles on the leaves and branches, coats birches and pines, creating magical plays of light.*

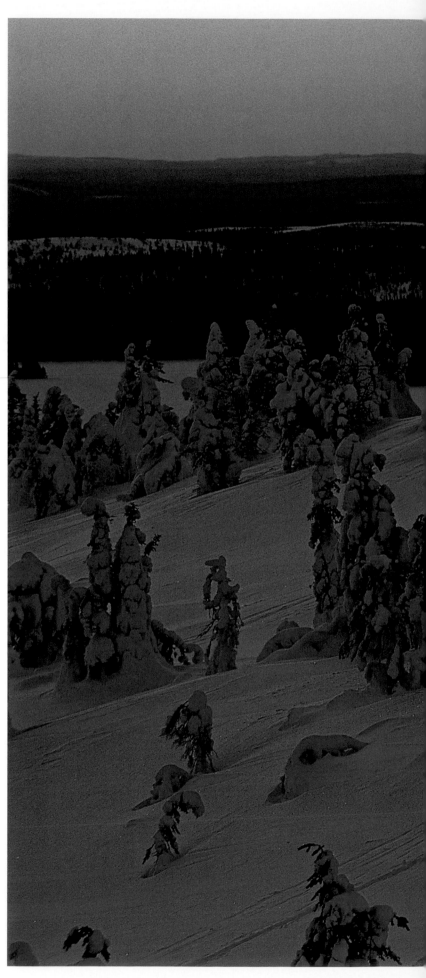

72-73 *The breathtaking landscape of the vast expanses of the snowbound taiga is a fleeting sight: just the slightest change in weather can cause all the trees to lose their winter shroud.*

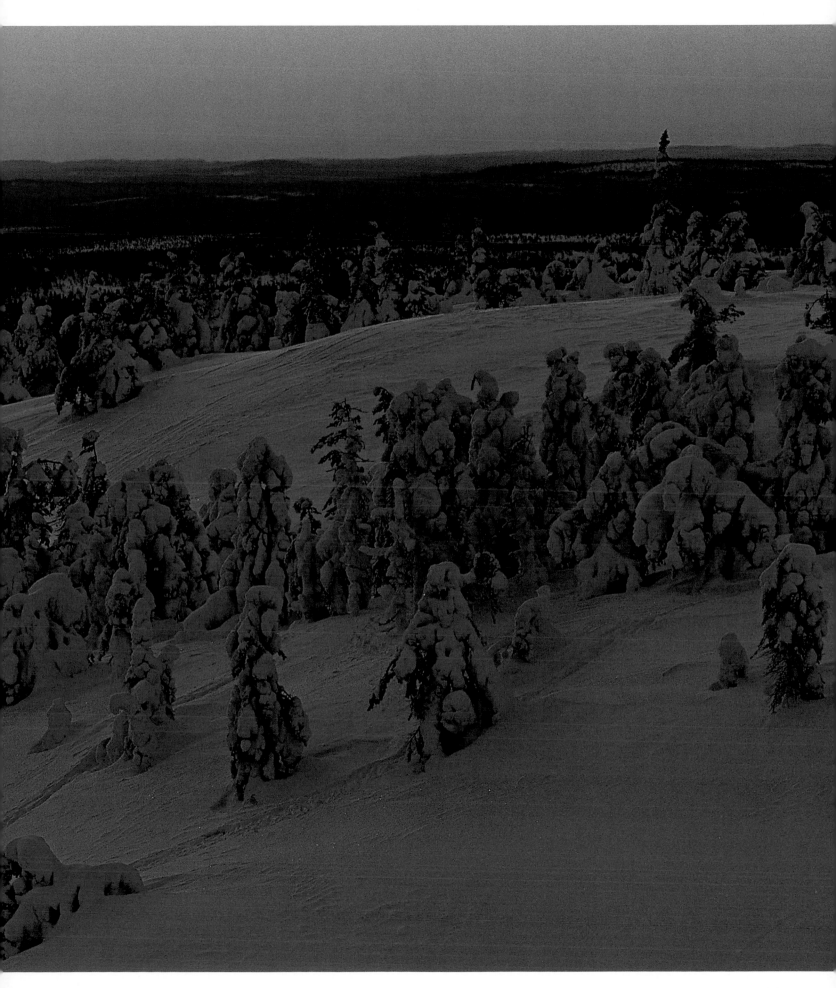

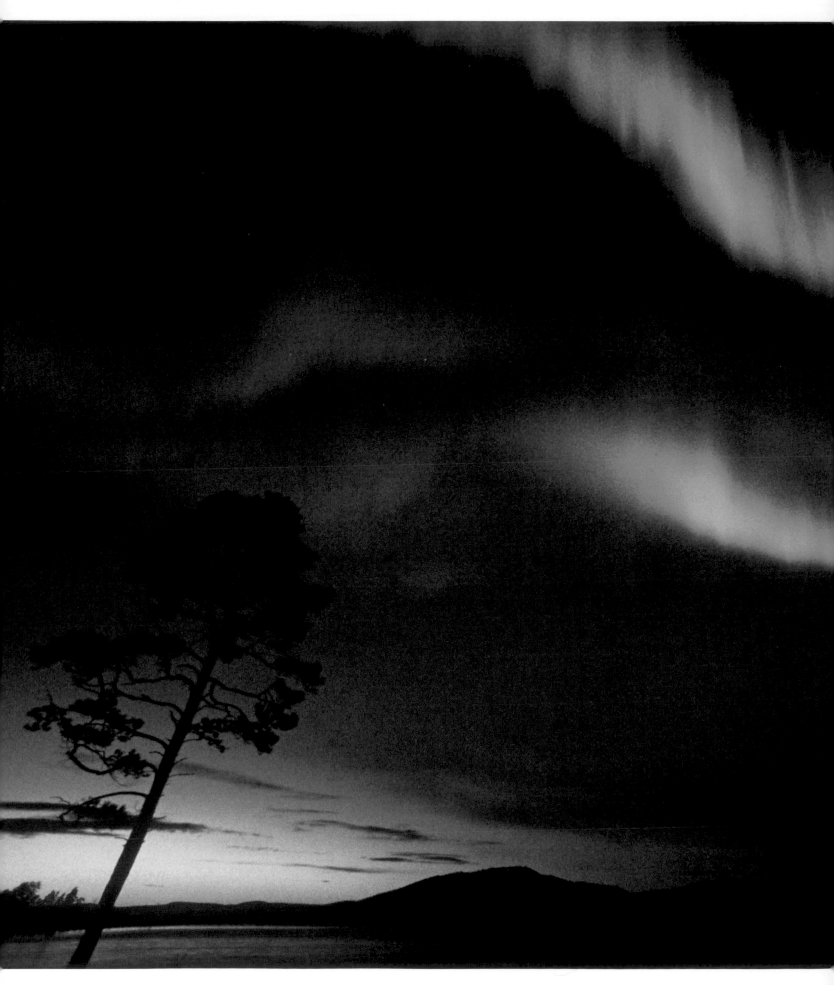

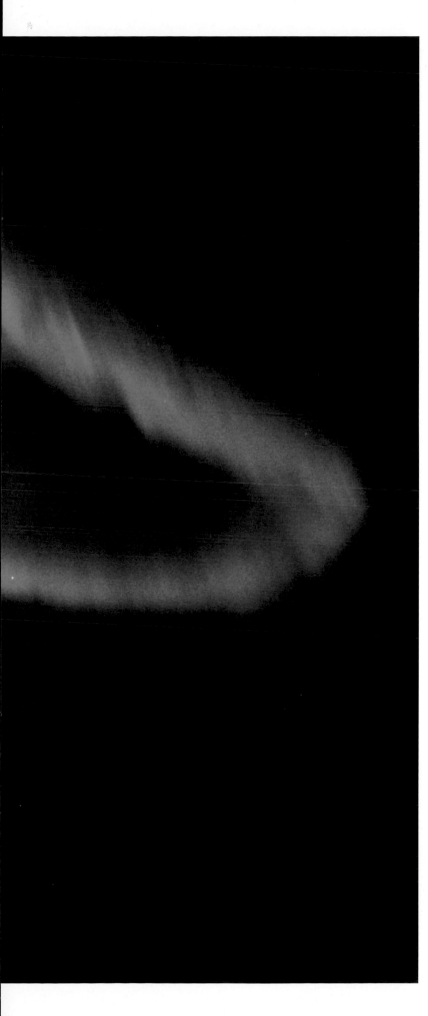

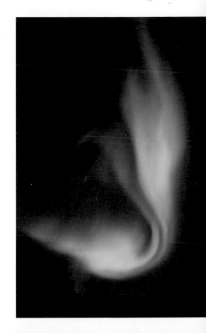

74-75 In the heart of the Arctic winter, it is common to have the opportunity to observe the phenomenon of the aurora borealis.

75 top To best observe the aurora borealis, it is necessary to distance oneself from the artificial lights of town and find an open space like the surface of a frozen lake or the top of a high hill.

75 center and bottom In Finnish, revontulet, or the aurora borealis, means "fox fire." Legend has it that when the fox runs across the snowbound expanses of the tundra during the Arctic night, its tail stirs up clouds of luminous icy snow.

76-77 Flaming waves in continuous movement, the colors and ethereal shapes of the aurora borealis rise and vanish suddenly.

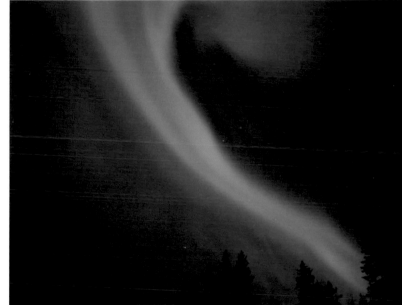

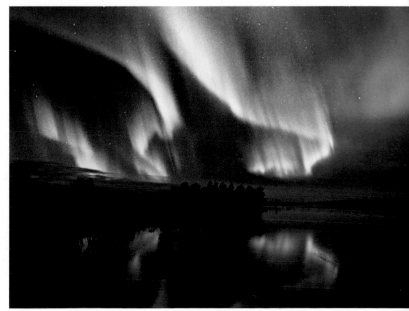

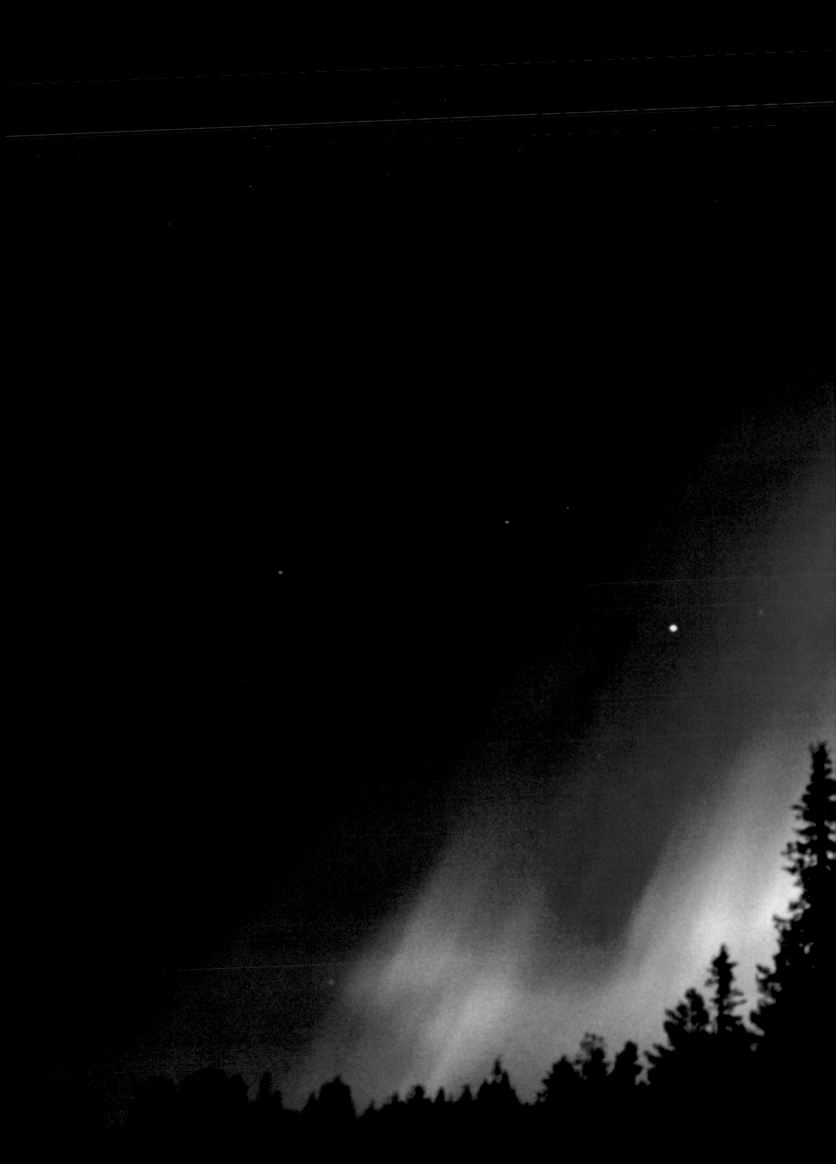

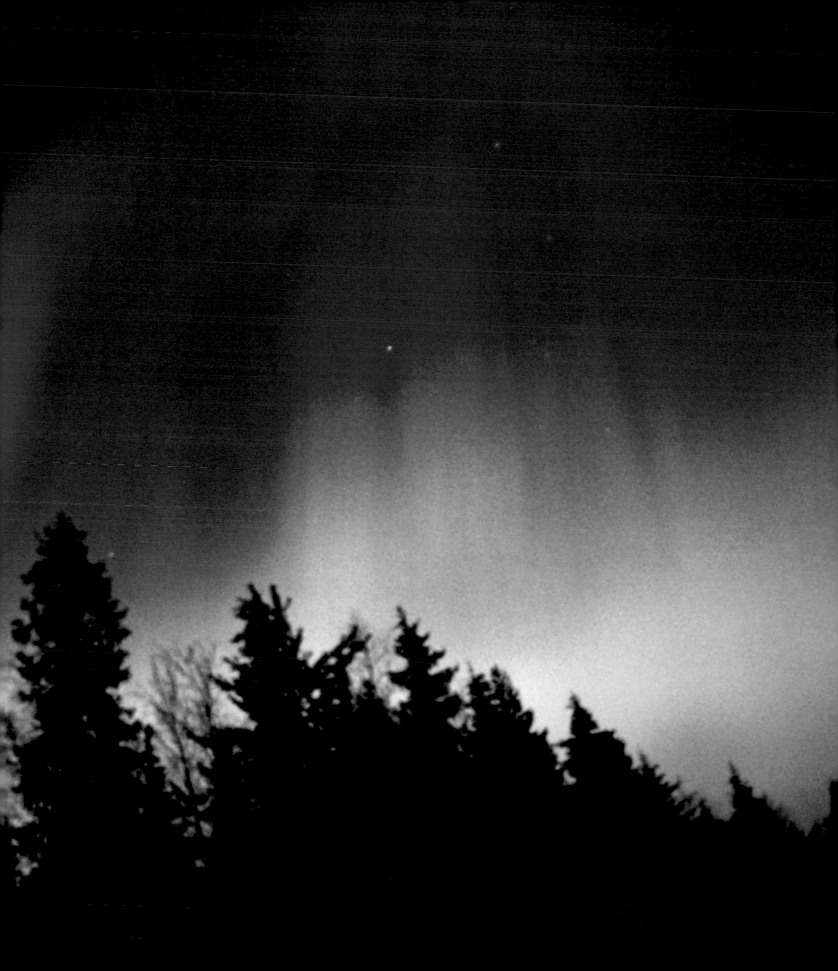

Cities on a Human Scale

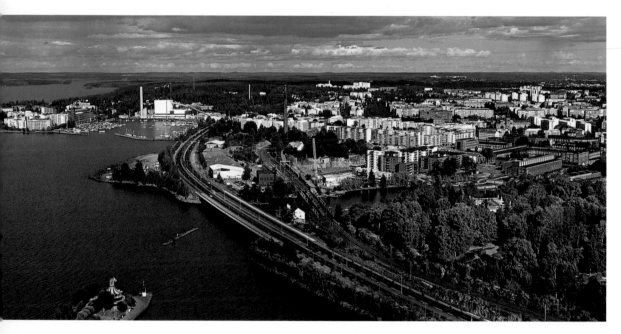

78 top The town of Tampere is the third largest city in Finland by size. Once renowned for its textile industry, today it is one of the liveliest and busiest cities in the country, also thanks to a healthy student population.

78 bottom With its picturesque wooden houses on the water, Porvoo, whose old part is very pretty and well preserved, is a characteristic historic spot, a good place for a day-trip from Helsinki.

79 The statue of Czar Alexander II in Senate Square in Helsinki was completed in 1894 and emphasizes the great influence that Russia wielded over Helsinki in the nineteenth century.

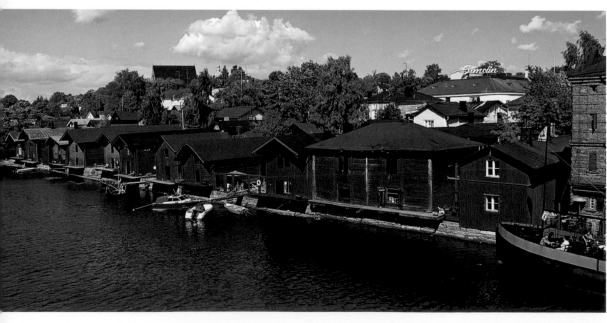

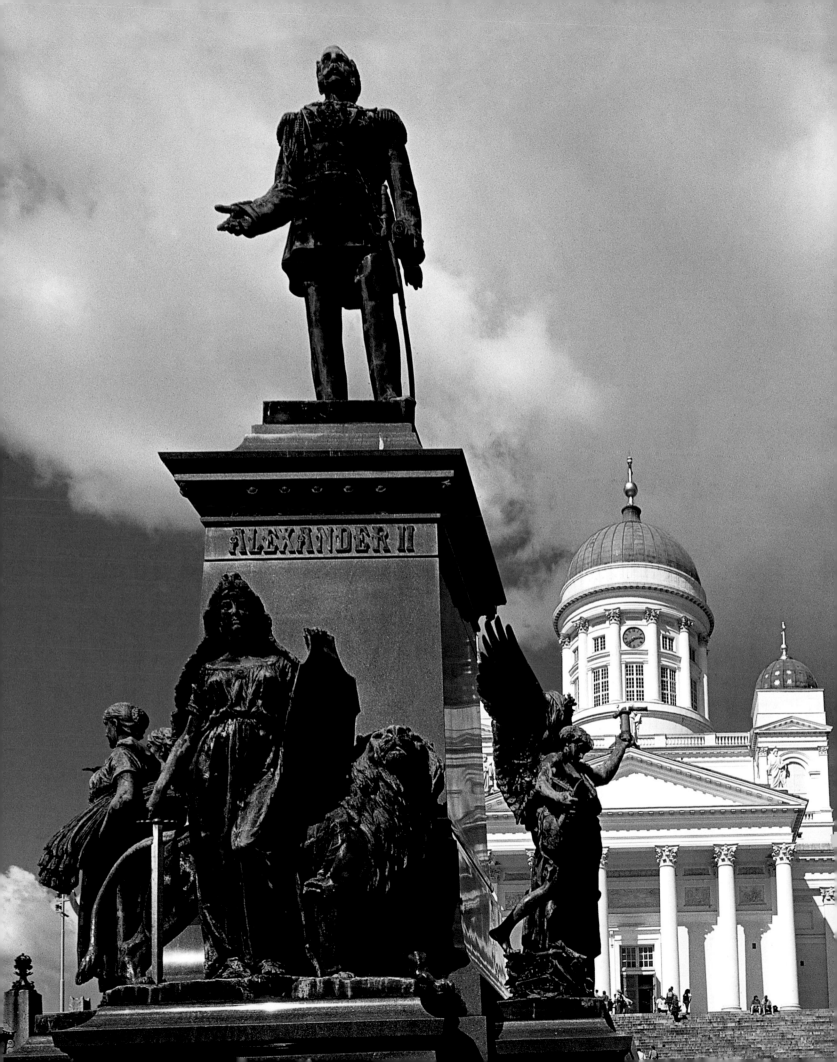

Helsinki: The Historic Capital

80 top The Palace of the Council of State forms, together with the Lutheran cathedral, the university, and the university library, the architectural frame for Senate Square, the official center of Helsinki.

80 bottom The photograph shows a detail from the majestic and white Tuomiokirkko, the Lutheran cathedral, the flashiest building on Senate Square, not to mention the most recognizable structure in a panoramic view of Helsinki.

80-81 In the bay of Helsinki, protected and enclosed by numerous little islands and above-water reefs, the island of Katajanokka, connected to the mainland by a bridge, is worth a visit: many of its narrow streets feature residential buildings in Art-Nouveau style.

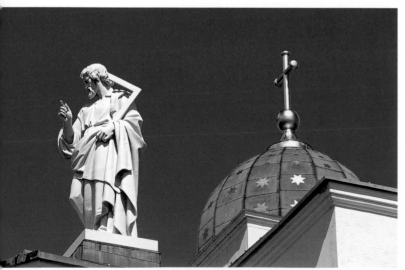

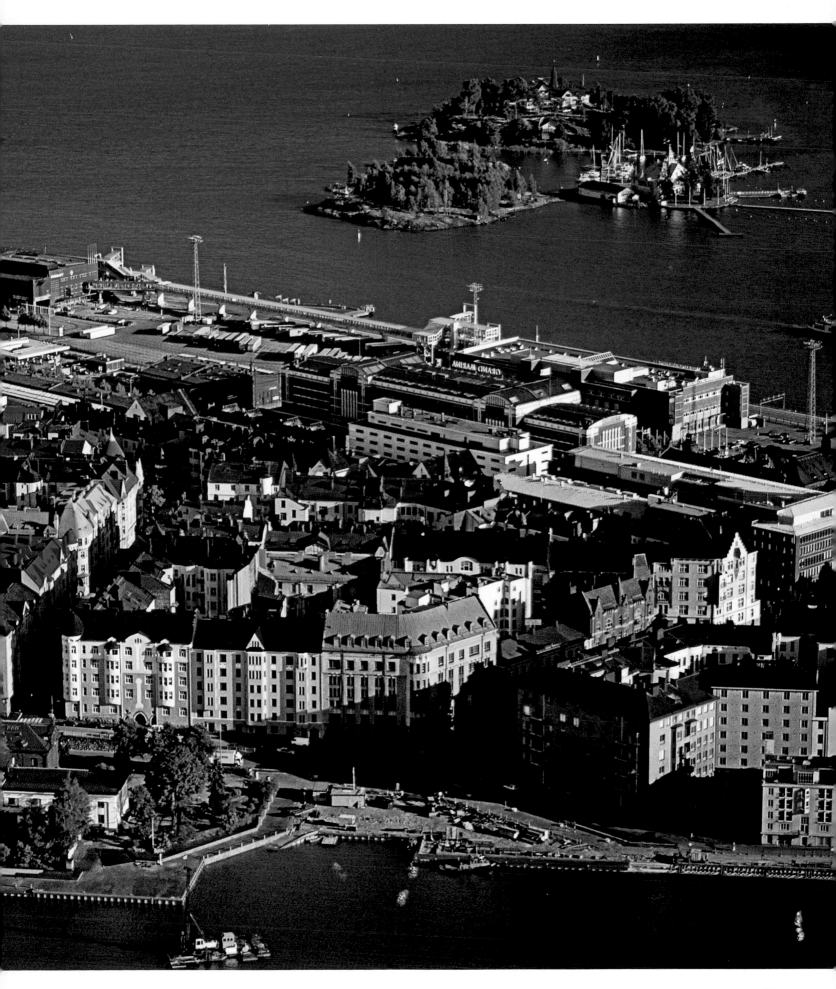

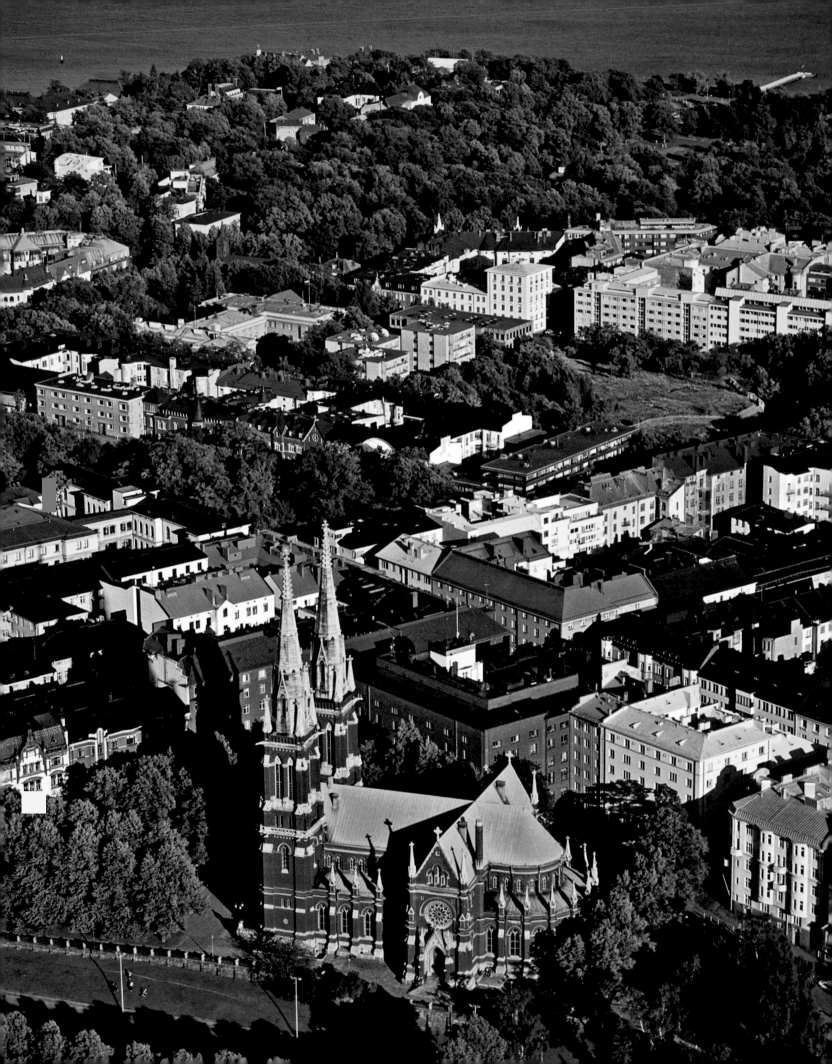

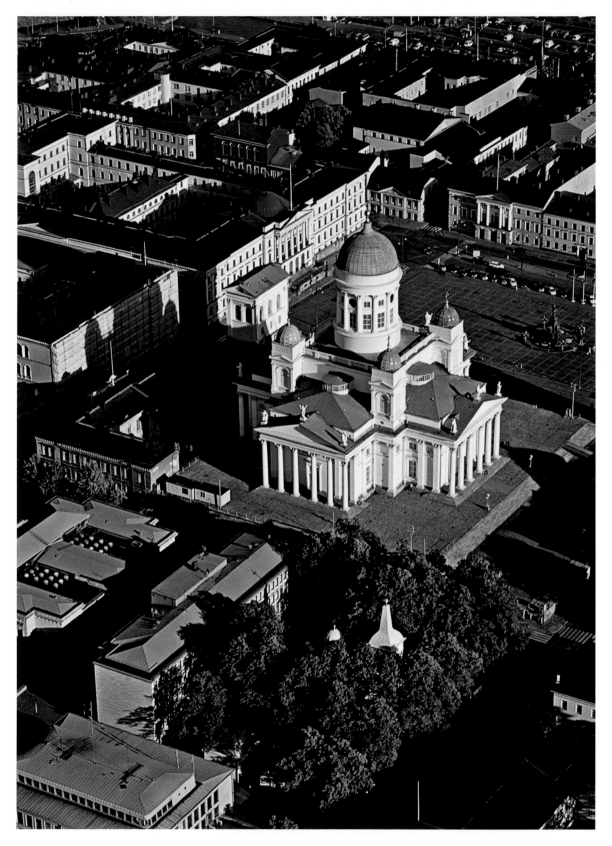

82 The biggest church in Helsinki is
the neo-gothic church of Saint John,
located in Saint John's Park. It is
often used for weddings and often
holds concerts and choral
performances.

83 Senate Square in Helsinki:
designed by the architect Engel, the
square has a definitely Russian look
to it, such that Helsinki has been used
by some Hollywood directors as the
location for films set in Russia.

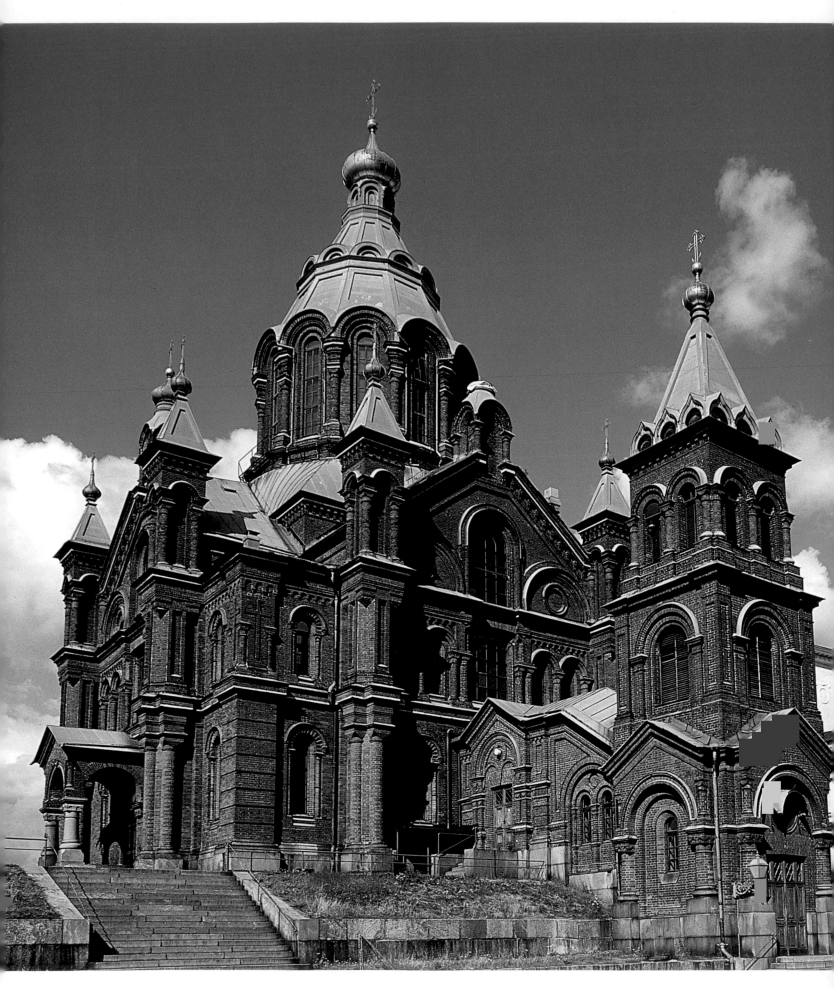

84-85 *Crossing the bridge that leads to the island of Katajanokka, it is possible to reach the Orthodox cathedral of Uspenski, perched on a hill above the port. With its domes typical of Eastern-European religious architecture, this charming church is one of the symbols of Helsinki.*

85 top *The Orthodox cathedral of Uspenski, built in Helsinki in Slavic-Byzantine style in 1868, is richly decorated inside with valuable icons.*

85 center left *Havis Amanda, the pretty fountain with a statue of a siren near the fish market, was designed in 1908. Here, on the holiday of May 1, students gather to celebrate the arrival of spring.*

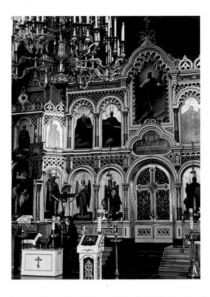

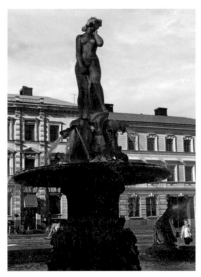

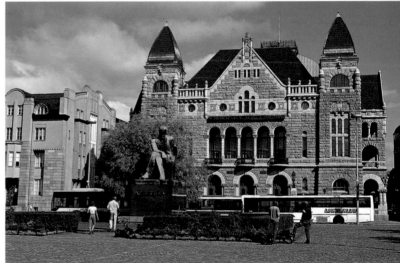

85 center right *The most important Finnish theater is the National Theater in Helsinki, founded in 1872. In the foreground, the statue of the writer Aleksis Kivi, sculpted by Wäinö Aaltonen, can be spotted.*

85 bottom *One of the main roads in the capital links the train station to the heart of the city's shopping area, where the majority of tourists visiting Helsinki are concentrated.*

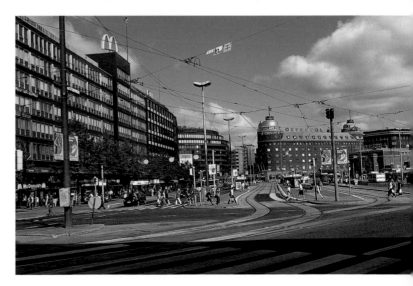

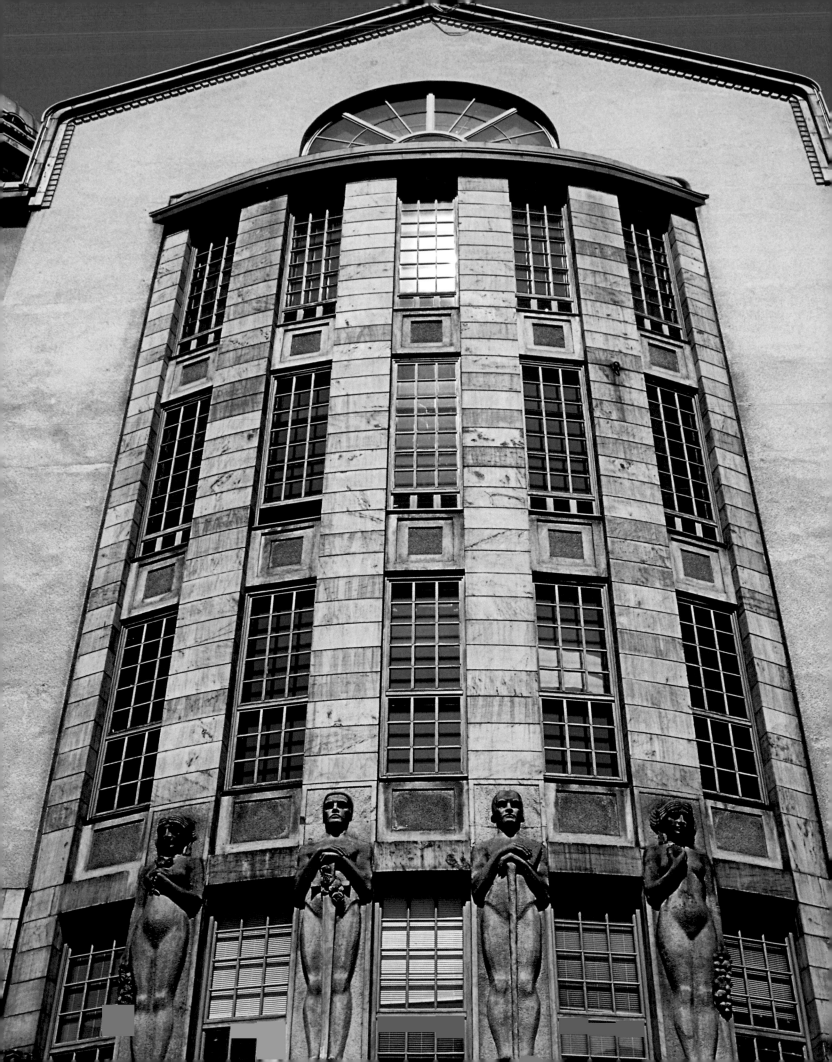

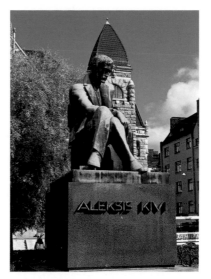

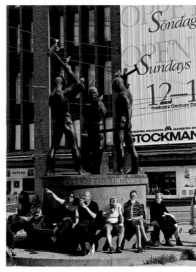

86 Finland's fame as a model country for modern architecture began to spread at the beginning of the 1900s, with Art Nouveau. The Finnish nation, determined in its opposition to the impending Russianization, was fertile ground for any modern ideas. There are several neighborhoods in the capital with concentrations of numerous buildings in Art-Nouveau style.

87 top left In front of the National Theater of Helsinki, there is the towering statue of the writer Aleksis Kivi, author of some everlasting Finnish classical literature and tragedies and comedies with a social theme performed in theaters.

87 top right Across from Stockmann, the famous department store, on warm and sunny summer days, tourists hang out under the Statue of the Three Smiths (Kolmen Sepän Patsas).

87 center At both sides of the entrance to Helsinki's train station, the most famous building designed by the Finnish architect Eliel Saarinen, tower the imposing torch bearers, the work of Emil Wilkström.

87 bottom The Church of the Rock (Temppeliaukio), designed in 1969 by Timo and Tuomo Suomalainen, is one of the principal sights of the city. Dug entirely out of the live rock, it has a roof 79 feet in diameter covered by 14 miles of copper wire and often holds concerts.

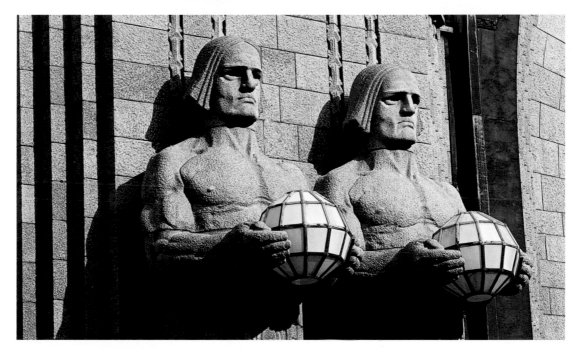

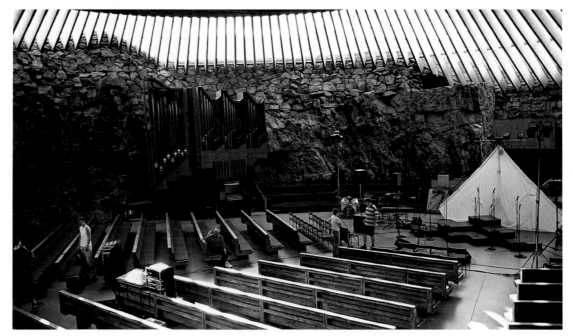

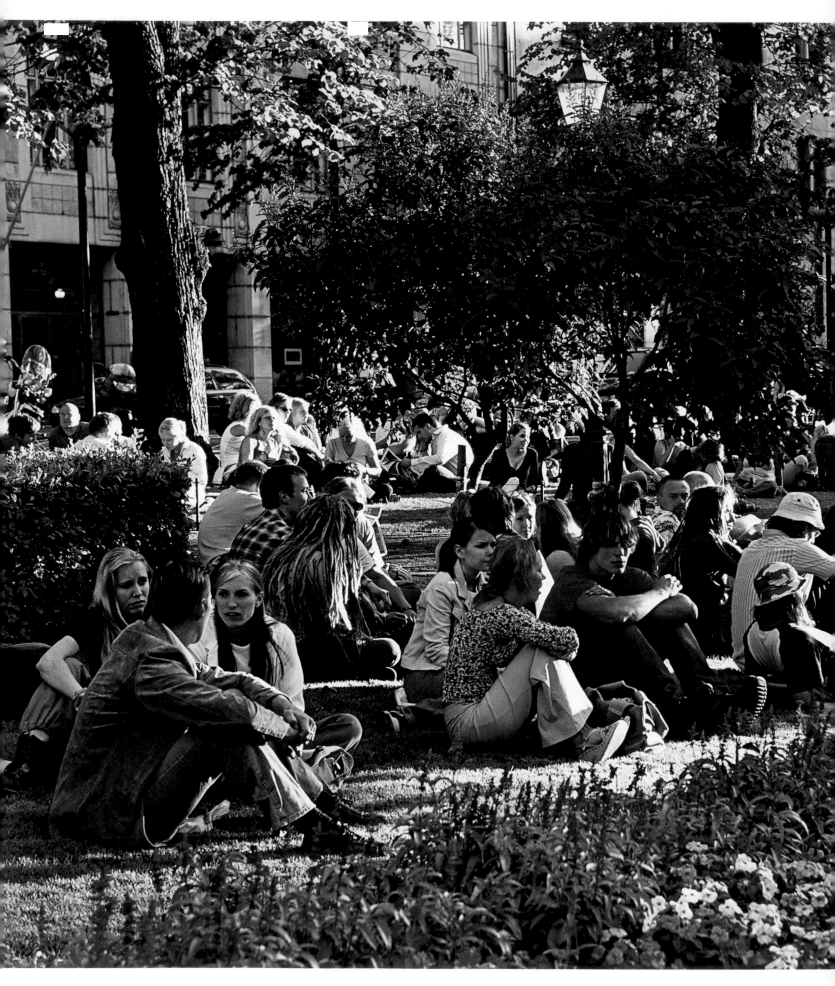

88-89 *In the heart of the Finnish summer, when the temperature on hot days can easily reach 86°F, among the flowerbeds of the Esplanadi, the avenue leading to the sea from Market Square, the inhabitants of Helsinki mingle with tourists on the lawns in search of a Nordic suntan.*

89 top and center *Market Square (Kauppatori), facing onto the port of Helsinki, is one of the liveliest and most crowded areas in the capital with its stalls of vegetables and forest fruits. Some vendors are inhabitants of the surrounding islands that come by boat to the capital's bay to sell their products at the market.*

89 bottom *Helsinki, with less than 500,000 inhabitants, is a small, human-sized capital, lively and cheerful. Young people pour into its streets and parks above all in summer, when it is warmer and the days are longer.*

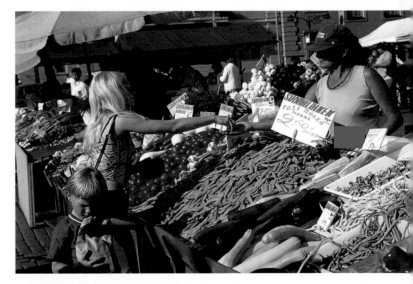

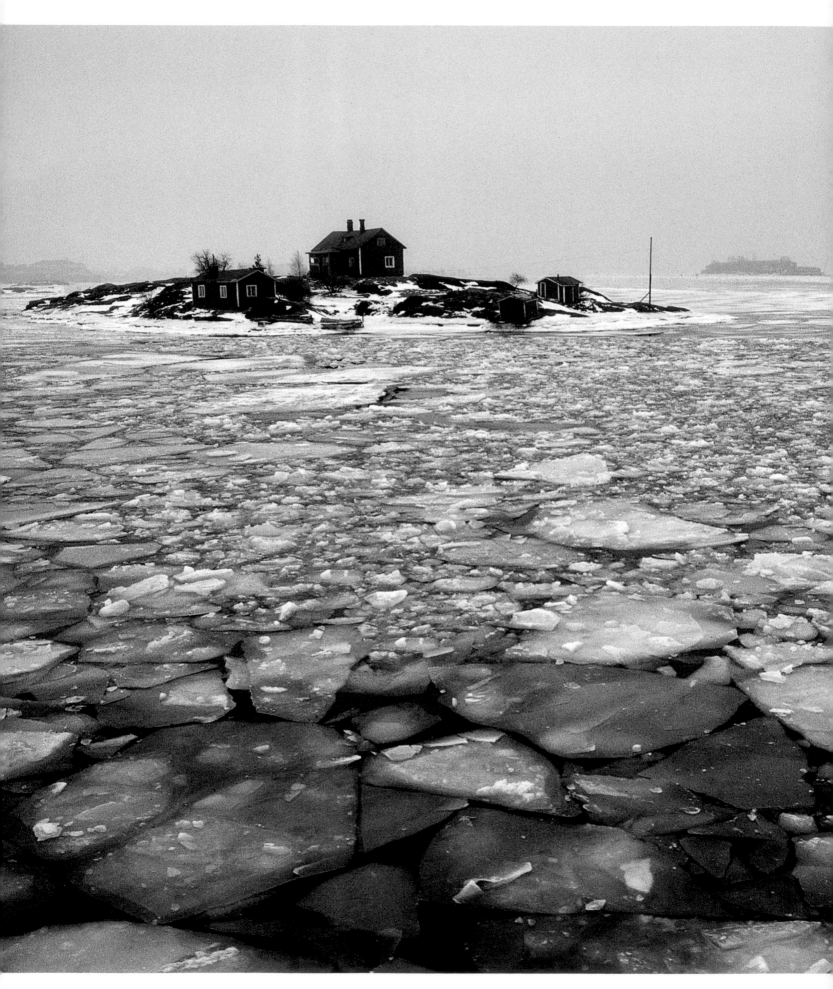

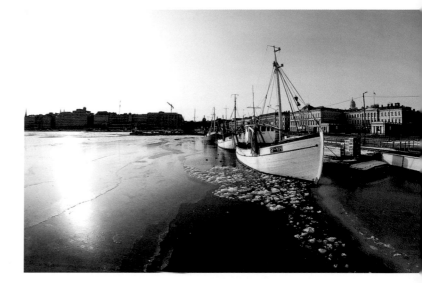

90-91 *In winter, during the coldest months, even the water in the bay of Helsinki freezes. Still today, the inhabitants of the most remote islands in the archipelago, where the icebreaker boats do not go, remain isolated from the mainland in the crucial period in which the ice is not solid enough to support the weight of motorized means of transportation.*

91 top *The port of Helsinki teems with boat traffic: fishing vessels, ferries to Sweden and the Baltic countries, sightseeing boats to the surrounding islands, and private sail boats.*

91 center *The big ferries of the Viking Line, together with those of the Silja Line (whose emblem is that of the Saimaa fresh-water seal), are basically floating hotels that link Finland to Sweden by way of the Gulf of Bothnia.*

91 bottom *In the naval sector, Finnish industry is highly specialized. In addition to being on the cutting edge of building icebreaker ships, which make it possible to keep the main ports open even during winter, the shipyards of Helsinki's port are renowned for the construction of large cruise ships used in the Caribbean and other seas around the world.*

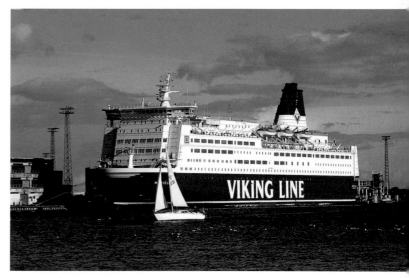

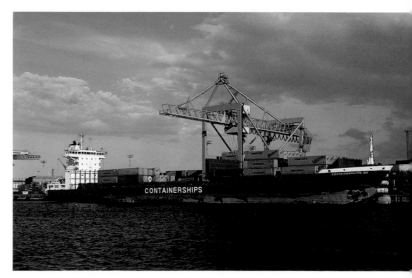

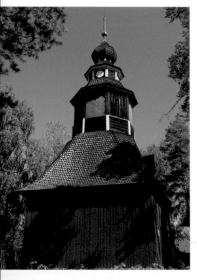

92 top The island of Seurasaari, west of downtown Helsinki, is an open-air museum with traditional eighteenth- and nineteenth-century constructions from throughout Finland.

92 center To see the inside of the old homes on the island of Seurasaari means discovering a slice of life from yesteryear.

92 bottom In summer, the museum holds the "days of Finnish handicrafts": visitors can observe, trades of the past.

92-93 The open-air museum of Seurasaari in Helsinki was inaugurated in 1909 and contains, surrounded by conifers and birches, about a hundred old Finnish houses.

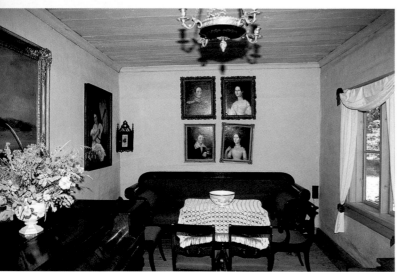

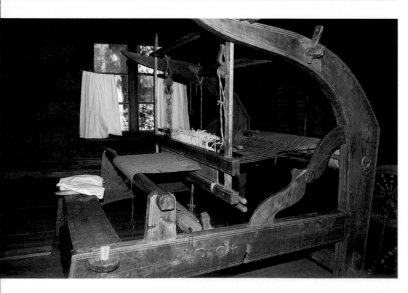

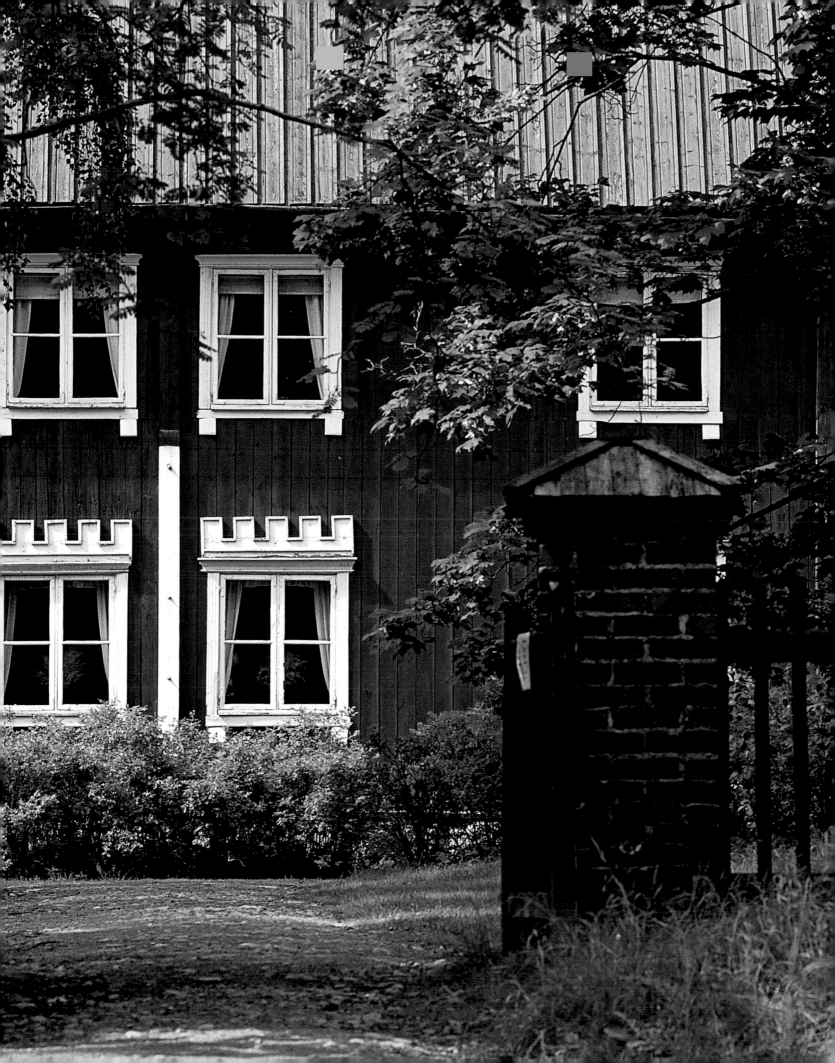

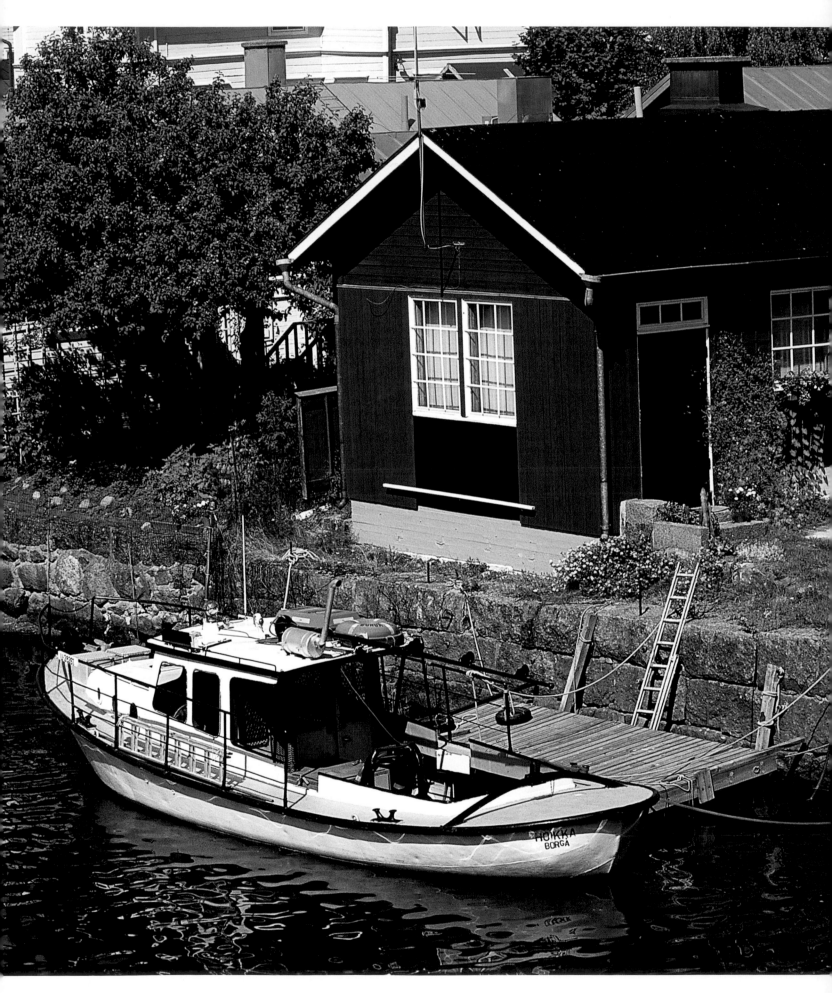

Porvoo: The Wooden City

94-95 *In the old historic village of Porvoo, the characteristic wooden houses line the banks of the Porvoonjoki River.*

95 top *A characteristic of old Porvoo are its cafés and bars in the Old City and along the river.*

95 center *Located 30 miles east of Helsinki, Porvoo is the second-oldest city in Finland after Turku.*

95 bottom *The cathedral of Porvoo is a medieval stone church built in the Old City. In 1809, the first Diet of Finland gathered there.*

96-97 *The wooden houses of Porvoo, once warehouses, are today gorgeous private homes.*

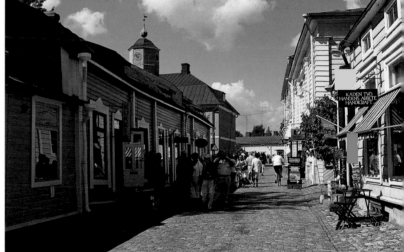

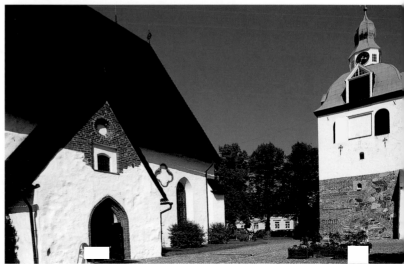

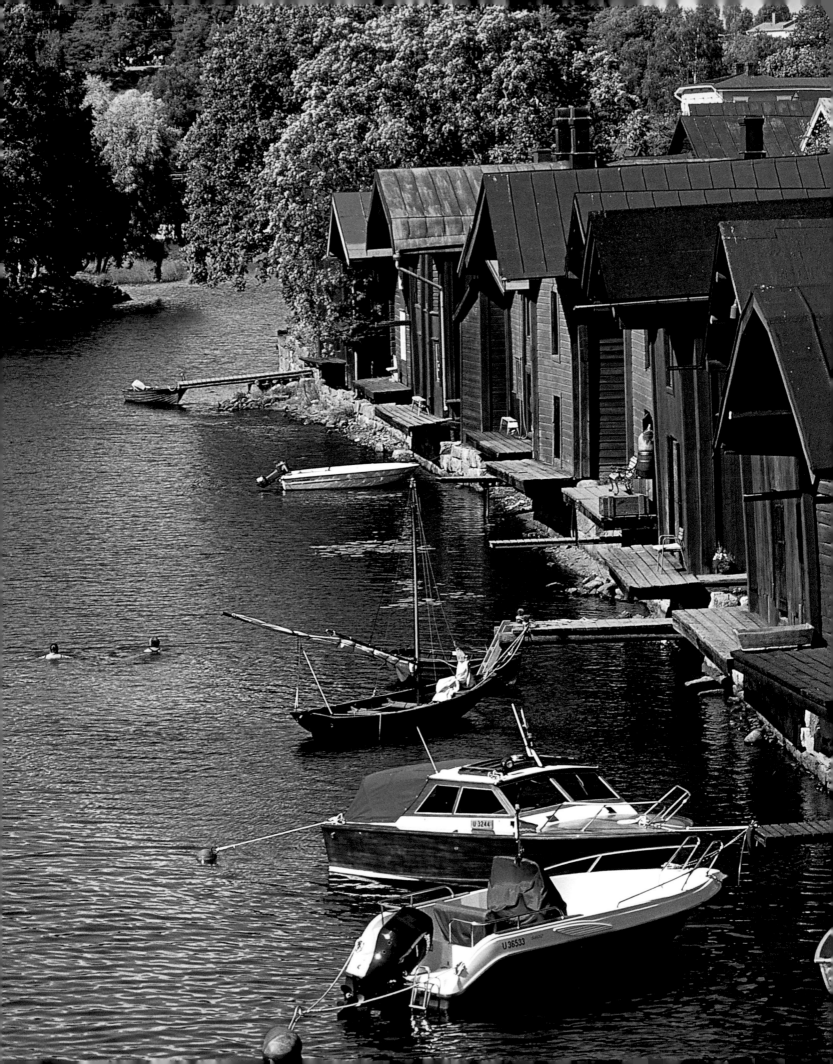

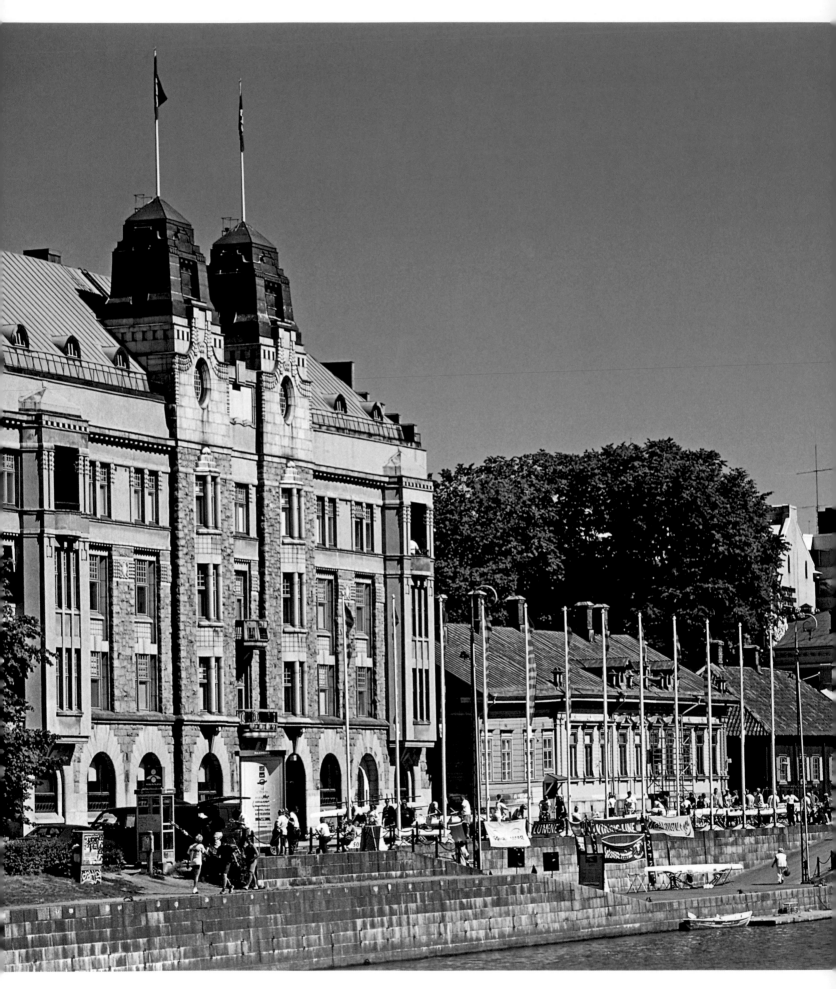

Turku:
Gateway to the Baltic

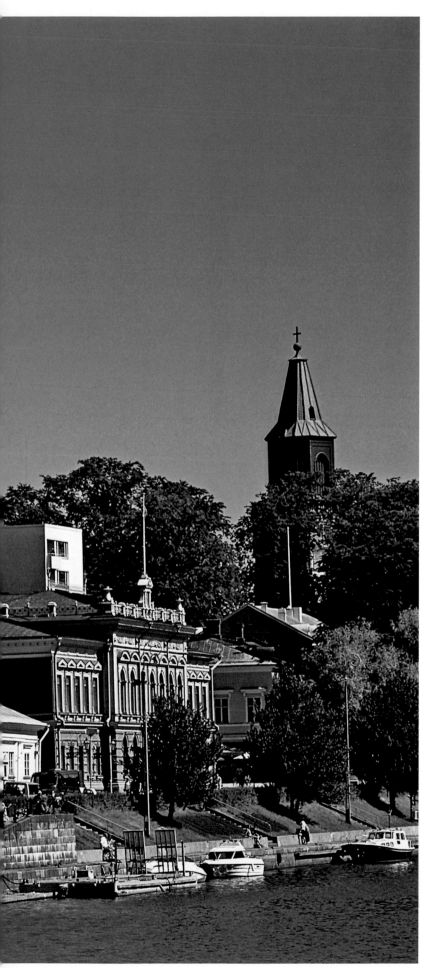

98-99 Turku is the oldest city in Finland and the old capital of the country. Its historic center extends over both banks of the Aurajoki River.

99 top The photo shows the courtyard of the castle of Turku. Built in 1280 at the mouth of the Aurajoki River, over the centuries, the castle has undergone numerous enlargements. Exploring the building will lead to the discovery of a labyrinth of restored rooms, its historical museum, and two underground prisons.

99 bottom In Turku and along the southern coast of the Gulf of Bothnia, numerous prestigious manors face onto the sea, denoting a lifestyle superior to that of other regions in the country.

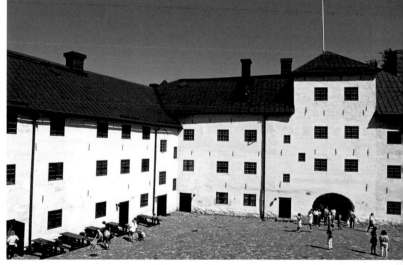

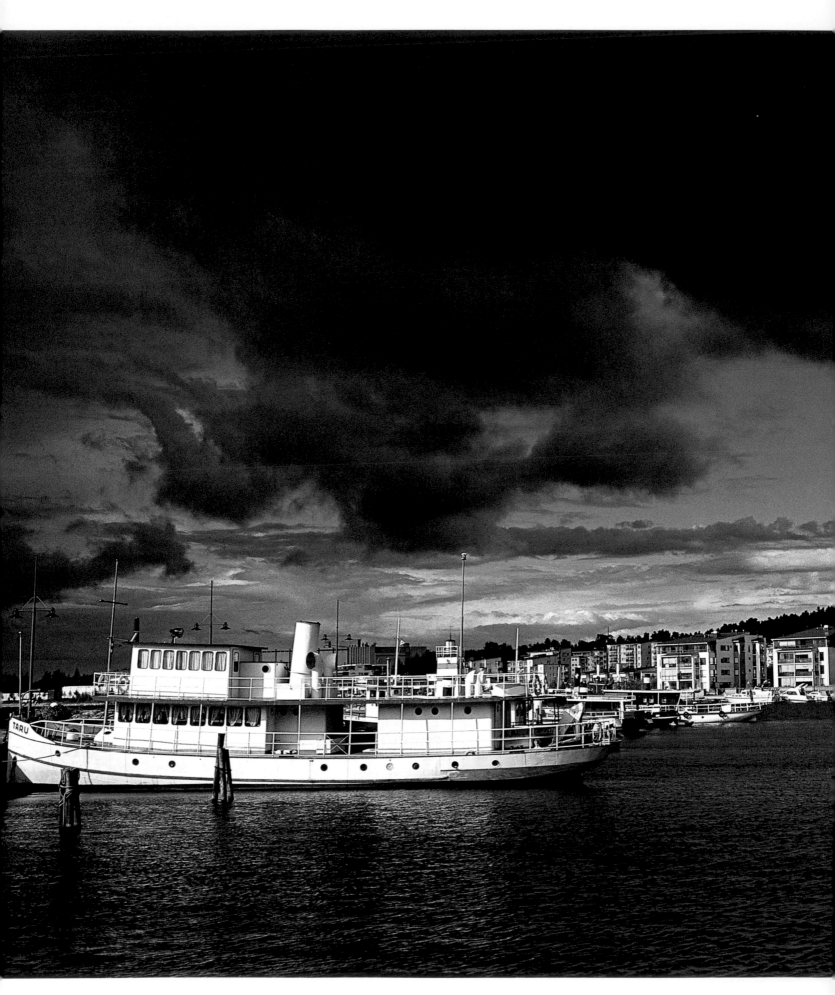

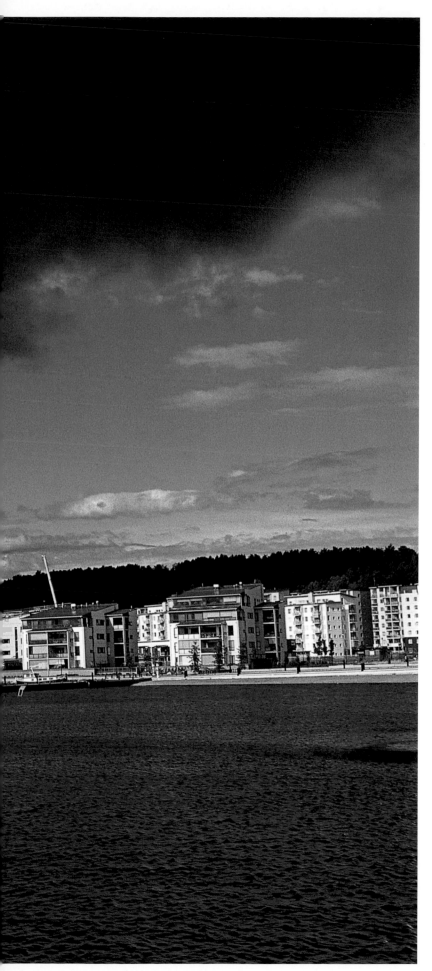

Lahti: The Capital of Winter Sports

100-101 Located north of Helsinki on the banks of Lake Vesij_rvi, the city of Lahti is a modern commercial and business hub, a quality that distinguishes it from other cities in the lake region, and is renowned above all for winter sports.

101 top and bottom Because of its location on Lake Vesijärvi, in turn linked to the large Päijänne River, the port of Lahti is the base for ferryboat departures crossing a complicated tangle of interconnected canals and waterways that connect several cities in southern and central Finland.

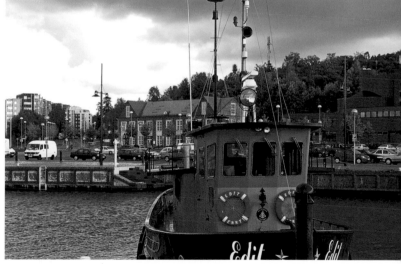

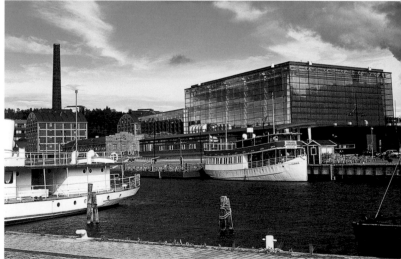

Tampere: Where Nature Reigns Supreme

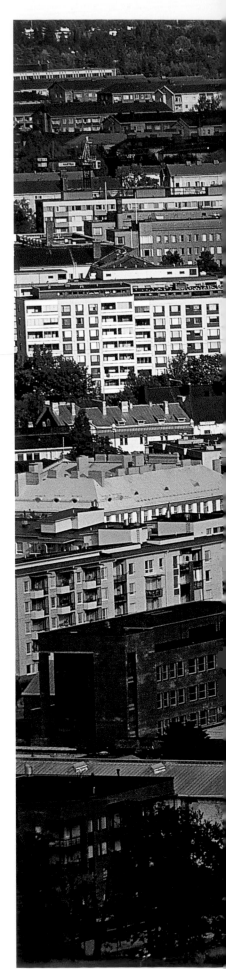

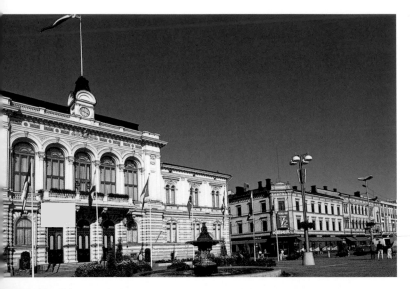

102 top Tampere, once renowned for its textile industry, is today a lively built-up area in the middle of the Häme region.

102 center left Often defined the "Manchester of Finland," Tampere is actually a small, pleasant, city on a human scale.

102 center right Tampere has known how to combine its modern industrial activity with its past architectural beauty and cultural heritage.

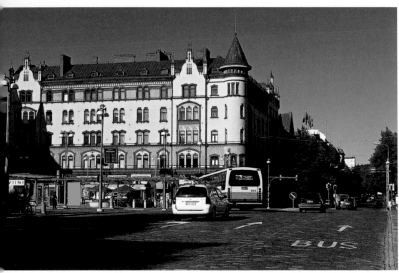

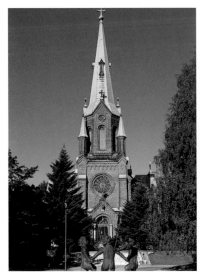

102 bottom Thanks to a healthy student population and a growing technological industry, the city of Tampere draws many Finns wanting to live and work there.

102-103 This photo, taken from the sky, offers a bird's-eye view of the city of Tampere with its cathedral. With its almost 200,000 inhabitants, it is the third-largest city in Finland for size and the largest urban area in the north without a seaport.

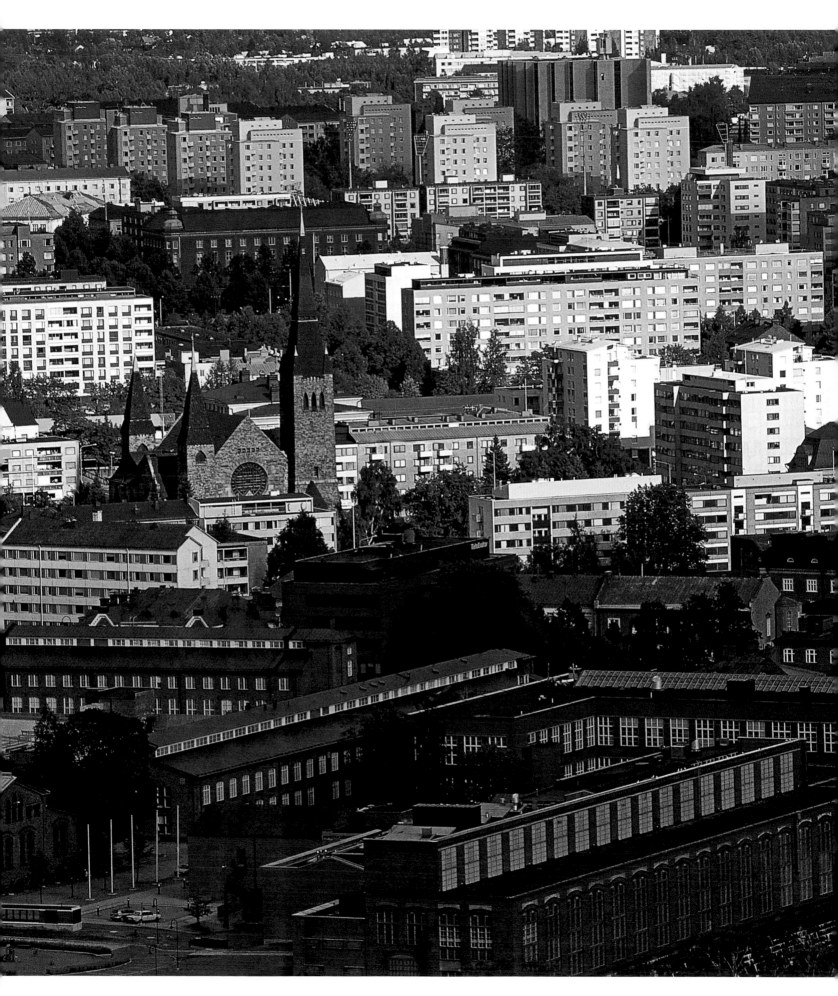

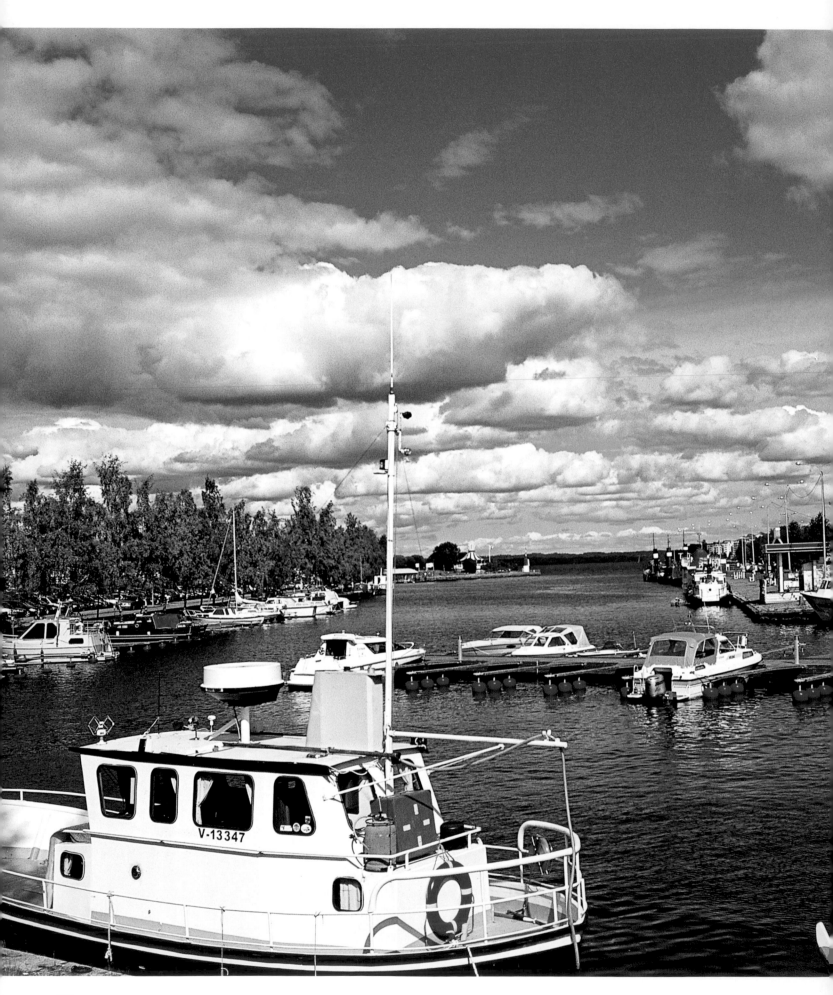

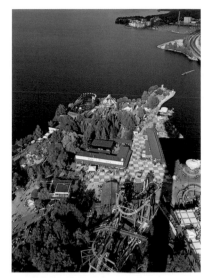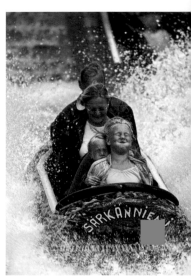

104-105 *Tampere stands between Lake Näsiärvi and Lake Pyhajärvi, connected by the famous rapids of Tammerkoski. The port offers the local population quick access to the outdoors and the typical lake landscape of the Finnish taiga.*

105 *top and center The amusement park of Särkänniemi, located north of Tampere, is very popular with Finnish families. The available attractions are numerous: Ferris wheels, roller coasters, and water slides in addition to the biggest aquarium in Finland and a children's zoo.*

105 *bottom Proximity to the water and the constant presence of nature even within the city make it possible for the inhabitants of Tampere to fish regularly, one of the Finns' favorite outdoor hobbies.*

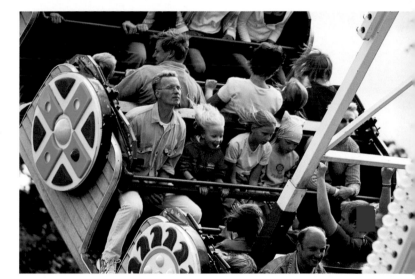

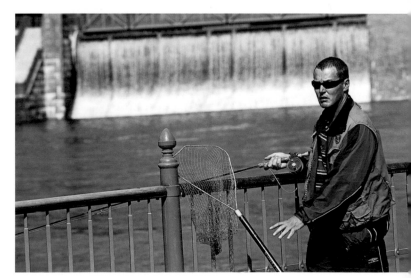

Oulu: Crossroads of Commerce

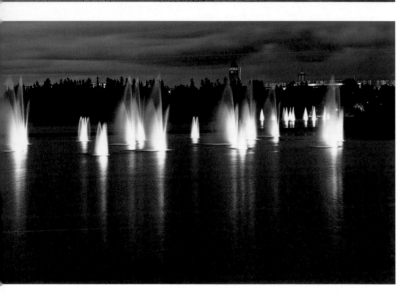

106 top In the heart of Oulu stands the monument to the policeman: this little city, found on the northern coast of the Gulf of Bothnia, is a wealthy and lively university town in rapid expansion.

106 center left The city stands at the mouth of the Oulujoki and is connected by a series of bridges to numerous islands off the coast in the Gulf of Bothnia.

106 center right The nineteenth-century church of Oulu sits on the site of a much older church built before the great fire of 1822.

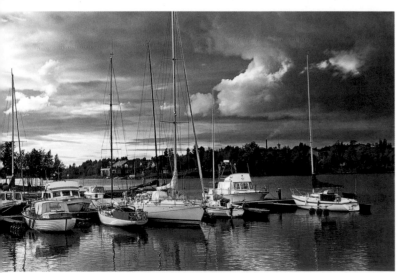

106 bottom Standing at the mouth of the Oulujoki River, Oulu affords its inhabitants almost immediate access to the open sea and numerous surrounding islands.

106-107 In 1822, the city of Oulu was razed to the ground by a tremendous fire; it was rebuilt, but today very few of the older buildings remain standing. Oulu is one of the most interesting places to visit during the summer for its cosmopolitan atmosphere and the number of festivals and cultural events organized there.

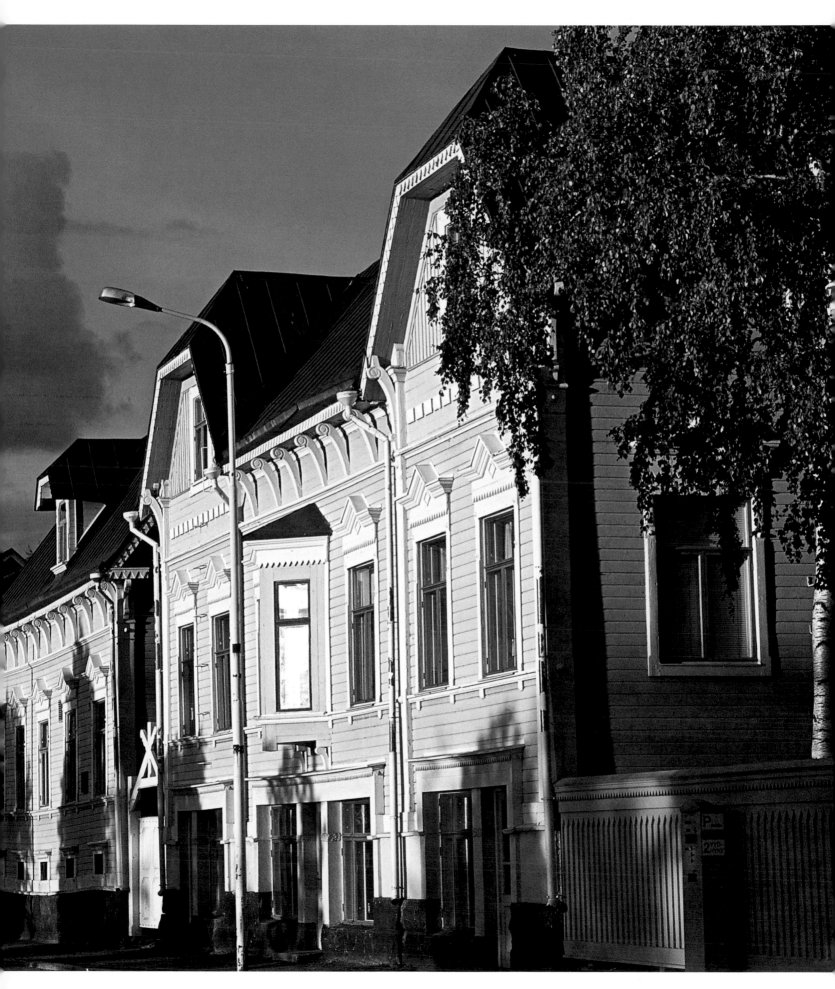

Rovaniemi: The House of Santa Claus

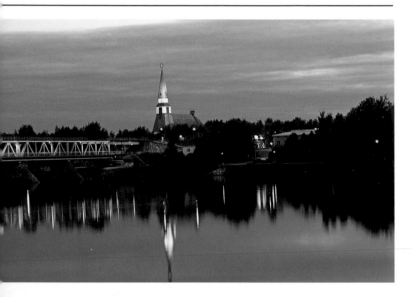

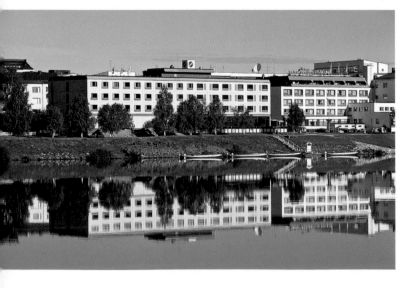

108 top Rovaniemi is the capital of the Lapland region not to mention the main port in the Arctic region. Located in the Arctic Circle, it is a good point of departure for expeditions in sleds pulled by dogs or reindeer and for winter safaris on snowmobiles.

108 center The bridge on the Ounasjoki River in Rovaniemi was destroyed by the Germans in 1944 and resurrected according to a plan by the architect Alvar Aalto. The capital of Lapland is worth stopping in for the Arktikum, a museum dedicated to the Arctic flora, fauna, and peoples.

108 bottom The houses of Rovaniemi are reflected in the waters of the Ounasjoki River.

108-109 Together with Santa Claus, the reindeer is one of the symbols of Rovaniemi, capital of Lapland and an obligatory stop for visitors.

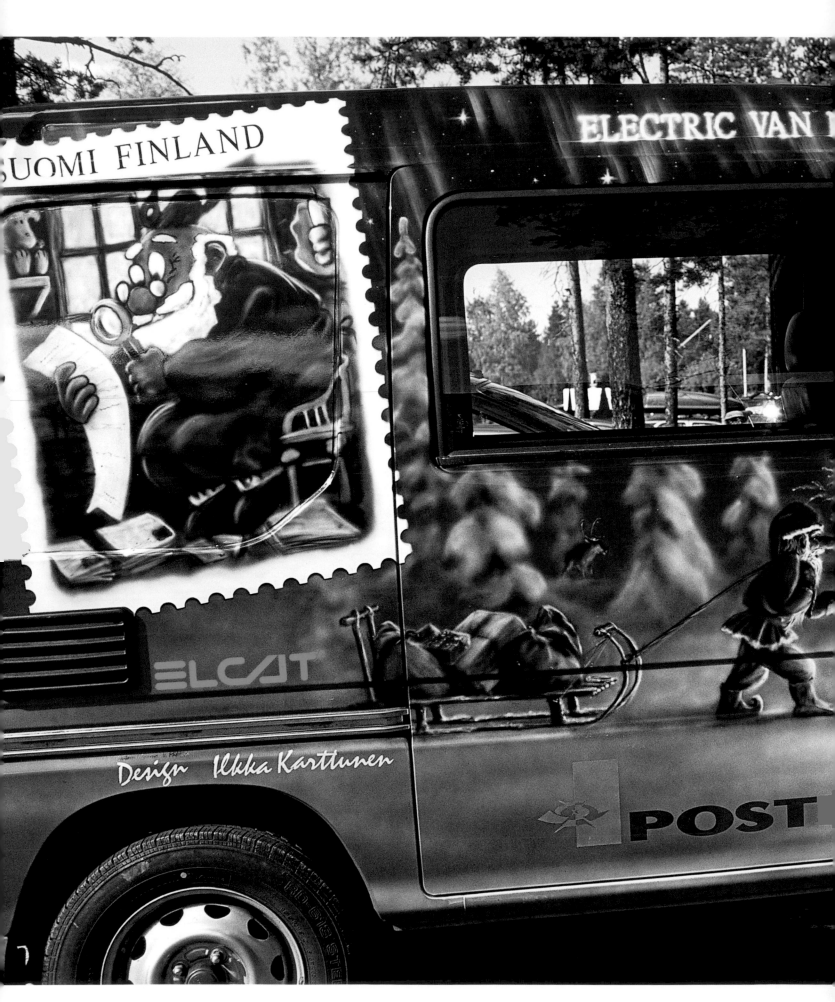

110-111 *The central post office of Santa Claus in Santa Claus' Village in the Arctic Circle receives almost a million letters from children around the world every year.*

111 top left *The Arctic Circle is located at a northern latitude of about 66.5 degrees: in Finland it is called Napapiiri.*

111 top right *Santa Claus' Village is found in the Arctic Circle about five miles north of Rovaniemi on the main road linking the capital of Lapland to Sodankylä.*

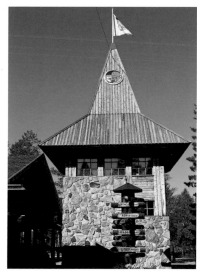

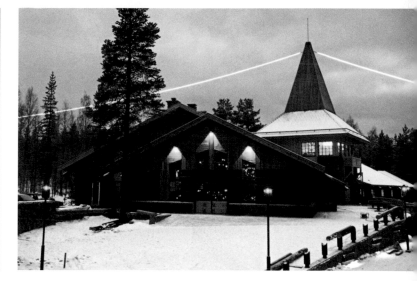

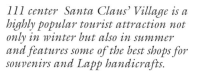

111 center *Santa Claus' Village is a highly popular tourist attraction not only in winter but also in summer and features some of the best shops for souvenirs and Lapp handicrafts.*

111 bottom *From Santa Claus' post office, it is possible to have a postcard sent to your house with Santa's official stamp.*

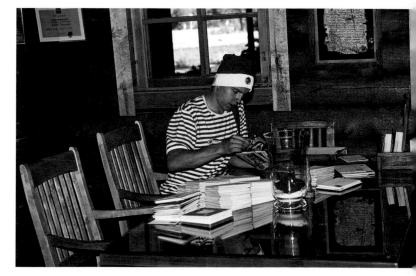

Man and Nature

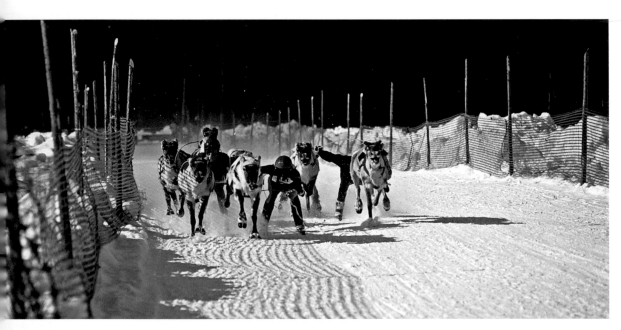

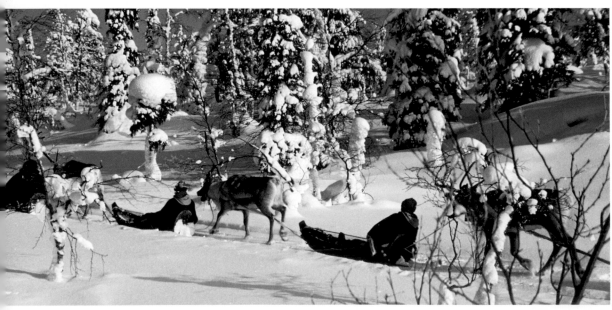

112 top Breaking into a gallop, reindeer driven by jockey's on skis shoot towards the finish line. It is one of the traditional events that take place every year between the end of March and the beginning of April in Inari in northern Lapland.

112 bottom In the snowy forest beyond the Arctic Circle, short and long safaris in the wilderness with reindeer pulling a traditional sled (pulka) are organized for tourists.

113 An important aspect of Lapp culture remains their national outfit: worn every day up until a few decades ago as their normal work uniform, today it is dusted off only on special occasions and ceremonies.

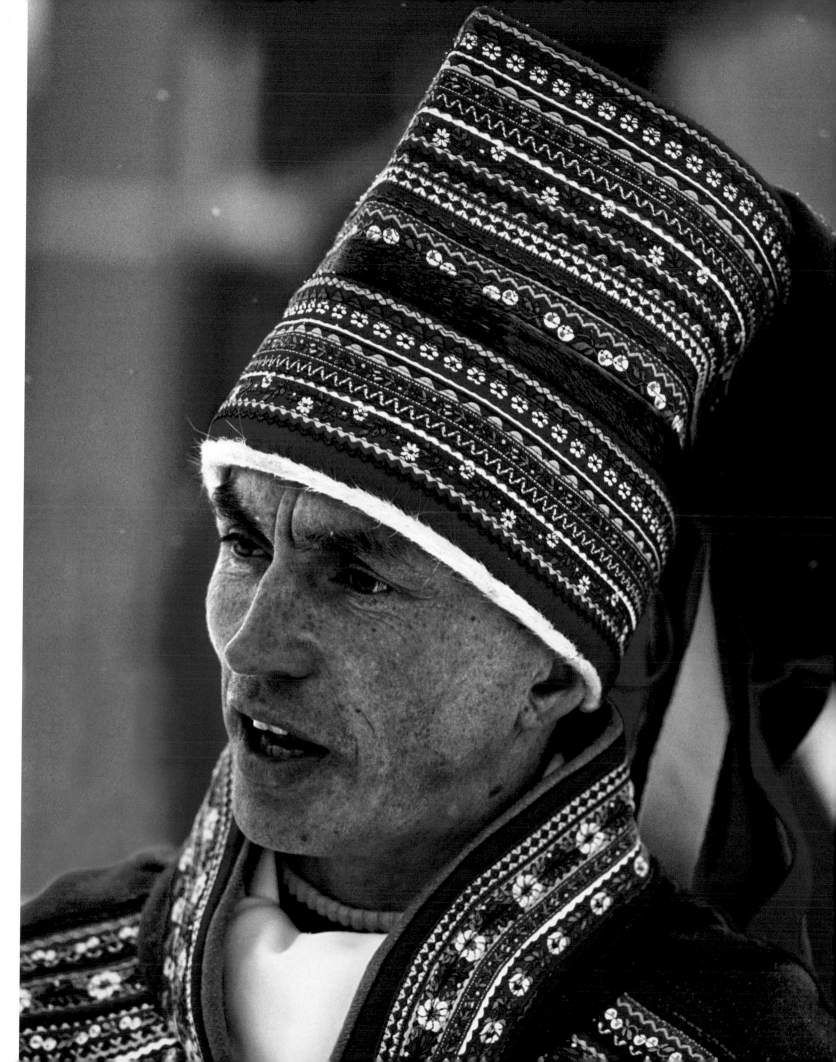

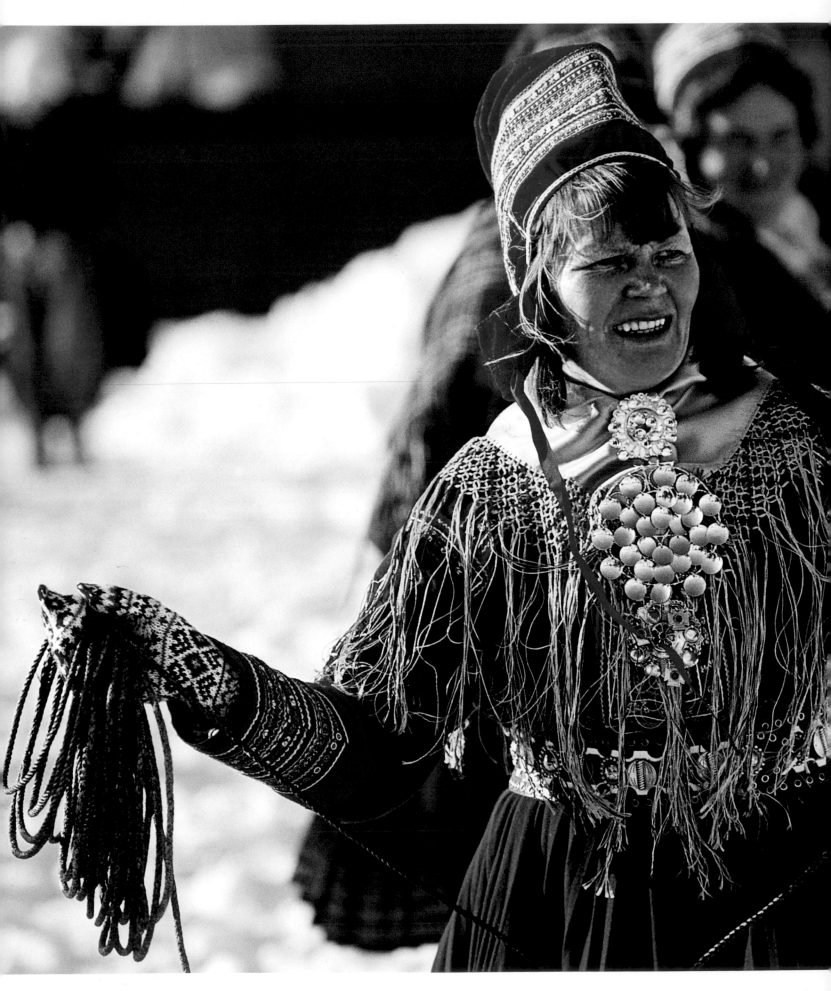

114-115 *A Sami woman grapples with a lasso during preparations for the autumn gathering of the reindeer into pre-prepared enclosures.*

115 *The traditional Lapp outfit consists of a head covering that varies slightly according to region, a sort of blue-cloth tunic decorated with colorful bands, and a wide leather belt worn tight around the waist.*

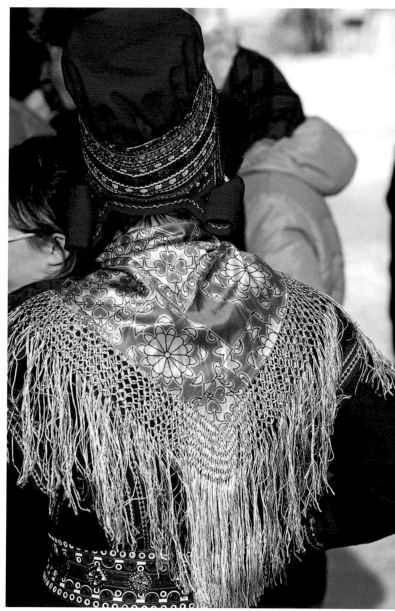

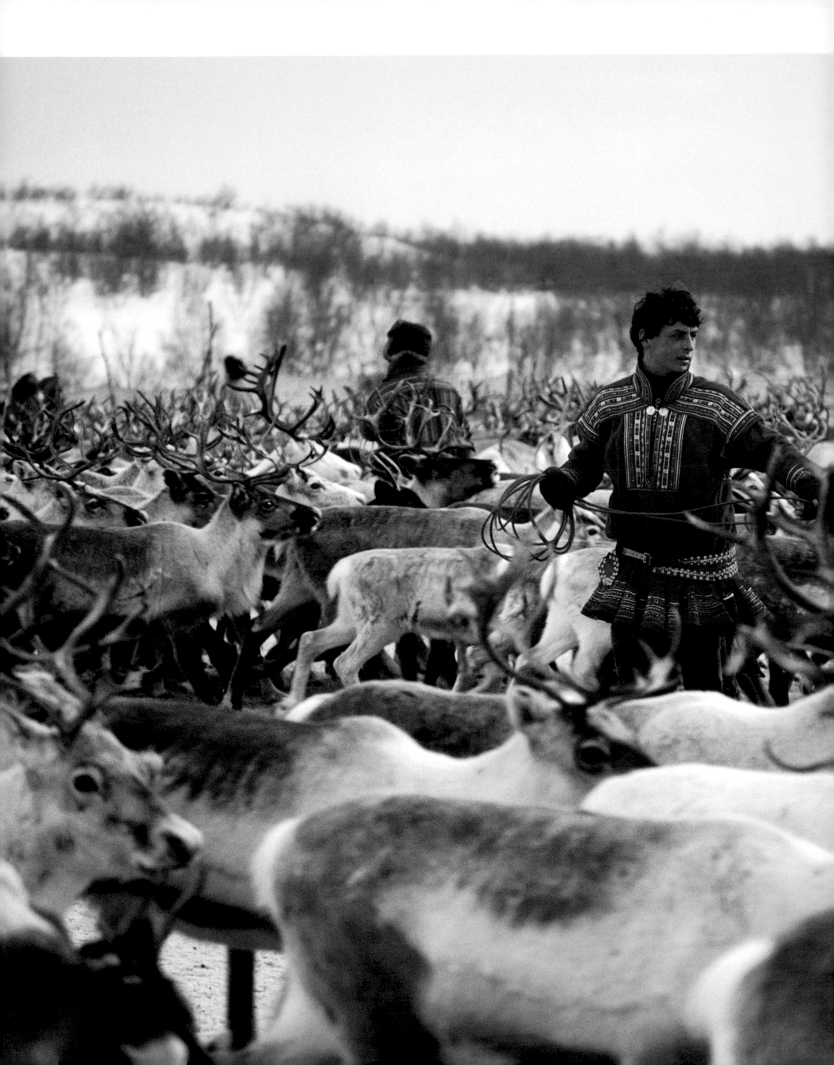

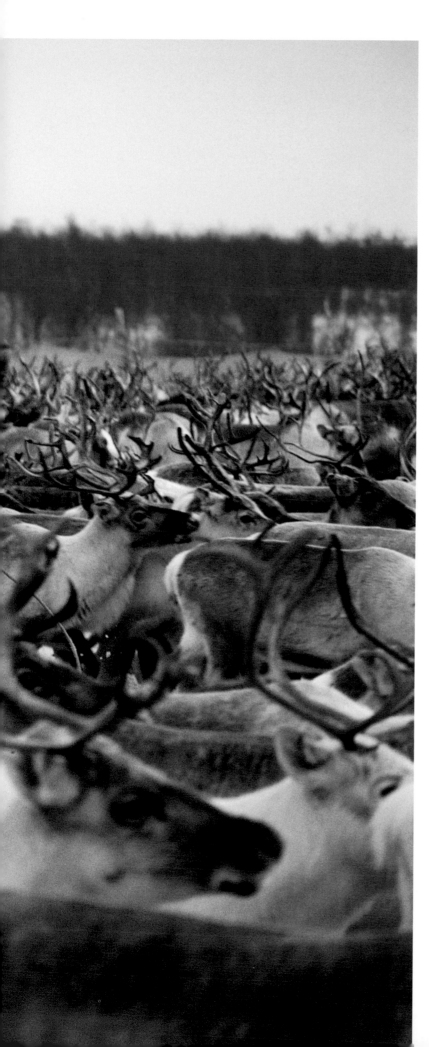

116-117 A young Sami woman works with a lasso in the corral during the autumn gathering of the reindeer.

117 top Rounding up the reindeer that live in the wild during the rest of the year has become a tiring task for the Lapp herdsmen, despite the help of advanced modern technologies.

117 bottom In the Lapp cultural tradition, the reindeer has maintained a fundamental role over the centuries.

118-119 According to the most recent estimates, the present-day population of the Sami people in Finland amounts to about 6,000 individuals (out of 60,000 to 70,000 total living in the rest of Scandinavia and the Kola Peninsula in Russia).

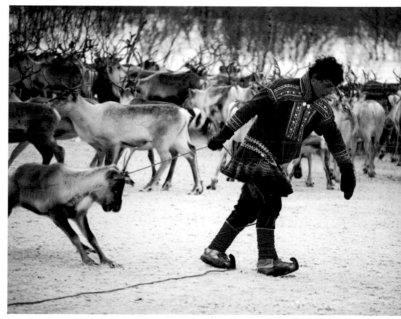

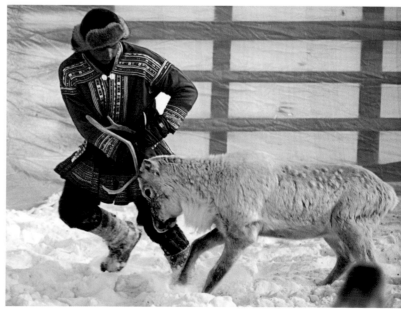

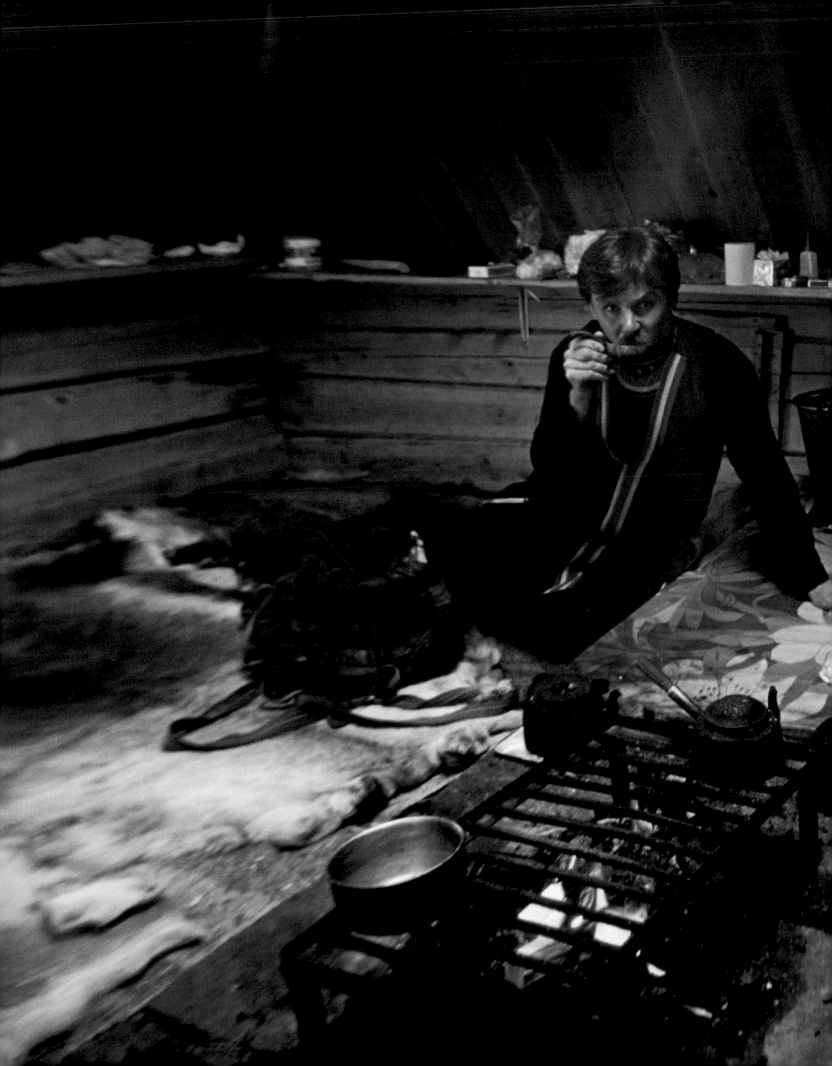

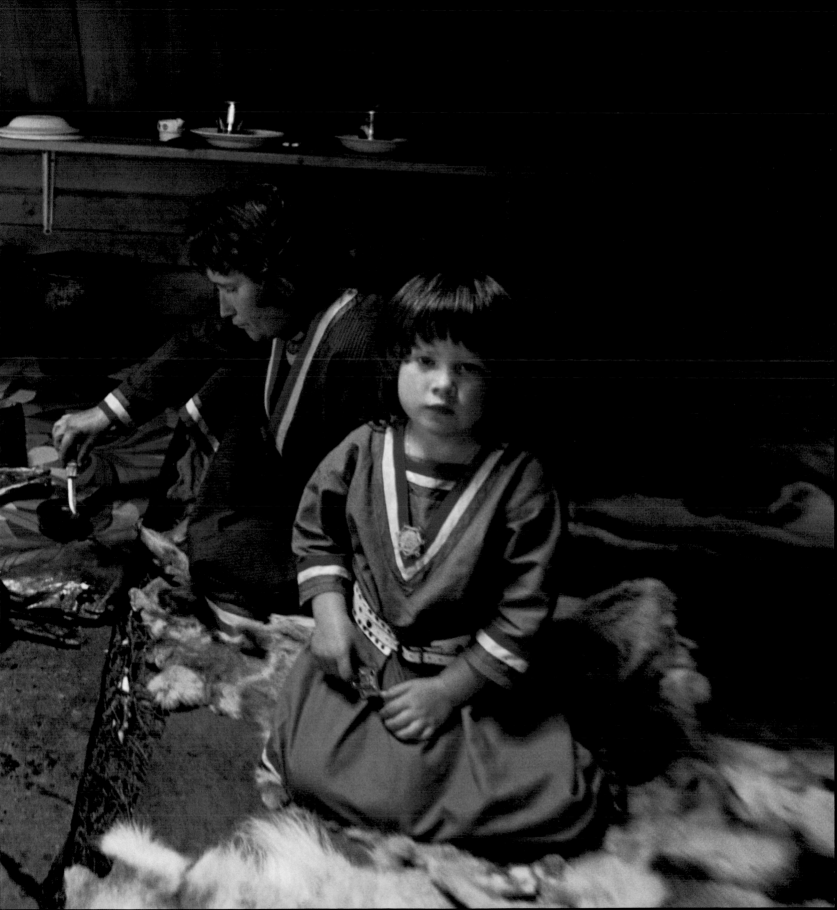

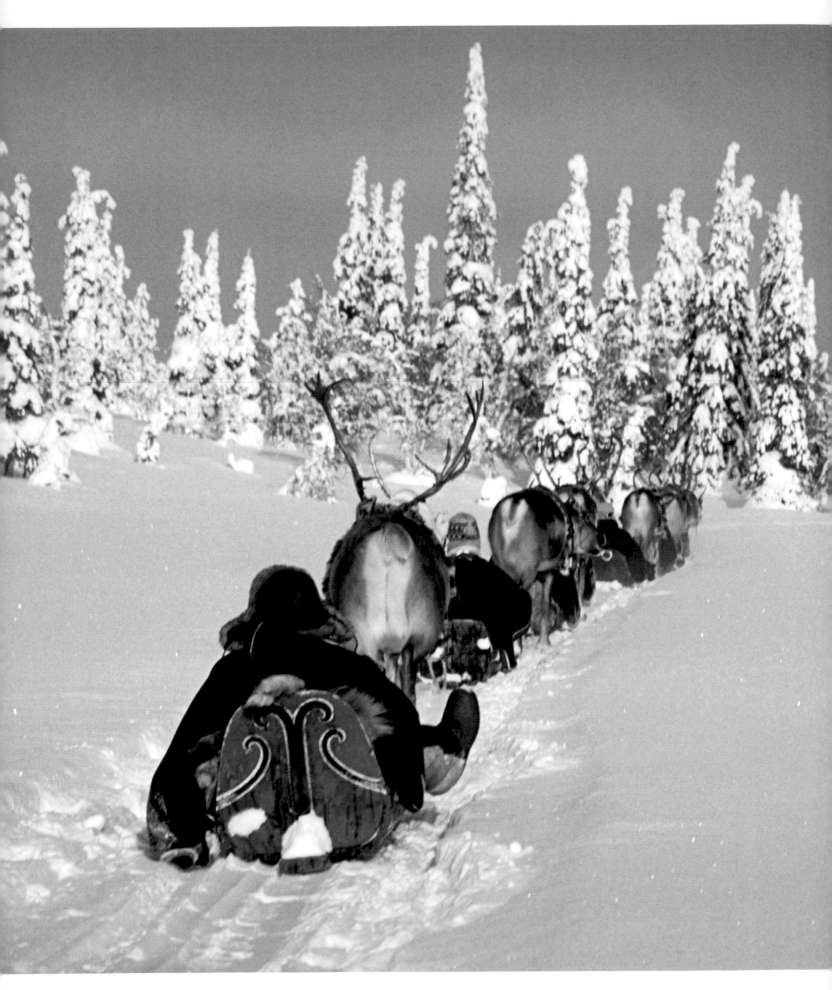

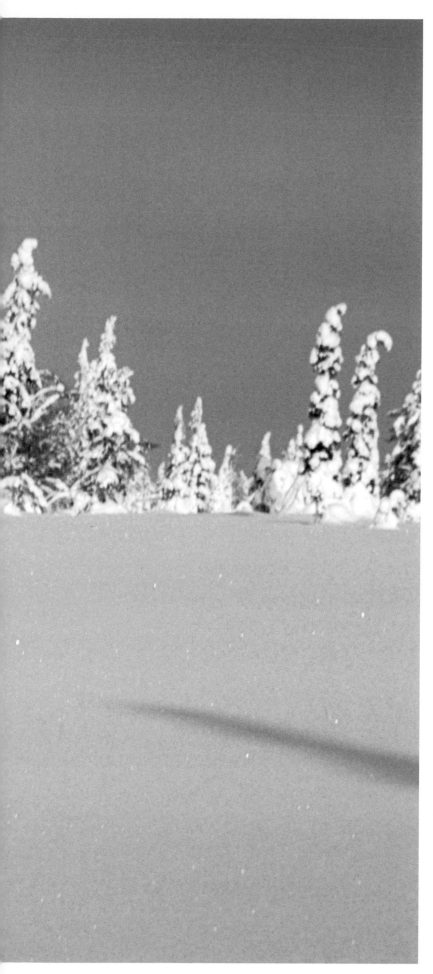

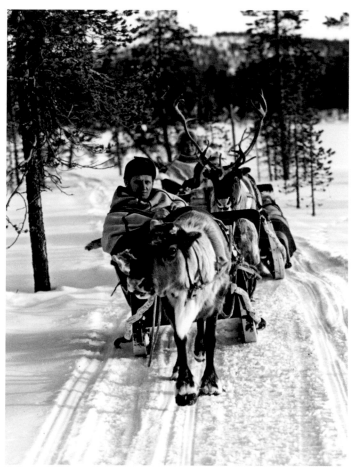

120-121 Today, reindeer are also used for tourist safaris in the taiga, but in the past they served to pull the sleighs and were an indispensable part of the life of every Lapp, from infancy, when the animals became the first play companion of the little Sami, to their wedding day, when they were offered by the suitor in exchange for consent to the marriage, and finally, after butchering, for the usefulness of their skins and prized meat.

121 Once domesticated reindeer were also used as draft animals to pull sleds. Nowadays, modern snowmobiles have taken over, however, in the tourism sector, reindeer are still used for wilderness safaris, though it is increasingly popular to use the non-traditional dog-pulled sleds.

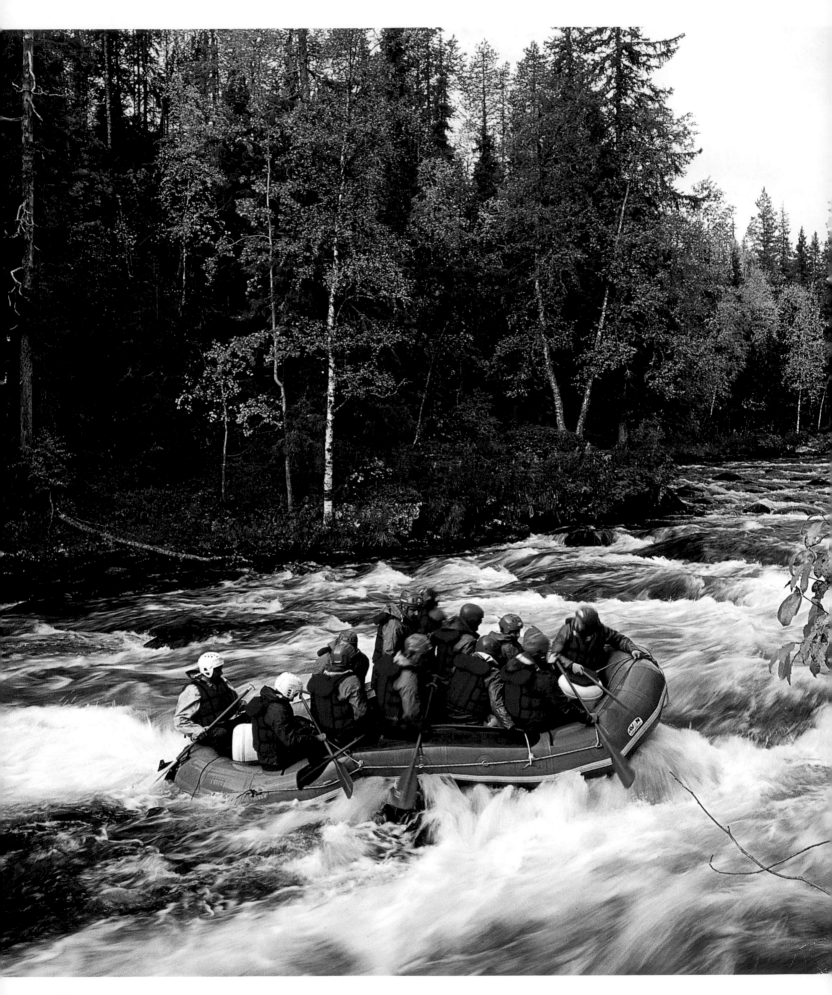

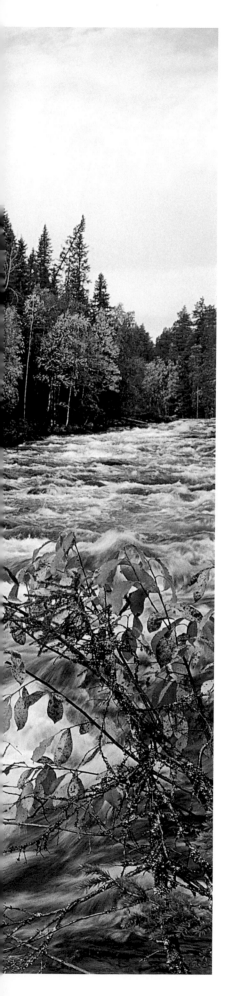

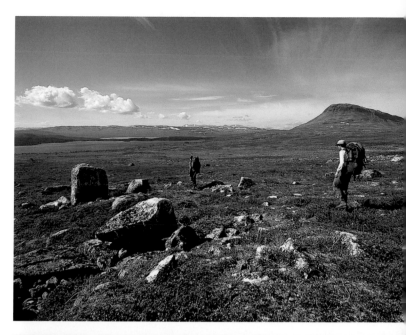

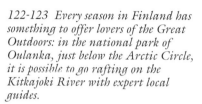

122-123 *Every season in Finland has something to offer lovers of the Great Outdoors: in the national park of Oulanka, just below the Arctic Circle, it is possible to go rafting on the Kitkajoki River with expert local guides.*

123 top *The Kilpisjärvi area in northwestern Lapland is a paradise for hikers: in the vastness of the tundra, excursionists can reach the mountain sacred to the Lapp people, Mount Saana (in the background), and the highest peak in Finland, Mount Halti (4,357 feet).*

123 center *The maze of mirror-like lakes and interconnecting waterways in the Lake District offer canoeists the possibility to surround themselves with wilderness, camping in tents or special refuges on the banks of the lakes and rivers for as long as they want.*

123 bottom *In the fairy-tale world of the snow-covered fir-tree groves, a group travels by cross-country ski, from the shores of Lake Kitkajärvi to the slopes of the hills in the national park of Riisitunturi.*

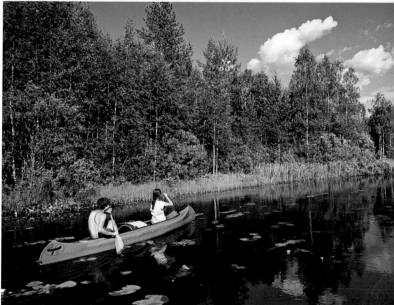

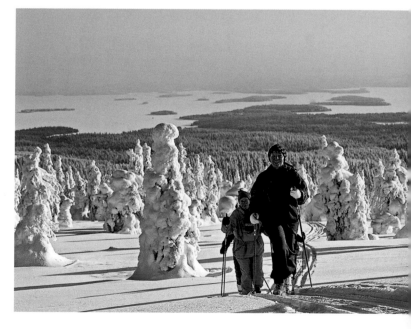

123

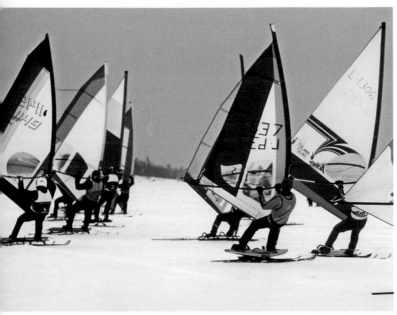

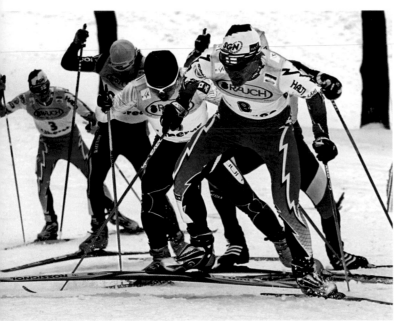

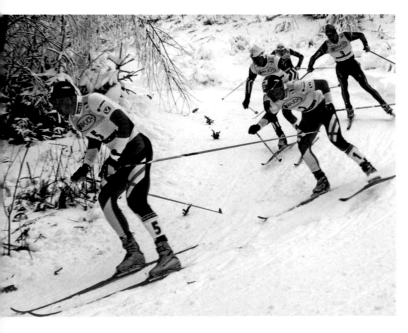

124 top During the cold Arctic winter, the outdoor activities of the Finns do not decrease, they actually expand into their full glory as demonstrated by the windsurfing races on the frozen surface of lakes or the sea (iceboard).

124 center and bottom Once, skis were the quickest means to get around during winter. Kids went to school by ski, mothers pushed baby carriages mounted onto skis, and Finnish soldiers at war were known for their blitzes on skis. Today, with the arrival of snowmobiles, the use of this transportation tool has greatly decreased, but this is not the reason for which the Finns have stopped excelling and winning at cross-country ski competitions and marathons.

124-125 Ice hockey is the national sport: the championship season goes from the end of September to March. The strongest teams in the league are those of Tampere, Helsinki, Turku, Oulu, and Rovaniemi. The national team is top-level and at world championships is always found in the finals along with the other major international competitors: Canada, Sweden, and the United States.

126-127 At Inari, in northern Lapland, at the beginning of the spring, when everything is still frozen and snow-covered, the spectacular competition takes place that determines the fastest reindeer in Finland.

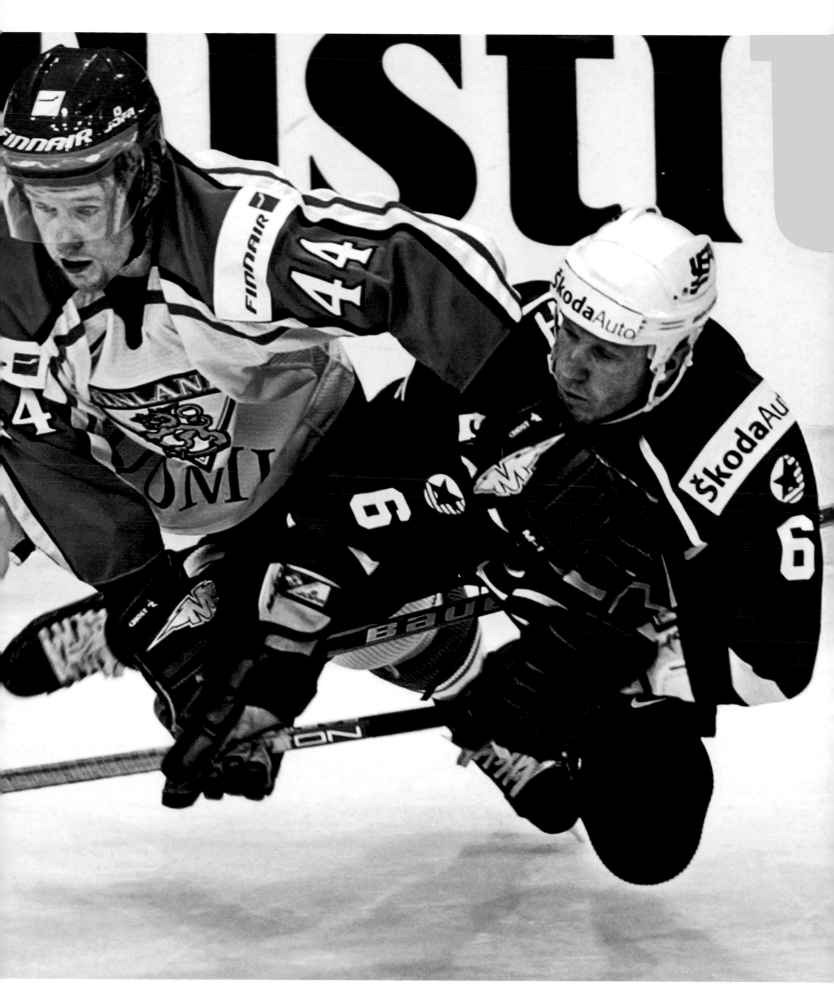

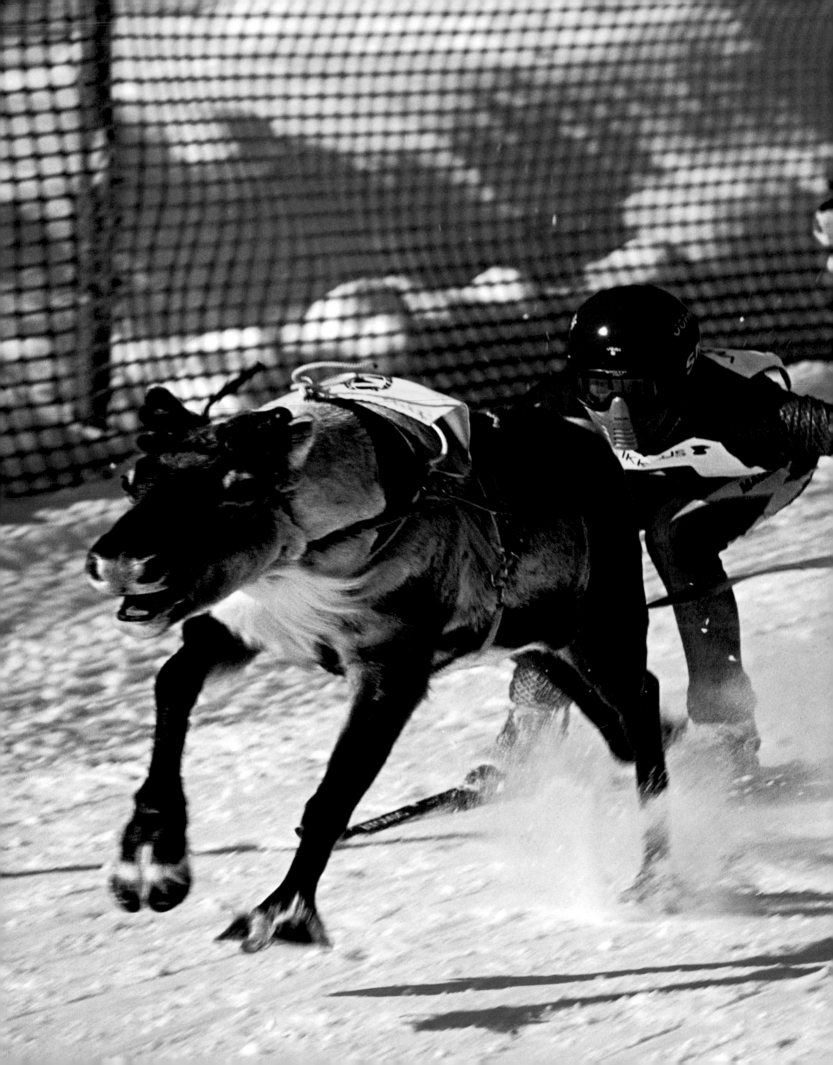

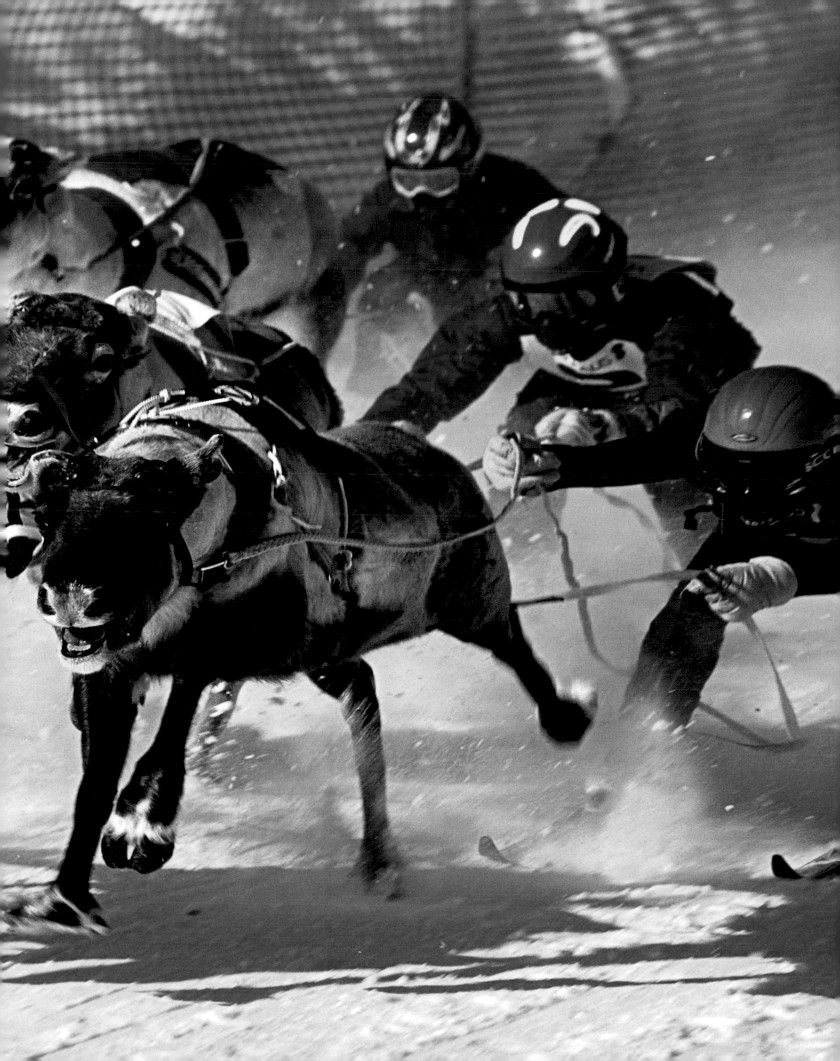

128 The cathedral of Uspenski in Helsinki with its forest of spires and domes is the biggest Orthodox church in Finland. The temple dominates the zone of the port on the island of Katajanokka, linked to the city by several bridges.

Photo Credits:

Alamy Images: pages 19 bottom, 76-77, 116-117, 117 top and bottom.

Yann Arthus-Bertrand/Corbis/Contrasto: page 124 top.

Marcello Bertinetti/Archivio White Star: pages 19 top, 80 top, 87 center, 89 top left, 90-91, 91 top and center, 114-115, 115.

Eric Chretien/Gamma/Contrasto: pages 4-5.

Angelo Colombo/Archivio White Star: page 17.

Jean Du Boisberranger/Hemispheres Images: pages 46-47, 47 top, center and bottom.

Grigory Dukor/Reuters/Contrasto: pages 124-125.

Franco Figari: pages 29, 33 top, center and bottom, 42-43, 44-45, 49 top, 52 top left and right, 52 center left and right, 52 bottom, 53, 55 top, 55 bottom, 58 left and right, 60-61, 68 top, center, bottom, 68-69, 70-71, 71 top and bottom, 89 top right, 92-93, 122-123, 123 top, center and bottom.

Fausto Giaccone/Anzenberger/Contrasto: page 121.

Hannu Hautala: pages 2-3, 7, 10-11, 12-13, 24-25, 30, 32, 34-35, 56-57, 59, 62-63, 64-65, 66 bottom, 66-67.

Dave G. Houser/Corbis/Contrasto: pages 8-9, 22 bottom, 49 bottom, 112 bottom, 120-121.

Petr David Josek/Reuters/Contrasto: page 124 center and bottom.

Martti Kainulainen/AP Press: page 111 center right.

Juha Kinnunen: pages 26-27, 28 top, 74-75, 75 top, center.

Danny Lehman/Corbis/Contrasto: pages 80-81, 82, 83.

Marcello Libra: pages 18 bottom, 65 top, 65 center left and right, 65 bottom, 72, 72-73.

Marcello Libra/Archivio White Star: pages 6, 28 bottom, 31, 41, 43, 78 top and bottom, 79, 80 bottom, 84-85, 87 top left and right, 87 bottom, 88-89, 89 center and bottom, 91 bottom, 92, 94-95, 96-97, 100-101, 102-103, 104-105, 106-107, 108-109, 110-111, 111 top left and right, 111 center left, 111 bottom, 128.

Chris Lisle/Corbis/Contrasto: pages 1, 14-15, 21, 37, 38-39, 40-41, 48-49, 86, 98-99, 99 bottom.

Jorma Luhta/Nature Picture Library: page 75 bottom.

Andy Rouse/NHPA: page 66 top.

Piergiorgio Sclarandis/Sime/Sie: pages 54-55.

Jon Sparks/Corbis/Contrasto: page 22 top.

Riccardo Spila/Sime/Sie: pages 23, 50-51.

Hubert Stadler/Corbis/Contrasto: page 36.

Nik Wheeler/Corbis/Contrasto: pages 99 top, 112 top, 113, 126-127.

Staffan Widstrand/Corbis/Contrasto: page 18 top.

Bo Zaunders/Corbis/Contrasto: pages 118-119.